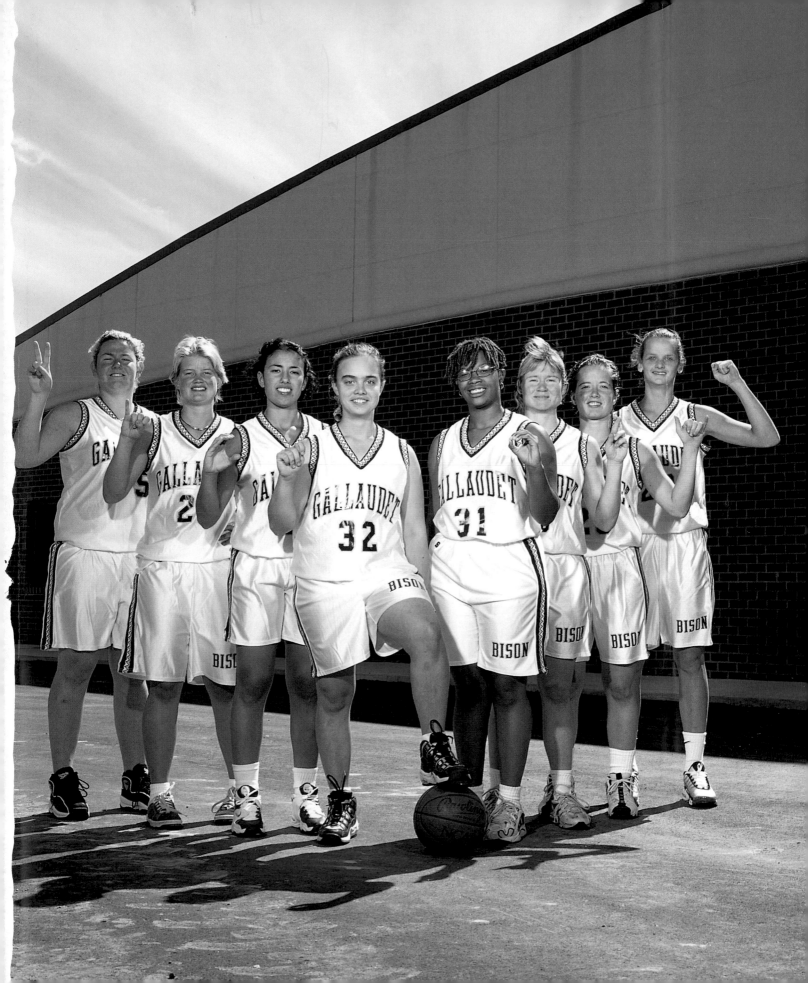

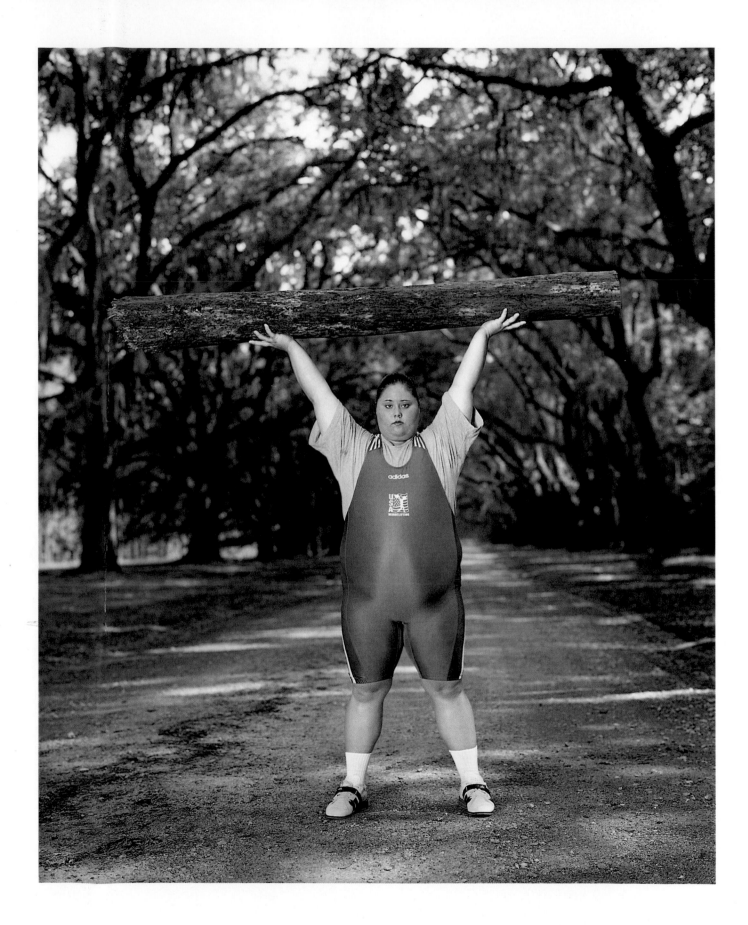

Game Face

What Does a Female Athlete Look Like?

Created and developed by Jane Gottesman

Edited by Geoffrey Biddle

Foreword by Penny Marshall

With support from MassMutual Financial Group,

including OppenheimerFunds, Inc.

Random House, New York

Copyright © 2001 by Game Face Productions

Library of Congress Cataloging-in-Publication Data
Game face : what does a female athlete look like? /
 [compiled by] Jane Gottesman.
 p. cm.
Book will coincide with a 6-month exhibition at the Smithsonian Institution in Washington, D.C., and will continue as a traveling exhibit over the next five years.
ISBN 0-375-50602-0 (alk. paper)
1. Sports for women—Pictorial works—Exhibitions. 2 Women athletes—Pictorial works—Exhibitions. I. Gottesman, Jane. II. Smithsonian Institution.
GV709.G36 2001 00-045976
796'.082—dc21

Random House website address: www.atrandom.com

Printed in Italy on acid-free paper

9876543

Book Design: Lawrence Wolfson Design, NY

The *Game Face* book and traveling exhibition are projects of Game Face Productions. For more information go to www.gamefaceonline.org or write egameface@aol.com.

This title is available at a discount when ordering 25 or more copies for sales, promotions, or corporate use. Special editions, including personalized covers, excerpts, and corporate imprints, can be created when purchasing in large quantities. For more information, please call (800) 800-3246 or e-mail specialmarkets@randomhouse.com.

Page 1
Gallaudet's Victory
Washington, D.C.
Karen Fuchs, 1999

Page 2
Weightlifter Cheryl Haworth
Savannah, Georgia
Mary Ellen Mark, 2000

In the inaugural women's weightlifting competition at the 2000 Sydney Olympics, Cheryl Haworth won a bronze medal in the 75+ kilo weight class.

"Everybody is good at something and too often people think because they aren't the same size or shape as some other people that they'll never find what they're good at. They think they're finished and give up."
—Cheryl Haworth

Page 4
Winners, Olympic Tryouts
Harrisburg, Pennsylvania
Photographer unknown, AP/Wide World Photos, 1952

Page 8
Aubrey Becker, "Nottingham Northstars"
Trenton, New Jersey
Nancianne Vizzini, 1994

Page 10
Wilma Rudolph of Clarkesville, Tennessee
New York, New York
Photographer unknown, AP/Wide World Photos, 1960

page 218
Hell on Wheels
Chicago (?)
Photographer unknown, 1946

Page 224
Four Colorado Teams
Craig, Colorado
G. H. Welch, 1920

Contents

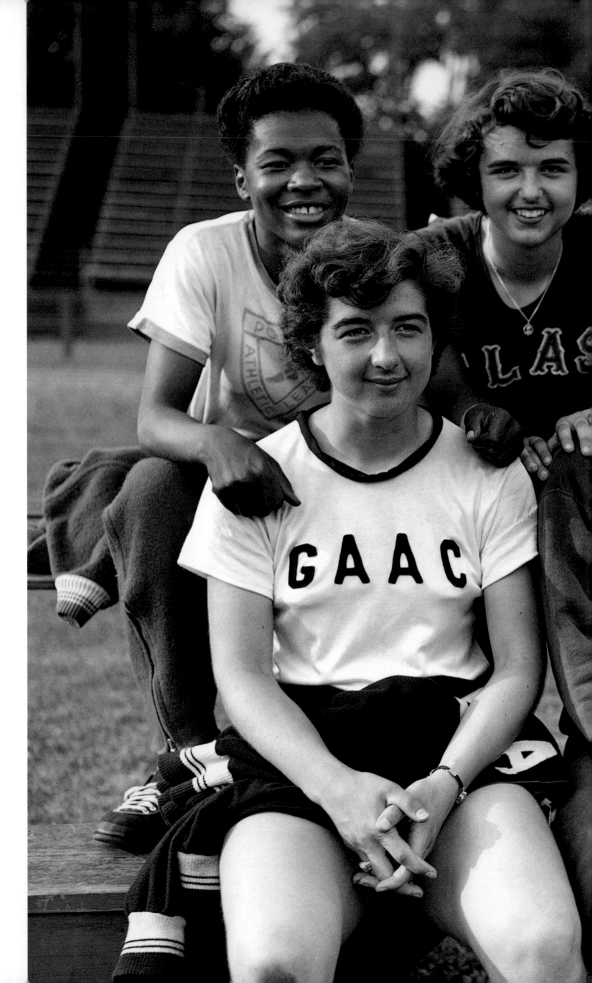

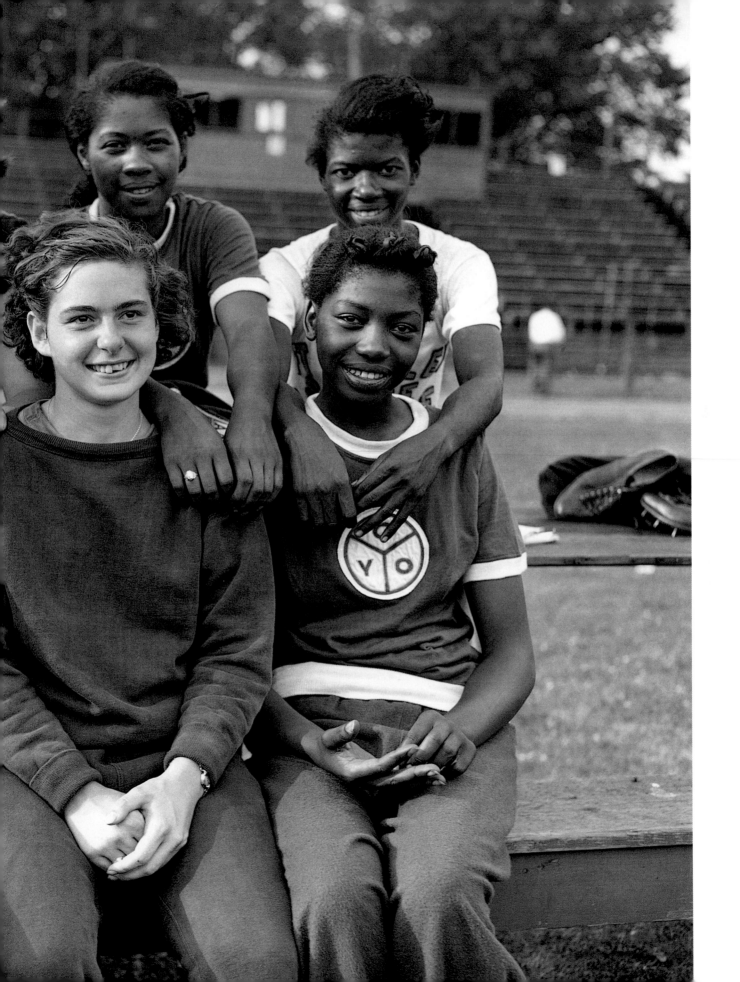

Foreword by Penny Marshall

I've been in love with sports my whole life. I grew up in the Bronx as the quintessential tomboy and was always running off into the street to play ball with the neighborhood boys while the other girls stayed on the sidewalk and jumped rope. So being asked to write the Foreword for *Game Face* is a grown-up tomboy's dream come true. To me, sports and girls go together like Pepsi and milk.

When I was in the first and second grades, the boys and I played punchball, a game similar to baseball but without a pitcher. Each batter would toss the ball up into the air, punch it as far as he could with his curled-up fist, and then run the bases. Most of the girls I knew wouldn't even try to punch the ball because they saw no reason to. One day I hit the ball the length of a city sewer. For a boy or girl, that was considered pretty far. So from then on, whenever the boys were short a player, they'd pick me to be on their team because I was athletic. I was a sewer hitter. I was in heaven.

My mother, however, never encouraged me to play sports because she said the boys wouldn't like me if I was better than they were. Back then, popular girls carried players' jackets and mitts instead of playing ball with them, because—truthfully—the boys liked girls who just "watched." And if a girl ever did pick up a bat, she had to feign ignorance in the name of flirting and let a boy teach her the proper batting stance and swing. But I knew the proper batting stance and how to swing a bat and wasn't afraid to show it. Thus, I failed flirting.

In college I majored in "recreation," because I could play games with the guys but didn't have to take those tricky science classes like P.E. majors did. Since there wasn't much of a future in sports for a girl, my expected career path was to join a cruise line and become the activities director. However, I took a shot in the dark and went to Hollywood to become an actress instead. I soon found my way into another all-boys game: directing movies.

I didn't pick directing as a profession. Directing picked me. I started hanging out with some of the guys, and before I knew it they were asking me to direct. I said I'd much rather play ball with them than direct a movie. But ultimately, I stuck with directing, because to me it offers a new adventure every time I get behind the camera. After I completed a few movies, I decided to try to develop my own ideas. One day I saw a television documentary on the All-American Girls Professional Baseball League of the 1940s. It was about a group of courageous women who were recruited to play baseball when the men who played ball professionally had gone off to fight in World War II.

I chose to direct *A League of Their Own* because I thought it was a story that needed to be told, and told with accuracy, inspiration, and humor. All of the actresses I cast had to pass a baseball field-ing and hitting test before they were hired—even Madonna. And like real players, some of the actresses got injured. Anne Ramsey broke her nose while trying to catch with a period mitt that didn't have webbing. Rosie O'Donnell played with a broken finger. Lori Petty spent six weeks of the movie with a leg cast under her sock after she got her cleat caught on home plate. And that's not to mention the three concussions that also occurred while the girls were practicing their sliding. One of them was my daughter, Tracy Reiner, who played Betty Spaghetti. But everyone survived the scrapes and bruises because finishing the movie and telling the true stories about these real-life women athletes was important to all of us.

A League of Their Own was a film with a powerful message: Don't be ashamed of your talent. It doesn't matter if you are a good player or a bad player, a boy player or a girl player, a new player or an old player. What matters most is that you play the game, give it the best shot you can, and perhaps open the doors for a few new players to sneak into the locker room and join you. *Game Face* carries that same message about talent and risk. The pictures collected here chronicle the history of women's changing role not only in sports but in all professions. These photos are encouraging and inspiring, but most of all, they are true. They are a testament to the fact that the final story of women and sports is yet to unfold, because women athletes are getting smarter. They are getting tougher. They are getting better at playing their games because the fears, phobias, and stigmas that once hindered them are disappearing. And men are becoming more open to accepting women as teammates on and off the playing field.

I used to dream about playing on the boys' team—I don't have that dream anymore. But I still thrive on the pain and joy of competition just like male athletes. Whether a player is competing against herself or someone else, the final score doesn't always come down to who wins and who loses. It's about how well you can play in your own mind and in your own opinion. I expect that soon we will see a whole new ball game emerge for women in sports. And I for one want a front-row ticket to see what happens. Who knows? By then the concession stands may be selling Pepsi and milk.

Penny Marshall has directed seven movies, including Big, Awakenings, *and* A League of Their Own. *From 1976 to 1983, she played Laverne in the television sitcom* Laverne and Shirley. *Her character's favorite drink was Pepsi and milk, mixed.*

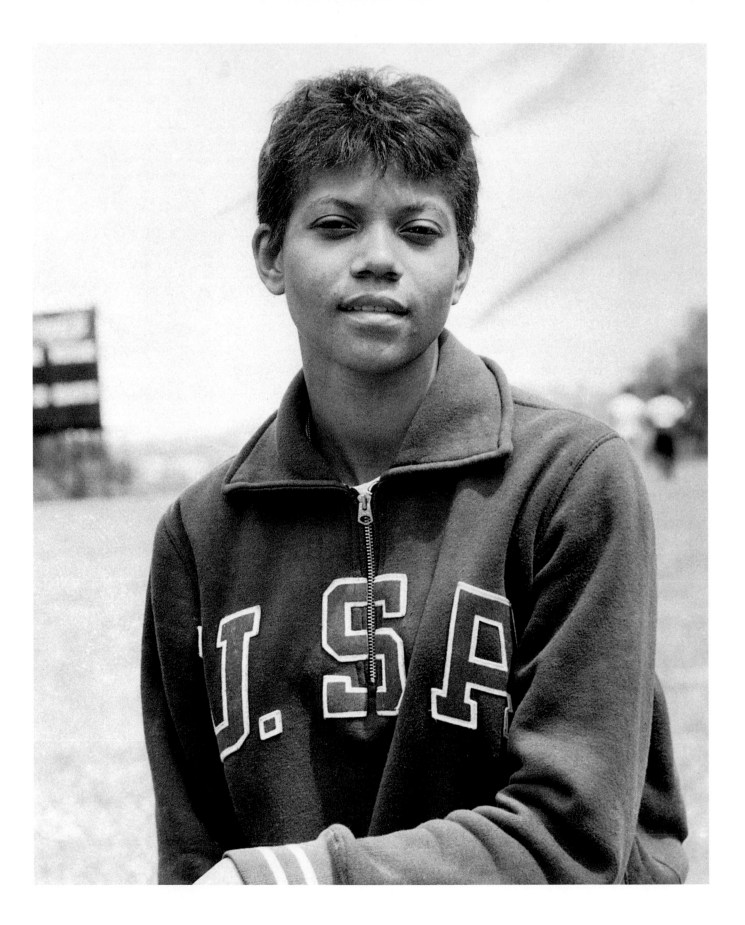

Introduction

"Women's sports is second-rate." This was the wisdom in the sports department where I worked in the early nineties. I was not long out of college, and I was the only woman on a sports writing staff of nearly twenty on a big-city newspaper.

To understand the departmental attitude toward women, I began a casual tally of the pictures that ran in the section. Mostly, there were no pictures of women, so the count was simple: 15–0; 11–0; 12–0. A "good" day was a 9–2 day, an 11–1 day. Those were rare. As I counted, I saw that these seemingly inconsequential and repetitious pictures of able-bodied men hitting baseballs, throwing footballs, and rebounding basketballs actually had a cumulative effect on the way females saw themselves in relation to males and vice versa. When stories and pictures about women did find their way into the paper—a U.S. Open tennis report, an LPGA story, a column about Jackie Joyner-Kersee—such items about outstanding female athletes would clash on the page with the "escort" ads, always featuring women, that were relegated to the sports section.

Wanting to fit into that all-male environment, I learned to keep up with *Sports Illustrated*. But in 1994, when the "Swimsuit Issue" arrived, as it did every February, I worked it into my picture tally. It was, after all, the only issue each year when a woman was guaranteed to grace the cover of America's premier sports magazine. I reviewed all the covers since the previous "Swimsuit Issue," and I discovered that from the "Swimsuit Issue" of February 1993 to the one of February 1994, the only female athletes on the cover were featured at their most vulnerable: Monica Seles after being stabbed; Nancy Kerrigan after being hit; and Mary Pierce, whose father lost control at her matches.

I wrote an essay called "Cover-Girl Athletes" about the fact that women athletes were invisible in the sports media until they made news as victims—or as vixens—as was the case then, in February 1994, when the Tonya Harding scandal was monopolizing the media's attention. The response to "Cover-Girl Athletes" held the seeds of *Game Face*. I got calls from people I hadn't spoken to in years. I got the thumbs-up from some colleagues, and I got sneers from others. I got, you could say, a calling, because for the first time I asked myself, What does a female athlete look like?

Based on my own life experience, both in sports and reporting, I had a vision of the answer. In the media and in bookstores, however, I found nothing that reflected the beautiful and complicated relationship women have to sports in a world where prescribed feminine behavior does not include the muscle, sweat, and passion that are ingrained elements of sport. I circulated my question "What does a female athlete look like?" to photographers by flyers, e-mail, and word of mouth.

As I studied their responses and continued to look for more, the culture shifted. Though often misrepresented as anti-male, Title IX, the 1972 law largely responsible for creating opportunities for females in sports, was vindicated at the 1996 Olympics in Atlanta. There, men and women celebrated the gold medals U.S. women's teams won in basketball, softball, and soccer. The point was driven home two years later at the Winter Olympics in Nagano with another U.S. team victory, in women's ice hockey. Then, in 1999, in a sold-out Rose Bowl, and while some forty million U.S. households tuned in, the U.S. team won the Women's World Cup. Men and boys celebrated right alongside women and girls. Some celebrated sheer athletic mastery; others cheered women's gains in society. Some cheered their daughter's ambitions; others cheered for the opportunity to play they never had.

"You know what this picture did? It gave a voice to the people who were voiceless." This is how Brandi Chastain described for us the impact of the photograph on the cover of this book, an image that captures her famous reaction after scoring the point that clinched the Women's World Cup. We recorded some of those voices —from Olympians to elected officials, from coaches to corporate honchos, from schoolgirls to retirees. In these stories, which appear throughout the book, a few essential truths shine. As athletes, girls and women learn, without inhibition, the pains and joys of putting themselves on the line. As athletes, at any age, they discover the body and its gifts. Sports is a forum to gain insight into relationships with peers, family, and teachers; it is a place to discover personal and physical freedom.

Game Face's mission is big: to convey that athletics is a catalyst for girls' and women's self-creation, self-knowledge, and self-expression. It has a political mission as well: to reinforce the importance of Title IX by reflecting girls and women at play. To achieve these elaborate goals, we turned to the arc of the athletic experience as an elegantly simple organizing principle, and we divided the pictures into five sections: getting ready, start, action, finish, and aftermath. The arc is organic to sports, has built-in dramatic movement, and is rich metaphorically. When considered in terms of life stages, the various phases of the athletic experience symbolize determination, dedication, effort, completion, and satisfaction. They represent the phases we all experience in big and small ways throughout our lives, and parallel the stages women have had to pass through to get to the level of involvement in athletics we now enjoy.

Today the sports section had twenty-three pictures of men and one small picture of women playing basketball. *Game Face* carves out a different space, a niche where women's athletics is first-rate and women's abilities are the camera's delight. We hope readers will see themselves in this mix and understand that they are part of the story. —*J.G., December 2000*

Getting

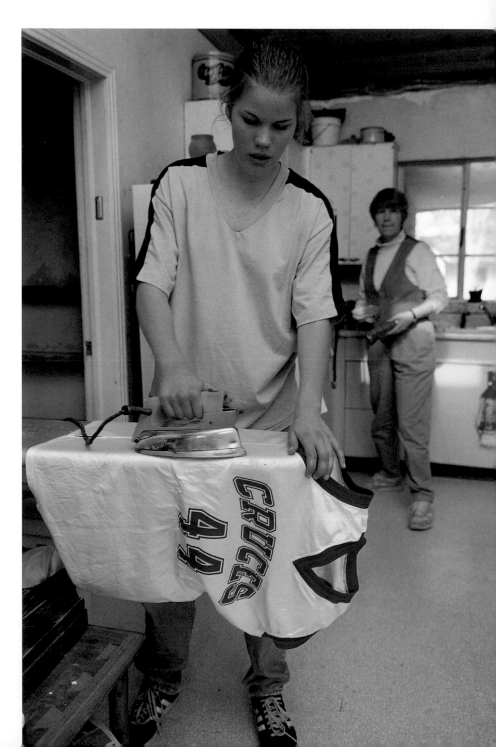

Erin Ironing Her Uniform

Las Cruces, New Mexico
Karen Bucher, 1994

Ready

I begin to carefully pull on my two pairs of socks, stretching them out just perfect, so that when my shoes are laced, there will be no tiny little irritating creases bunching up under my feet. Then I slowly tighten the laces, pulling them snug at every rung. It's got to be done just right—not too tight, not too loose. You'd think I was preparing for a NASA liftoff.

—Nancy R. Nerenberg

First Woman to Light Olympic Flame
Mexico City, Mexico
Photographer unknown, 1968

"I was the woman representing all the rest of
the women of the world."
–Norma Enrique Basilio

Getting Ready

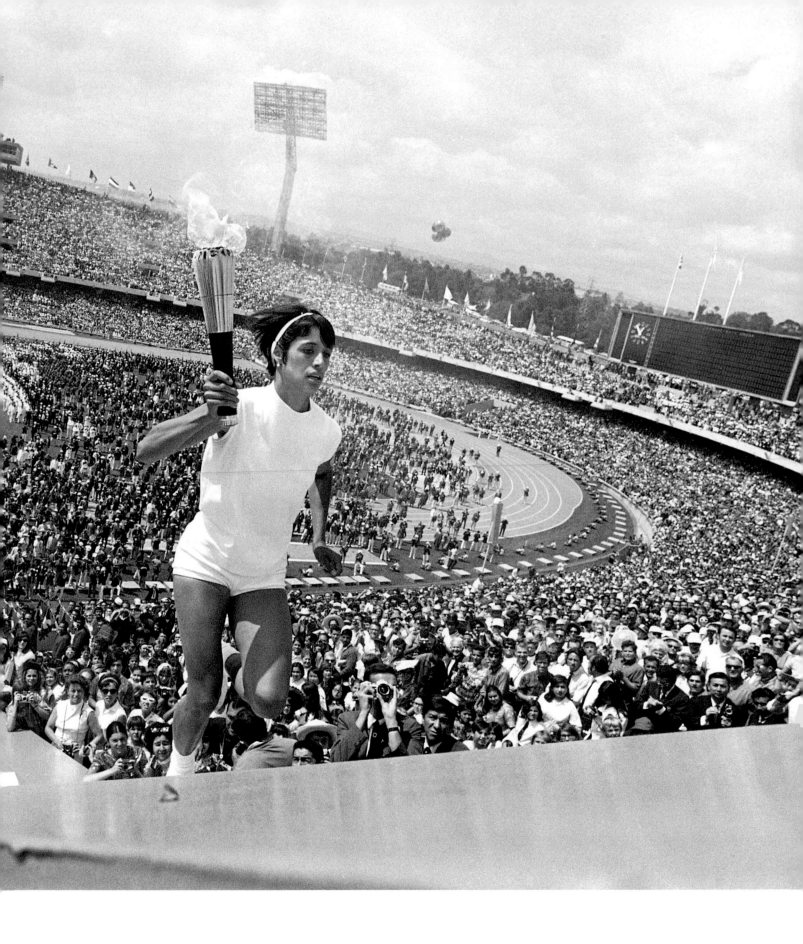

**Kellie Jolly Getting Ready for
Championship Game**
Cincinnati, Ohio
Lynn Johnson, 1997

At the University of Tennessee, Kellie Jolly
anchored three national championship–
winning teams: 1996, 1997, and 1998.

"At times, we couldn't walk in the mall with-
out being stopped for autographs. You wanted
some personal space, but you also wanted to
sign every autograph and talk to every kid who
came up to you. I got a taste of what it's like
to be a big-time entertainer."
–Kellie Jolly Harper

Getting Ready

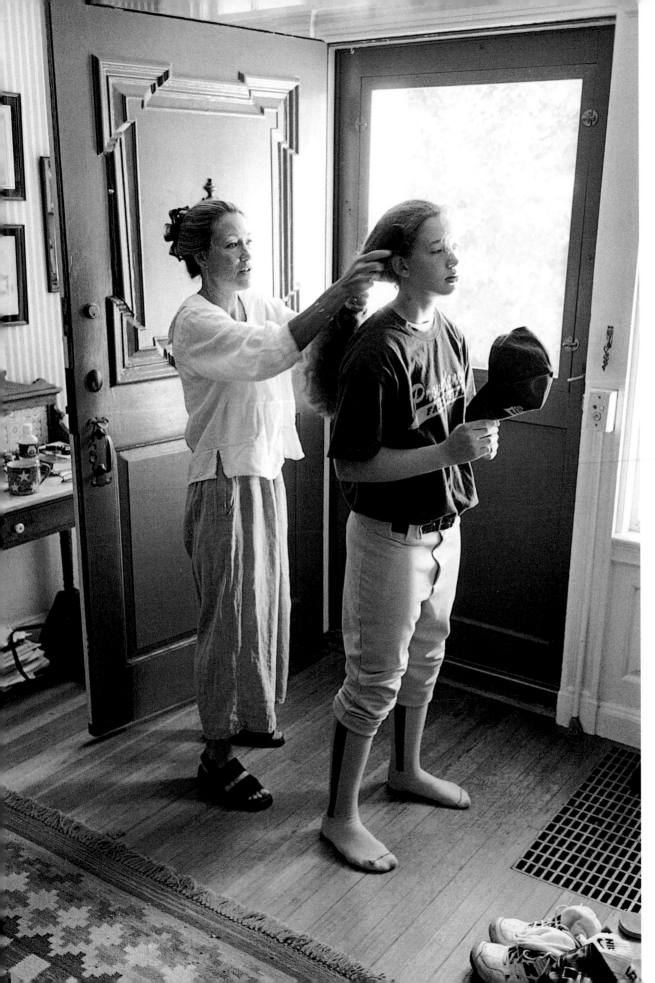

Little League
Providence,
Rhode Island
Geoffrey Biddle,
1999

Golden Gloves
New York, New York
Andi Faryl Schreiber, 1995

Mickey Pryor is a two-time New York State
Golden Gloves Champion, 1995 and 2000.

"A lot of people say they don't want to see
women get beat up in the ring, but it's a
sport and they have to realize that
we are trained to fight." –Mickey Pryor

Getting Ready

Twin Muscle Builder
Louisville, Kentucky
Charles Harbutt, 1973

Getting Ready

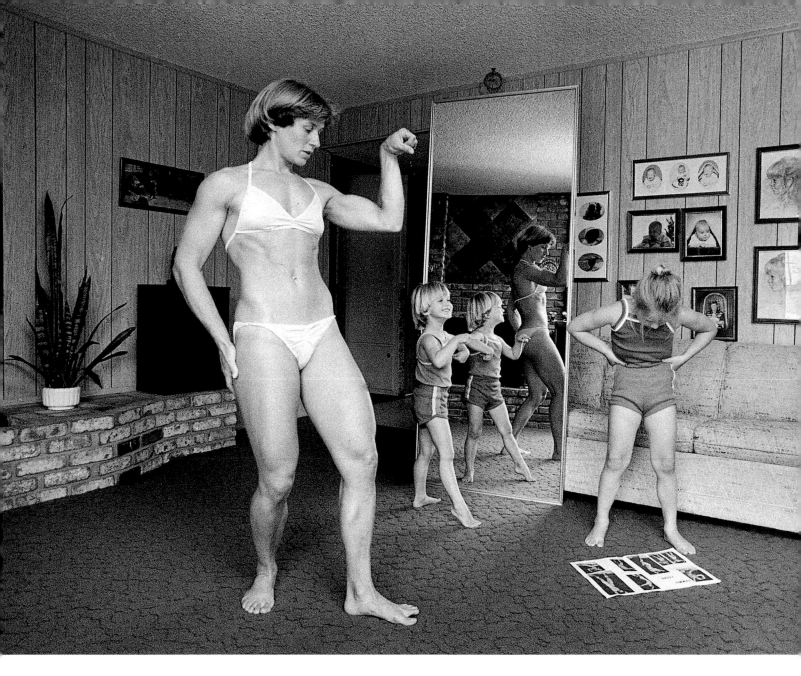

Mom Is a Body Builder
Newburg Park, California
Brad Graverson, Daily Breeze, *1979*

They Teach Each Other

Donna Lopiano

Girl Standing with Baseball Bat
Pittston, Pennsylvania
Mark Cohen, 1981

I lived on a street with fifteen boys and one other girl, and this was wonderful to grow up in, a very tight-knit gang of kids ranging in age from seven to seventeen. There was a leadership hierarchy, and the oldest organized the events. We had the equivalent of a basketball league, a baseball league, and we would go from season to season. Our basketball league was two-on-two, so we'd have seven two-person teams. We created elaborate rules systems. We posted results. We paid our fifty cents to be a part of the league, and the winners got what was left of everybody's fifty cents at the end. It was highly organized. It was the fantasy of children, yet it was very, very real.

Every day, we would get home from school and we would do these things. I grew up with this culture of sport. I was very talented. I was always the fastest. I was always the most coordinated, was always the first pick on a team. I never even thought there was a limit in sport at all. Never heard it. Did not hear a word that made me feel like a girl. Nothing. We would do some things where I knew I was a little bit unusual. For instance, when we went to play football four or five blocks away, they would make me put my hair under a helmet, so that "nobody knows you're a girl." But it was not meaningful to me. I just didn't compute what that was all about.

The organizational lessons learned were very significant. The first time I got to be captain I knew I had to pick the very best player. Whatever it was, the very best shooter, the very best pitcher, the very best defender, if I didn't pick well, I knew I'd never be captain again. So I never fell into the girl thing, which was picking your best friend, or the person you like the most, the girl you want to be best friends with. It was: How are we going to win? How are we going to put together the best team? Boys aren't taught these skills by dads; they teach each other.

My mentor was my older cousin Jimmy, who was seventeen. He was a catcher, and a very accomplished catcher, but he didn't have anybody to pitch to him when he needed to practice. So, every

Getting Ready

day after school, I would pitch to my cousin, which is how I learned pitching. I became convinced that I was going to be a pitcher for the New York Yankees, and that's all there was to it. I learned everything. I had a great catcher, he taught me a curve ball, a rising fast ball, I was working on a Bob Turley Drop, and I had a knuckleball. At the age of ten or eleven I was making believe I was Whitey Ford or Don Larsen or whoever was hot at the time.

I grew up with the same aspirations as my peer group, and my peer group was talented. At the age of ten or eleven, we went out for Little League baseball. Everybody thought they were going to play, and so did I. They were proud of me. They were convinced that I would be the first one picked for the draft, and they were hoping that a bunch of us would end up on the same team.

We had Little League tryouts, and I was drafted number one. We waited to get our uniforms, and I saw that my team's colors were navy blue and white, pinstripe, like the Yankees. And I thought, "Well, I'm gonna be a pitcher for the New York Yankees." I was fourth in line, really excited about getting my first uniform, when a very tall father came over with a Little League Rule Book and showed me, on page fourteen, the rule that girls were not allowed. So I was kicked out. My friends asked, "What's he talking about? What's going on here?" But there was no thought of challenging rules at that time. Parents would not even think of going to court and litigating. This was in the fifties, and the Little League sex discrimination case didn't come out until seventy-something.

I went to every single Little League game, watching them play. I was absolutely convinced that I was better. It was devastating. But I kept bugging my parents, "If I can't play on this team, you have to find me a team I can play on." That was their attitude, too. "We want you to play. We're going to find you a team." I would still play with all my friends, but I couldn't play organized ball.

One day when I was about fifteen, my father and mother came home and they were really, really excited. My father knew a guy named Sal Caginello who was an old army buddy. Sal was a scout for the Pittsburgh Pirates, but most important, he was best friends with Vince "Wee" DeWitt, who was the coach of the World Champion Raybestos Brakettes Softball Team, out of Stratford, Connecticut, only thirty miles from my hometown of Stamford. My father had been talking with Sal about how he was looking for a team for his daughter, and Sal said, "I know this guy, he's a coach . . ." you know, bragging. My father and mother immediately knew that they were going to convince Sal to take me for a tryout. So they fed him dinner at our restaurant, plied him with a bottle of Chianti, and when he was half soused he promised that he would take me for the tryouts, sight unseen. Sight unseen.

So the next week, true to his word, he comes to pick me up. But he is not a happy man. He is afraid that he's going to be embarrassed. Here he was, a scout for the Pittsburgh Pirates, bringing a kid who wasn't worth shit as a player to the attention of a world championship team. But I remember sitting in the car with him for that thirty-mile drive and really not caring. I was pounding my fist into my glove. I was just absolutely ready to play. We get to the field and he introduces me to the coach, and then he disappears . . . "See you later," he says, and he goes and he sits in the car because he doesn't want to be part of this debacle. And after ten minutes or so, he sees that I'm a very good player. So he kind of gets out of the car and he stands at the outfield fence; ten minutes later, he's standing at the third base line, and when the tryout is over, he's sitting in the dugout next to the coach. The coach is saying, "Sal, I'm telling you, you're the very best scout." I was the youngest player ever to make this world championship team.

Donna Lopiano played for the Raybestos Brakettes from age sixteen to nineteen. She was a nine-time Amateur Softball Association All-American in four different positions—pitcher, shortstop, first base, and second base. She is the executive director of the Women's Sports Foundation.

From the series
The Birth of Venus
Staten Island, New York
Christine Osinski, 1986

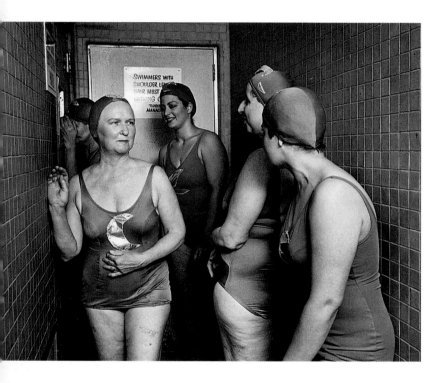

From the series
The Birth of Venus
Staten Island, New York
Christine Osinski, 1986

Lakia Washington is a student at Columbia
University.

"It was my first year rowing, and I'd already
moved from eighth novice to third varsity, but
I was always thinking about giving more and
getting higher and higher in the boats. You
had to give away everything your body had.
When you didn't think you had anything left,
you had to give more." –Lakia Washington

Getting Ready

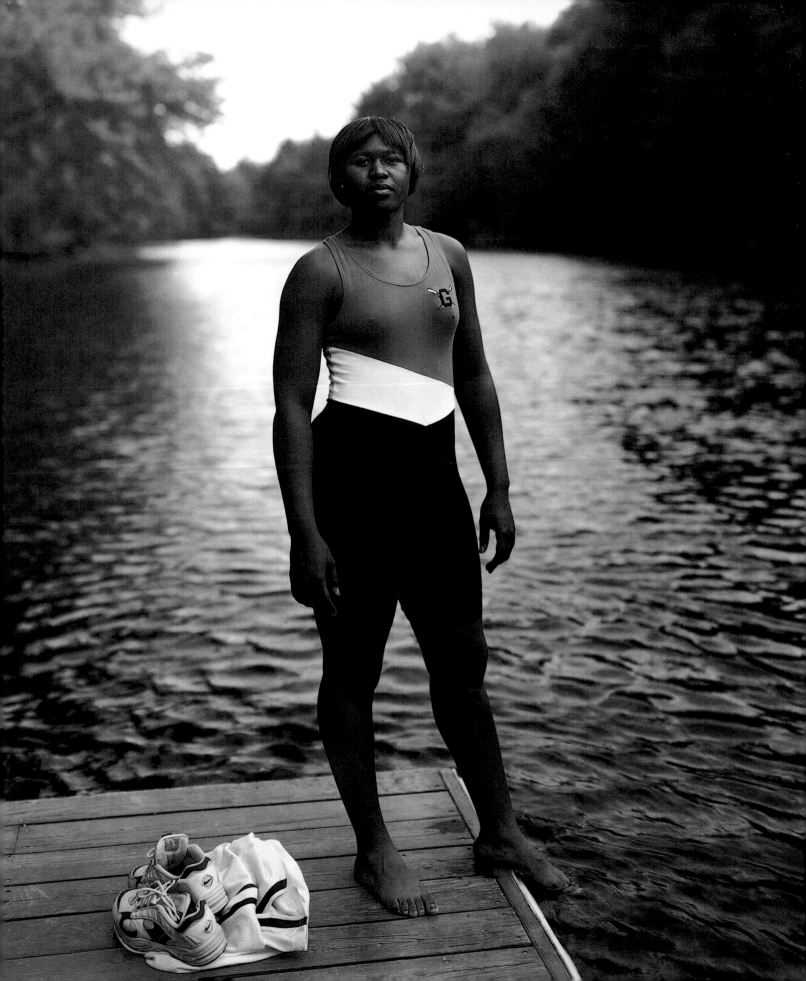

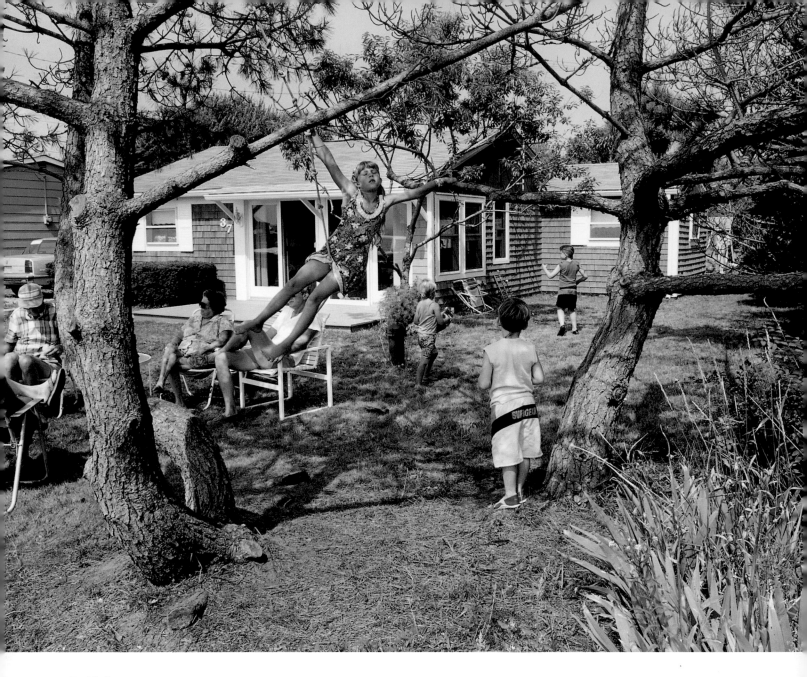

Untitled

West Haven, Massachusetts
Sheron Rupp, 1993

Getting Ready

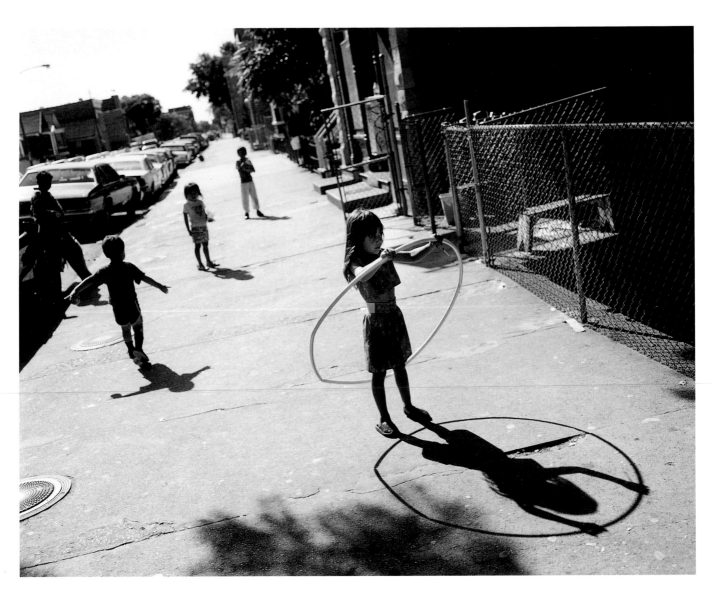

Girl with Hula Hoop
Chicago, Illinois
Paul D'Amato, 1991

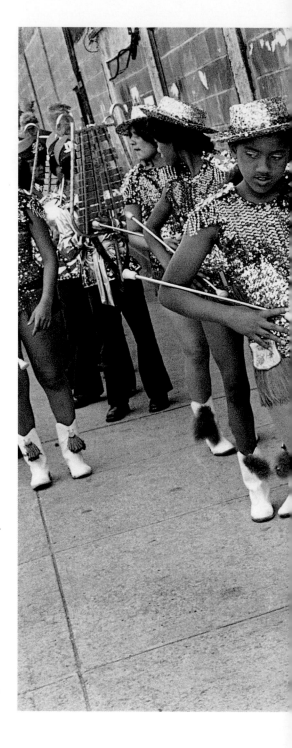

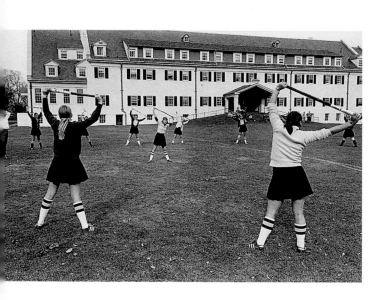

Hockey Team Stretching
Westover, Connecticut
Abigail Heyman, 1984

Twirlers
New York, New York
Geoffrey Biddle, 1977

Getting Ready

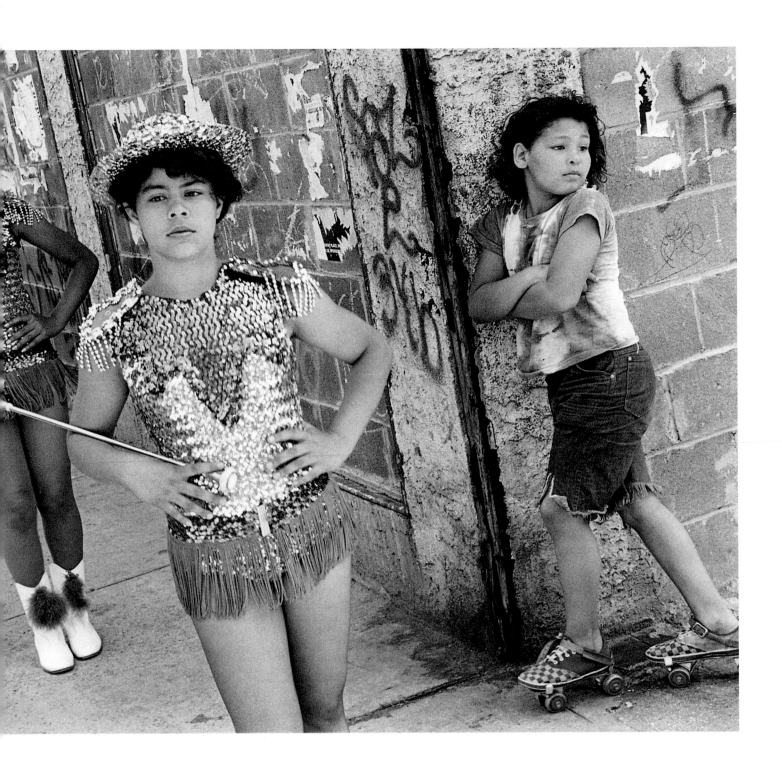

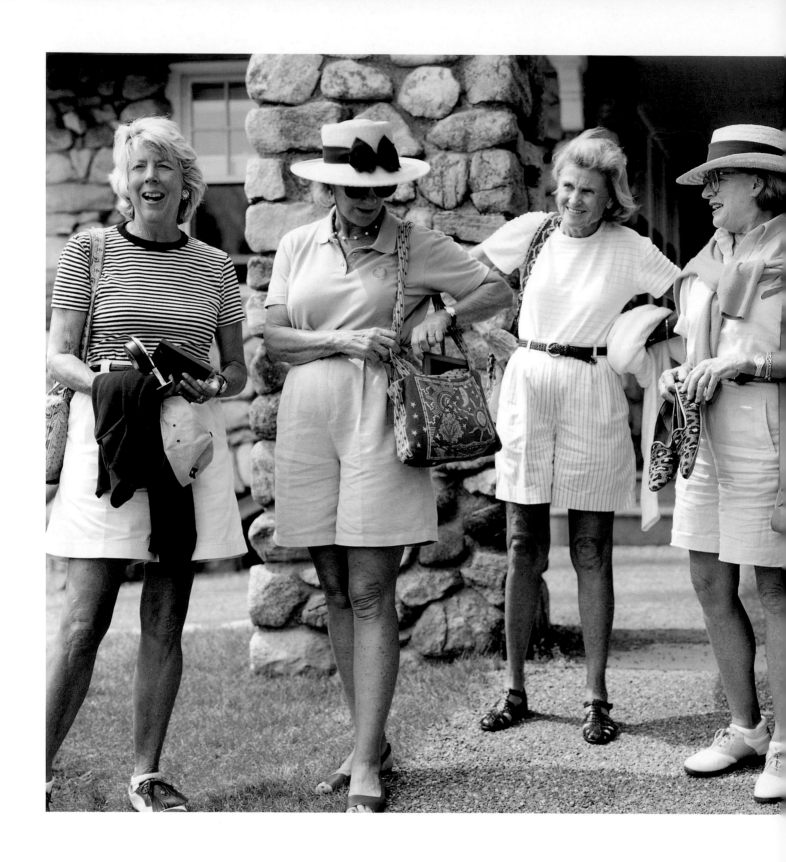

Getting Ready

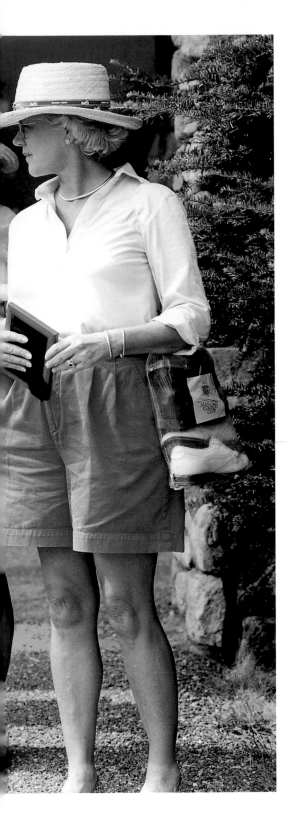

The Golfers
Watch Hill, Rhode Island
Tina Barney, 1998

Winifred High School
Winifred, Montana
William Albert Allard, 1996

In eight years of coaching basketball at
Winifred High School, Marietta Boyce's teams
have won three state championships.

"Female athletes come in all shapes and sizes.
I have short players, tall players, dark players,
and light players. When I think of a woman
athlete, I think of someone who is fit and
displays confidence." –Marietta Boyce

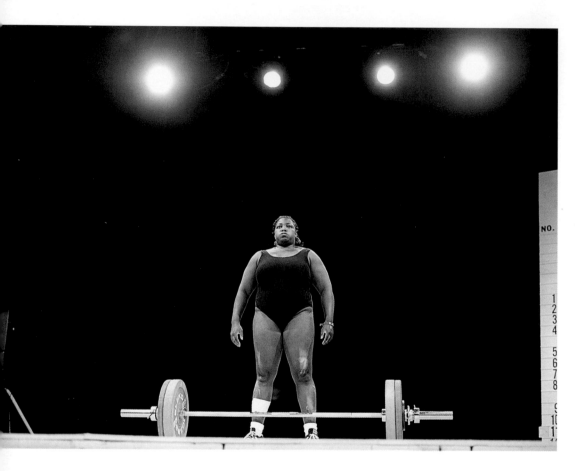

Weightlifting, Olympic Festival
Colorado Springs, Colorado
David Burnett, 1995

Patrina Thomas has won twenty gold and two silver medals in the Empire State Games in weightlifting, shot put, and discus.

"Some women were just born bigger, but most guys don't think that a big woman can come close to lifting anything. What they perceive to be extra fat, that's all they think you are and I can protest on that. I've been rejected for health insurance and I say, 'Dude, I'm an Olympic weightlifter! I wouldn't be about to do this if I wasn't in shape.'" –Patrina Thomas

Untitled No. 10
Orange County, California
Eve Fowler, 1999

Getting Ready

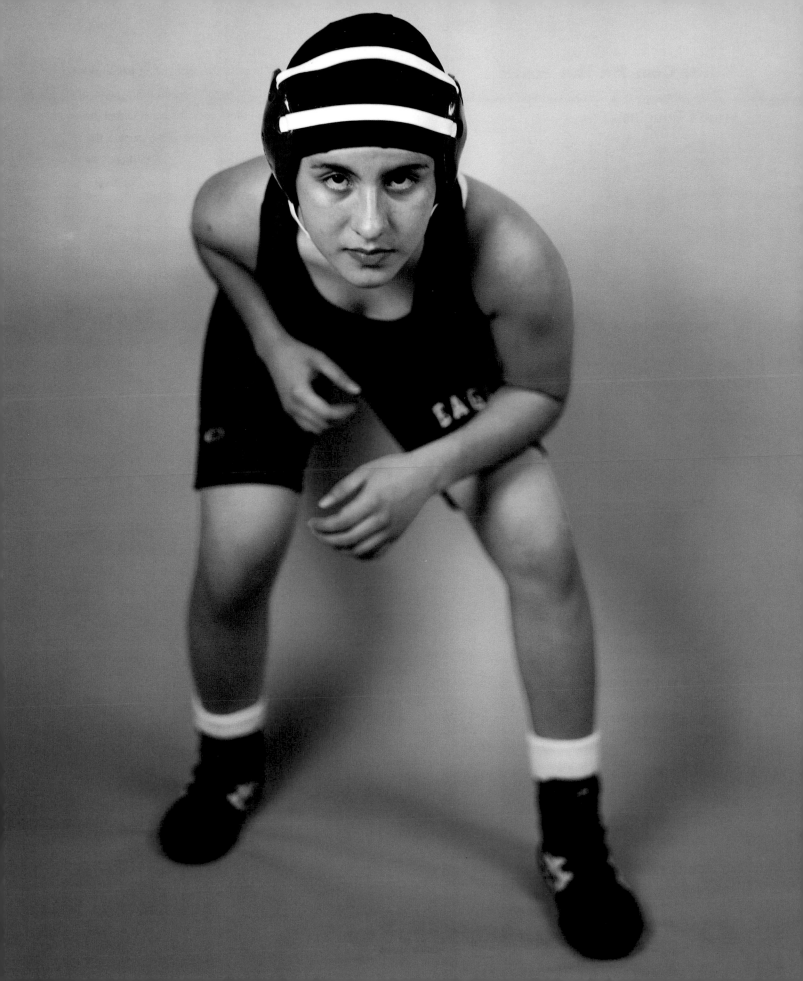

What Can Be the Harm?

Andra Douglas

When my father got ready to go to the hunt club, it was an event. He'd get all his huntin' gear, his camouflage, his fishin' poles, his bait. He'd pack up, loadin' all these guns. It kind of looked like an arsenal. "Number eight shells, buckshot, a twelve-gauge, a sixteen-gauge, here's a pistol in case we find a crow to shoot." He was so passionate about it. He was just happy when he did it.

We lived in this tiny, tiny, itty-bitty town in Florida called Zephyrhills. My father's a cattle rancher and citrus grower, and most of his friends are of like kind. He and about fifteen, twenty men went to this big hunt club out in the middle of the woods. They would go out, religiously, every weekend durin' the huntin' season and hunt deer and turkey, shoot quail and whatever else they could find.

When I was about eight or nine I begged my father to take me with him. The other men took their sons along, so I begged and begged him. He told me that girls weren't allowed, but I'd throw little fits, and finally he said, "Oh, what can be the harm?" My dad's actually very sweet, so he took me to the local store. Back then, in the 1960s, there weren't any big Kmarts or anything like that. He took me down to Monroe's, which had groceries and clothing and he outfitted me in all this huntin' gear. He dressed me up with boots and camouflage and the hats and whatnot. I thought I was cool.

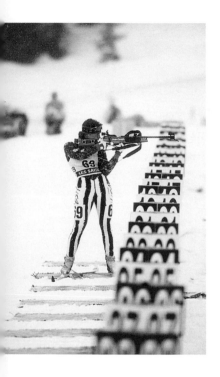

Day Four of Women's Biathlon
Albertville, France
Nathan Bilow, Allsport, 1992

Getting Ready

When he took me out to the woods I thought I'd gone to heaven. I had so much fun, absolutely so much fun. He taught me how to shoot the shotgun that was too big for me 'cause I was this scrawny little thing. He actually cut a hole in the stock of the gun and hollowed it out so, one, I could get my skinny little hand around it and, two, just to make it lighter.

That world was so idyllic. There were these awful little trailers out in the woods pulled around this huge campfire. There was a big cauldron of boilin' water so when you brought in the turkeys, you'd dump 'em in there before you'd pluck 'em. There was a little wooden cookhouse. I mean we're talkin' stereotypical Deep South, and Robert, a black man, would cook all the venison the hunters brought in. He'd cook the turkeys. He'd have breakfast startin' about four o'clock in the mornin'. He'd have lunch on the table when all the hunters came in for lunch. And it was a beautiful part of Florida where there's just thousands and thousands of acres of swampland and open fields.

One day after weeks and weeks of huntin', my dad had to go to this meetin' about me. The men had called a meetin' because there was a little girl runnin' around their huntin' camp. My dad said that I wouldn't be allowed to go huntin' anymore. "Why?" I said. And he said the men were complainin'. "You're a little girl," he said, "and they don't really want you out there."

Hey, I couldn't relate to that. As far as competition goes, I was outshootin' a lot of the sons out there. I didn't quite grasp the girl, boy, female, male stuff. It just didn't really sink in. I was one of 'em as far as I was concerned.

When he left that night to go to the meetin', I thought I was goin' to die. How could my friends reject me? Why did they not want me? What's wrong with me? It just didn't connect that I was a little girl and so in their eyes I didn't belong. The next day was Saturday and normally, when we were goin' to the woods, my dad would say, "Four o'clock, Toady, I'm wakin' you up to go huntin'." Instead of bein' excited, that night I went to bed thinkin' that my life was comin' to an end.

It was about twelve o'clock when my dad came into my room and sat down on the side of my bed. "Well," he said, "they had the meetin'." I was holdin' my breath. He said, "Well, they said you couldn't come out anymore." I was gettin' ready to die. And he said, "But I told them that if I couldn't bring you, then I quit." Now, for my dad, he's an Alabama boy, born and raised huntin' and fishin', and these men, this lifestyle, he's nothin' without it. For him to do that, in hindsight, it just brings tears to my eyes. He said, "Yep, and when I quit, Howard said, 'Well, if Doug and Toady aren't comin', then I'm not comin'. I quit.'" And when Howard quit, Sam quit. And I guess it was just like this domino effect of his close friends all quittin'. Bottom line is, he kind of punched me and said, "So, I'll wake you up at four."

It's one of the greatest things anyone has ever done for me. I hunted till I went off to college. To this day, I can still knock the 'nads off a fly from a hundred yards. And my dad still introduces me as his huntin' and fishin' partner.

Andra Douglas plays quarterback for the New York Sharks of the Women's Professional Football League. She is a writer, designer, and parrot enthusiast.

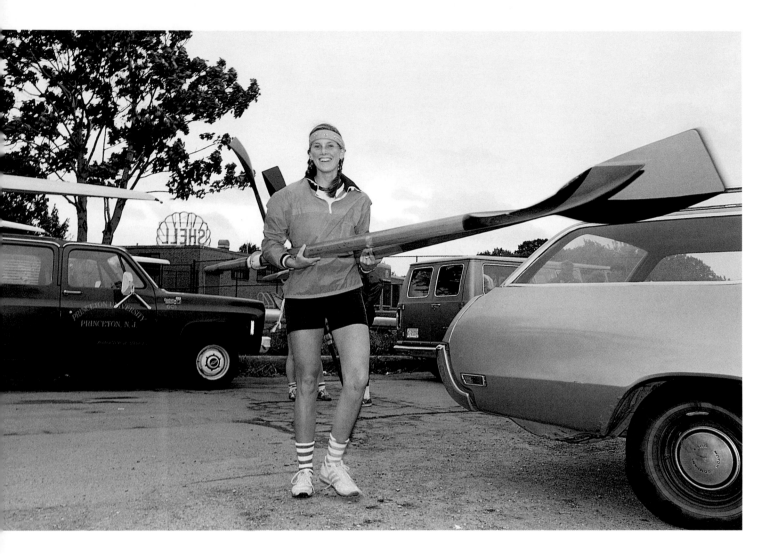

Head of the Charles Race

Cambridge, Massachusetts
Barbara Norfleet, 1980

Getting Ready

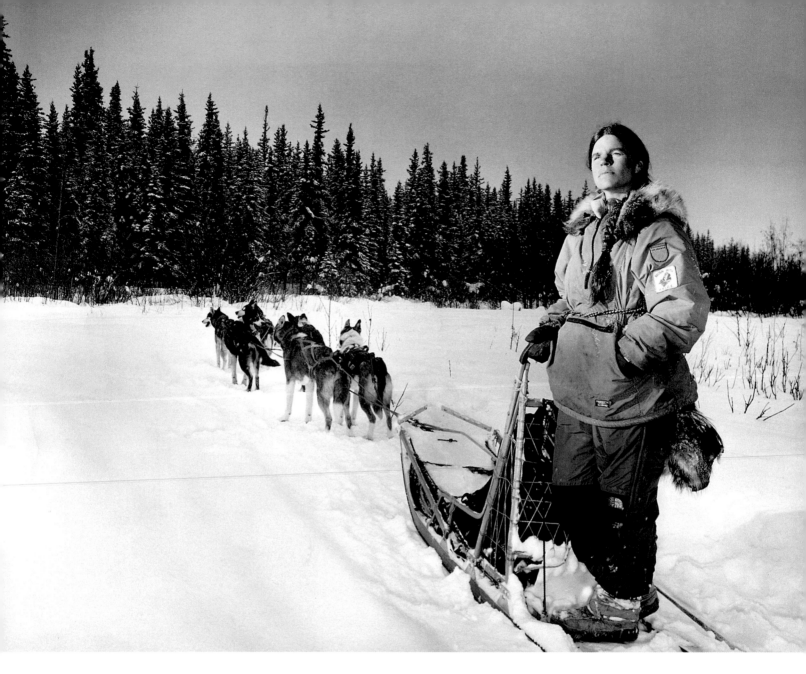

Iditarod Winner

Fairbanks, Alaska
Dan Winters, 1997

The Iditarod is a 1,100-mile dogsled competition from Anchorage to Nome, Alaska, a race Susan Butcher has won four times.

"When I'm mushing, or caring for the dogs, or picking up after them, I am in total contentment. I have found something that was made for me." –Susan Butcher

Oglala Sioux Reservation
Pine Ridge, South Dakota
Jeff Jacobson, 1990

Getting Ready

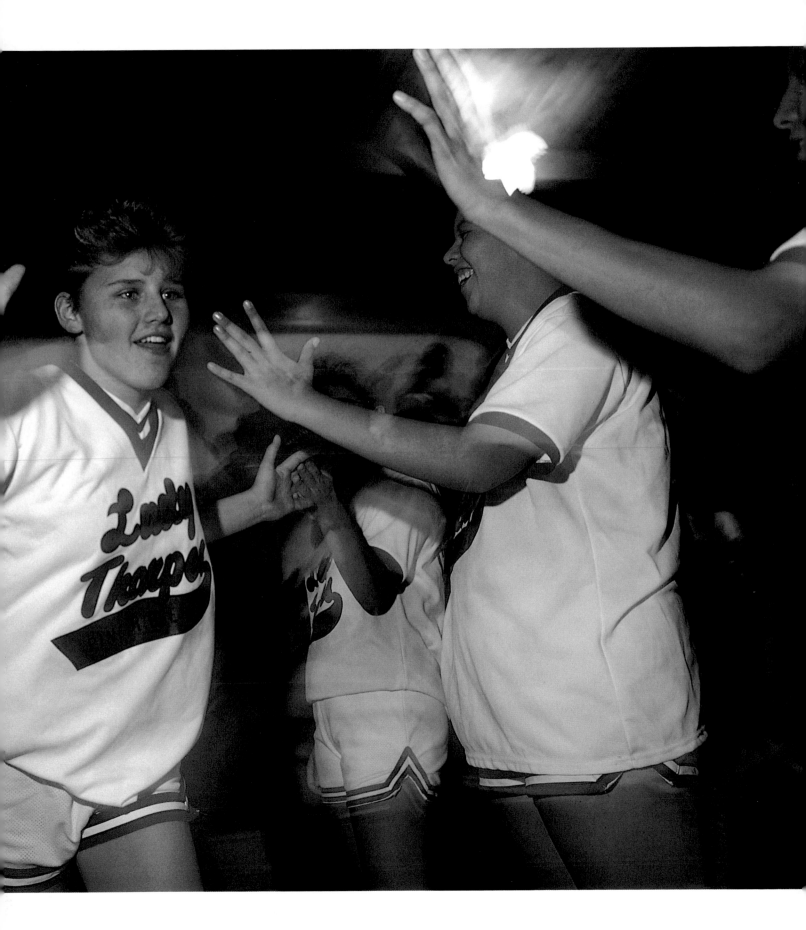

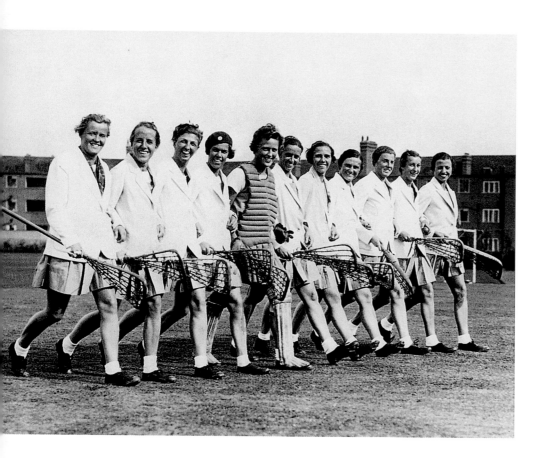

The American Women's Lacrosse Team
Acton, England
Photographer unknown, 1935

"I'm eighty-nine and I really haven't been sick
with anything. I'm in better shape than any-
one I know who is my age. I think it's because
I was out there on the playing field."
–Gretchen Schuyler (far left)

Getting Ready

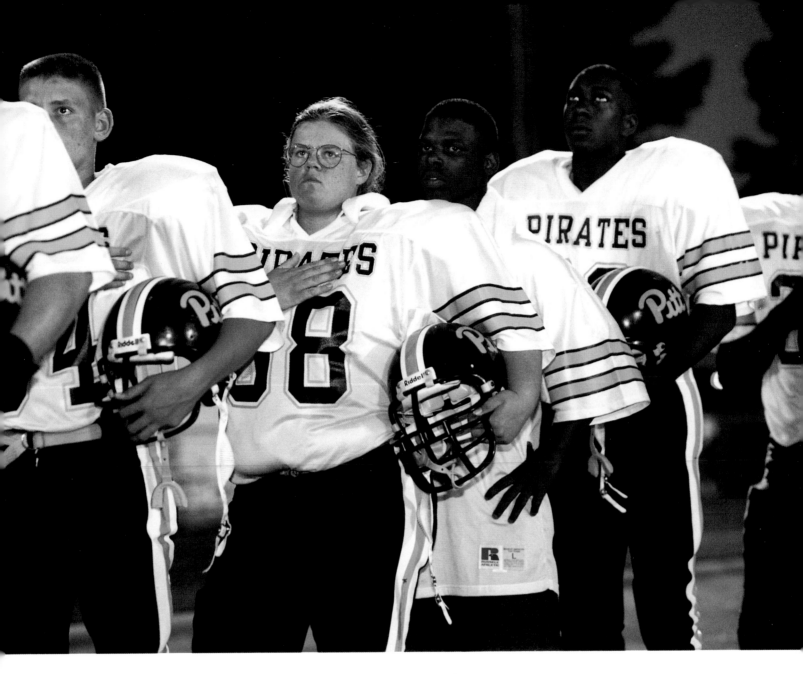

A Team Player

Fort Worth, Texas
Joyce Marshall, Fort Worth Star-Telegram, *1993*

Tammie Overstreet is the only woman ever to have played on the Pittsburg (Texas) High School football team. She was a linebacker.

"You still have your hard-nosed people who don't believe in it. But I don't think there would be any flack if a woman wanted to play football now." –Tammie Overstreet

Start

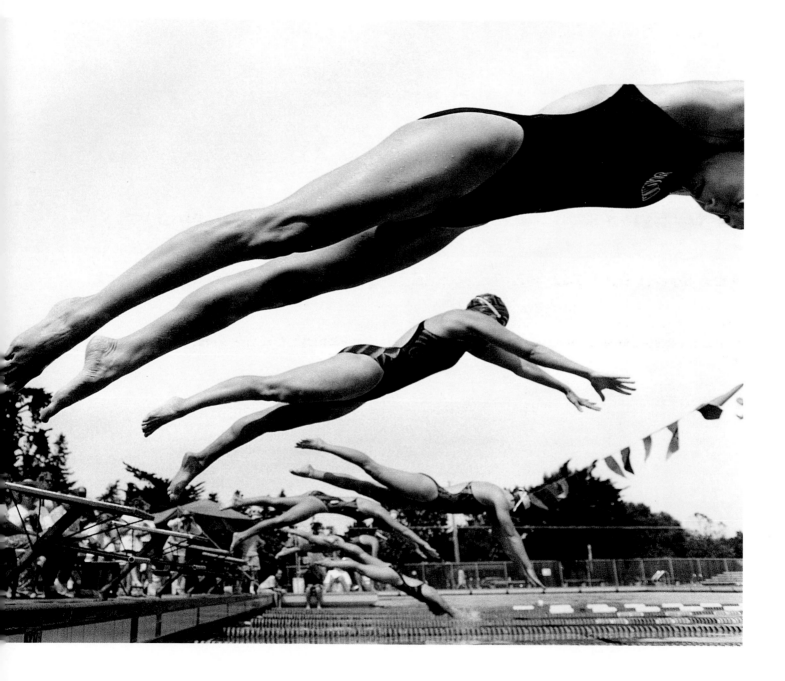

. . . And then I feel my weight coming back just behind my knees then down to my feet then into the earth and the pistol shot explodes in my blood and I am off weightless again, flying past the other runners, my arms pumping up and down and the whole world is quiet except for the crunch as I zoom over gravel in the track. —Toni Cade Bambara

Swimmers
Petaluma, California
Annie Wells, Press Democrat, *1993*

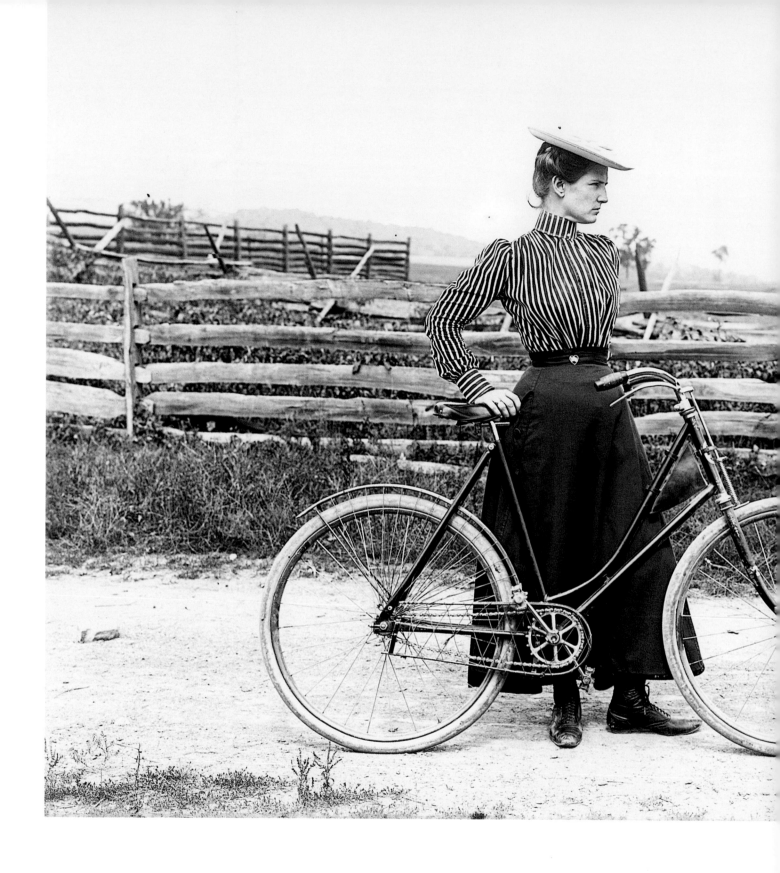

Gertrude Crawford and Her Bicycle
Spruce Hill, Pennsylvania
Francis L. Cooper, 1896–1901

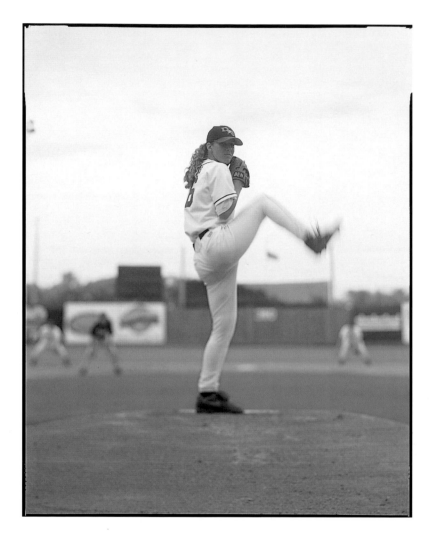

The Pro
Duluth, Minnesota
Bill Phelps, 1998

Ila Borders, a professional baseball pitcher,
plays in baseball's Northern League.

"The only thing on my mind when I'm pitch-
ing is winning." –Ila Borders

Gwen Torrence at Olympic Trials
Atlanta, Georgia
John Huet, 1996

Gwen Torrence ran in the 1988, 1992, and 1996
Olympics, in Seoul, Barcelona, and Atlanta;
she won a gold medal in the 200-meter dash
in 1992.

"My game face shows the seriousness of com-
petition." –Gwen Torrence

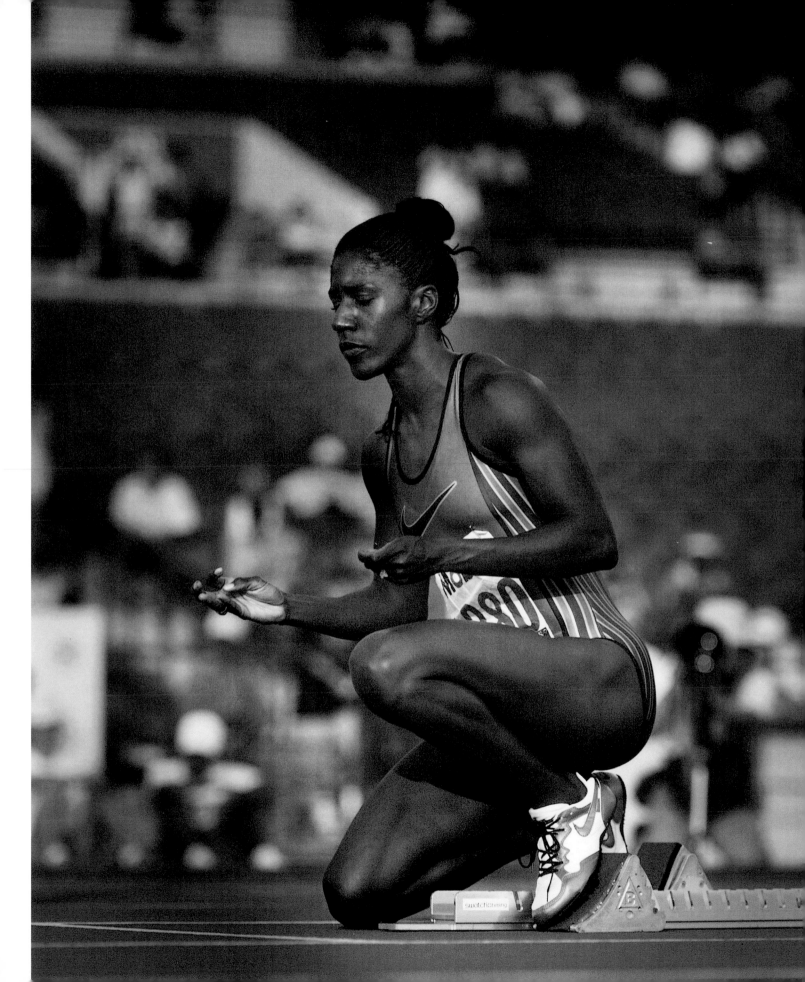

To the Real Contenders

Meredith Rainey Valmon

Kim Zmeskal Facing Parallel Bars
Seattle, Washington
Eileen Langsley, 1990

At major championship events, the callroom process goes on a half hour before the race, which means you're in a small room with the seven people you are about to go to war against. Each of you is out for one person: yourself.

Officials check your spikes to make sure they're regulation. They check your number two or three times; they give you a hip number with your lane number. They check all your logos to make sure nothing exceeds regulations. They check your I.D. They're making sure the right eight people get out on the track at the right time with the right uniform and the right spikes and not with any illegal advertising. It's tedious, actually. You really want to get the whole thing over with. Your stomach is all knotted up, you have to keep trying to breathe deeply, to keep your breath flowing, and you just can't wait until it's over.

Then they walk you out to the track, and it's as if your whole life is compressed into the next ten minutes before the race. Those last few minutes before you run a major event may be the hardest part of competing, because they reveal everything about your personality. What am I really like? What am I really made of? What can I really accomplish?

If you're a person who's very confident, it'll bring that out. If you're a person who tends to lack confidence, it'll bring that out, and magnify it. If you're a fighter when times get tough, it'll bring that out. If you tend to fold up your tent and give in when times are tough, it brings that out. If you're a person who likes challenges, doesn't like challenges, likes confrontation, runs from

confrontation, it'll bring all that out under a magnifying glass. Before you battle your competitors, you're locked into this intense battle with yourself and your doubts and fears and your confidence. You need to win that battle internally before you can win the one against the other people.

I made it to the finals of the World Championships at a stage of my career where I was really interested in trying to medal. My coach and I decided I had to run my own race, which was go out hard, not be scared of not medaling, not hold back. Getting to the point where I knew my body would obey took a lot of mental training and visualization, repeating the start over and over in my head, and seeing it the way I wanted it to go. It was getting to the first break, where everyone can cut into the inside lane, and Meredith is there first. I'm leading from the beginning. Everyone will tell you that is the hardest way to run, to lead from wire to wire. It's always a big deal when someone does that.

The preparation was years in the making, but as I went through the first round and the semifinals, I was convincing myself that I was going to do it; I was going to go out there and lead. In the finals, though, you're running against the best seven people in the world, so it's not enough just to lead. If you go out in the lead and set a slow pace, that's playing into everyone else's hands. They're waiting to rush by you. The important thing was to go out and set a fast enough pace that I would actually hurt some people in the first lap. Let's get this race down to the real contenders.

Even though it was a high-risk plan, I was maybe a little more confident because I knew I had a definite plan. All my adrenaline, all my psyching myself up to go out aggressively, I did it. I got to the two hundred in twenty-six seconds, which was just really fast. You're either setting yourself up for a fabulous race or dying a horrible death, running out of gas and struggling home afraid that others will catch you. When you go out that fast you know the lactic acid is coming, it's just a matter of how badly you're going to *rig*—track slang for rigor mortis. When too much

lactic acid builds up, your whole body stiffens and it feels like you can't move a single muscle—hence the term. It's a runner's worst nightmare. It's only natural to want to protect yourself from that feeling, but so much of competing is overriding those survival instincts. So much of getting the most out of yourself as a competitor is being able to put it all aside and do what you need to do anyway. Some people never do it.

I was so conditioned to overcome my fear that even though I'd gone out hard, I didn't back off. I came through in my fastest split ever, fifty-five, at the quarter. And the crowd made this noise like "Ohh," like they knew it was incredibly fast. I faded and finished fifth, but afterward, I got more respect than some people who finished ahead of me. After that, I was invited to all the meets. I was the person promoters wanted in their race because they knew I'd compete hard and make it a fast race.

It may not have been my best race ever, but it's the race that gets talked about and it's the one that stands out in my mind. I went out in fifty-five seconds, which is incredibly fast for the eight-hundred-meter distance. I'd been working with my coach for three years and he had really been working on me to compete like a warrior, not having any fear, getting out aggressively, going off at world-record pace. If you are ever going to achieve as much as you can in a sport, you are going to have to be willing to make a leap of faith to learn how much your body can handle. People criticized my coach for encouraging to me go out fast. They said, "You went out too hard," but I never looked at it that way. Even though I got fifth, I proved to myself that I had courage and that's more important than the outcome of the race, than sitting back and hoping someone in front of me dies so I can medal. I proved to myself I have what it takes.

Meredith Rainey Valmon quit running in seventh grade and didn't start again until she was an undergraduate at Harvard. She competed in two Olympics, in 1992 in Barcelona and in 1996 in Atlanta.

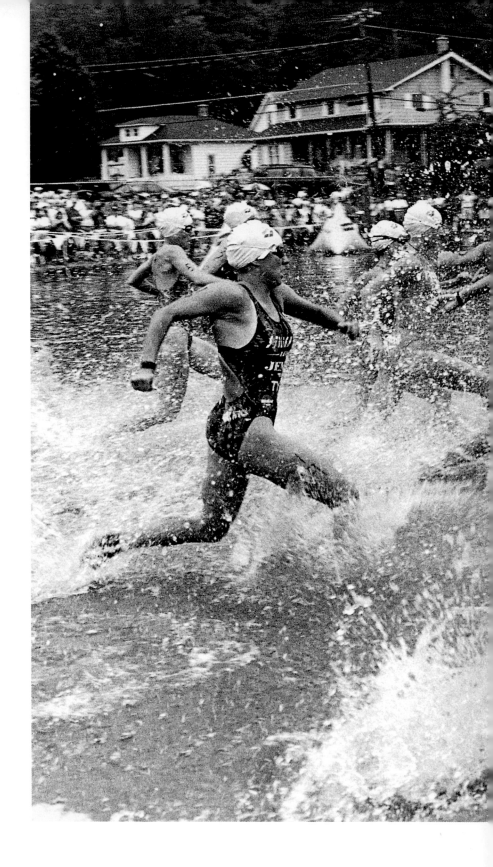

Triathlon Start

Harvey's Lake, Pennsylvania
Mark Cohen, 1994

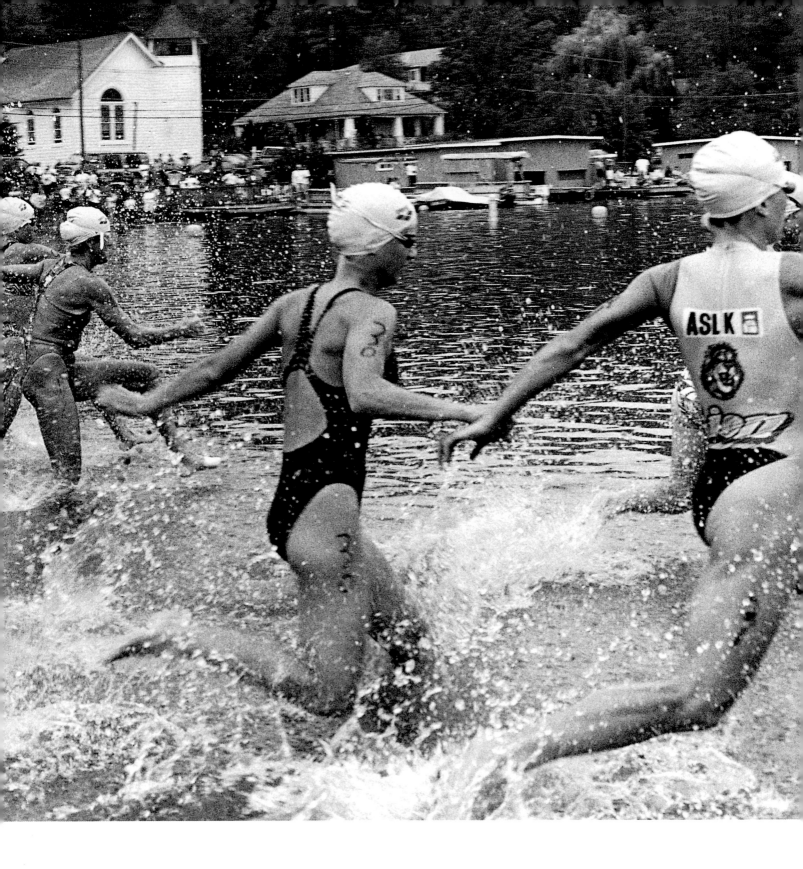

Action

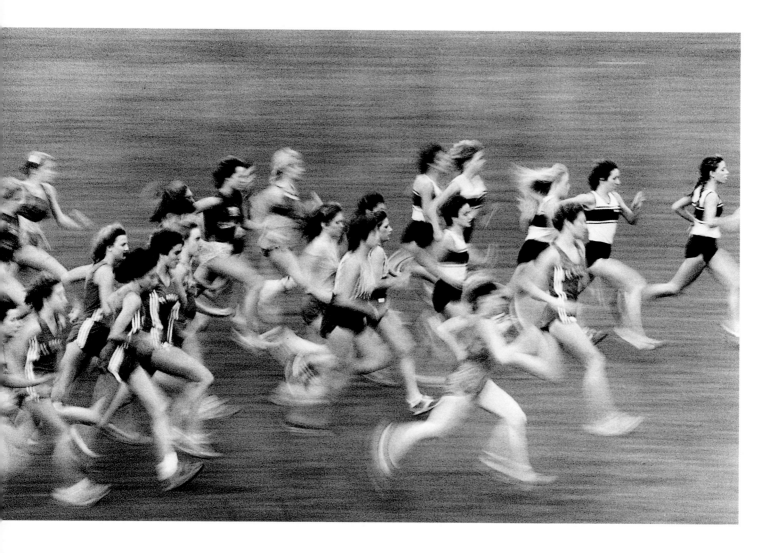

All this, steeped in miserable sweat and sacrifice. I knew it without knowledge of the mind, only the sure undying knowledge of the body that can run and love, give birth, sob, suffer. And knowing what was real, and that this, this was it, now, only this, and it was enough, and that I lived now, really lived, and knew now what it was to breathe . . . —Jenifer Levin

Runners' Blur
Rocklin, California
Richard D. Schmidt, The Sacramento Bee, *1983*

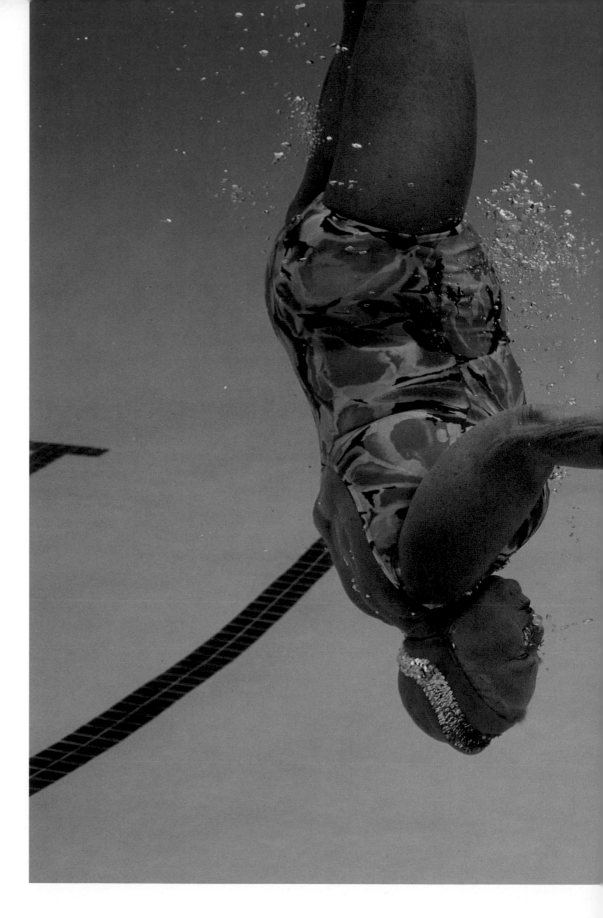

Ballerinas Rehearsing
Laguna Hills, California
Karen Kasmauski, 1997

Action

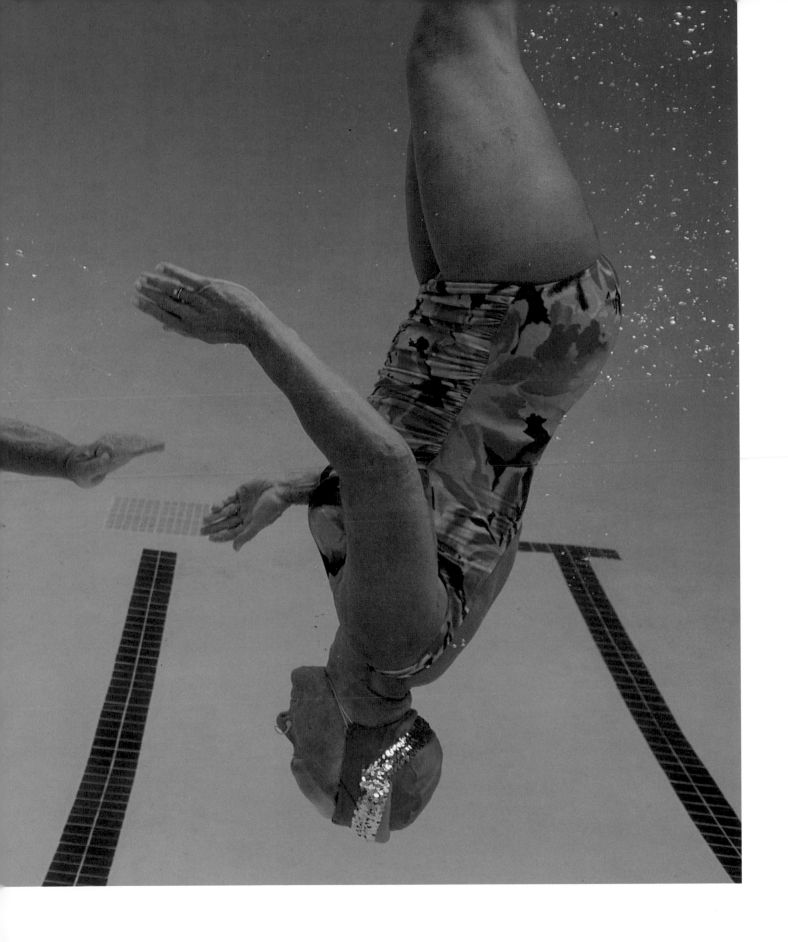

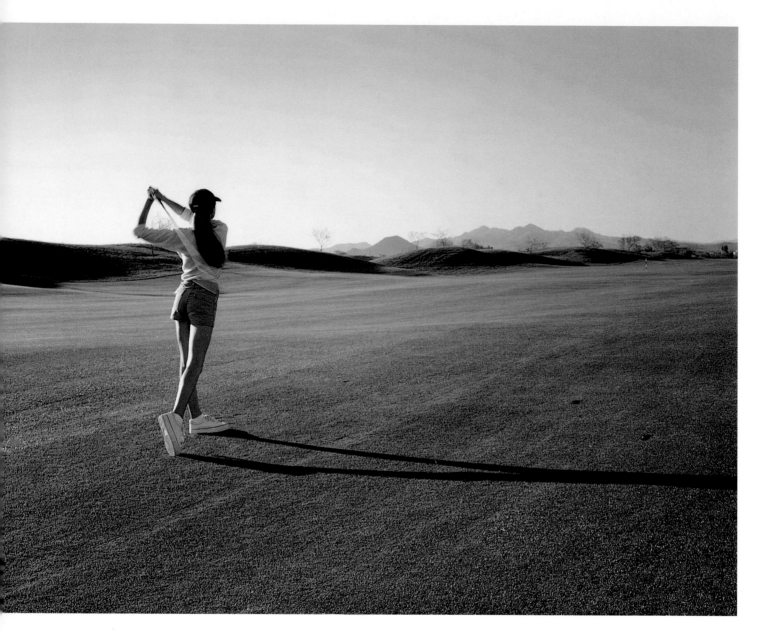

Jenny Clayton, Longbow Golf Course
Mesa, Arizona
Barbel Scianghetti, 2000

Action

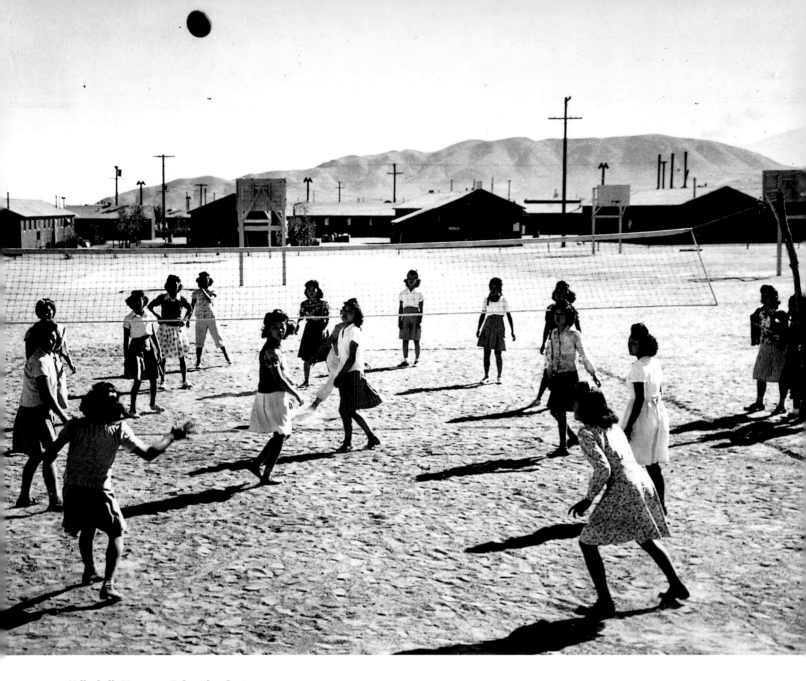

Volleyball, Manzanar Relocation Center

Manzanar, California
Ansel Adams, 1943

Women Exercising

Mary Frey, 1979–83

Defensive Moves
San Francisco, California
Photographer unknown, AP/Wide World Photos,
1961

Throwing the Shot

Baton Rouge, Louisiana
Rick Rickman, 1993

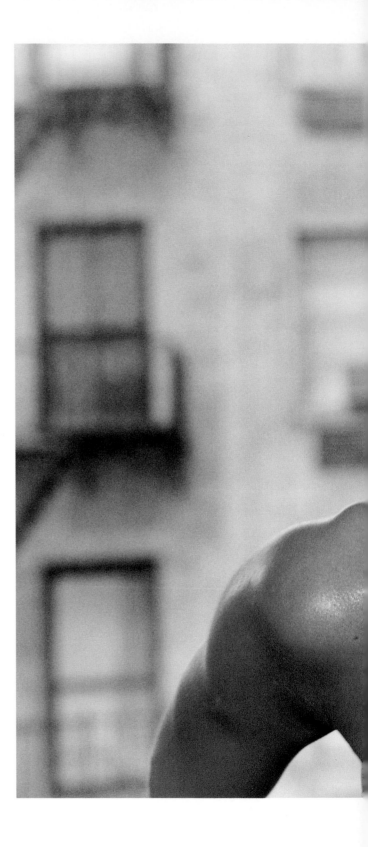

Health Club

New York, New York
Julie Meinich Jacobsen, 1998

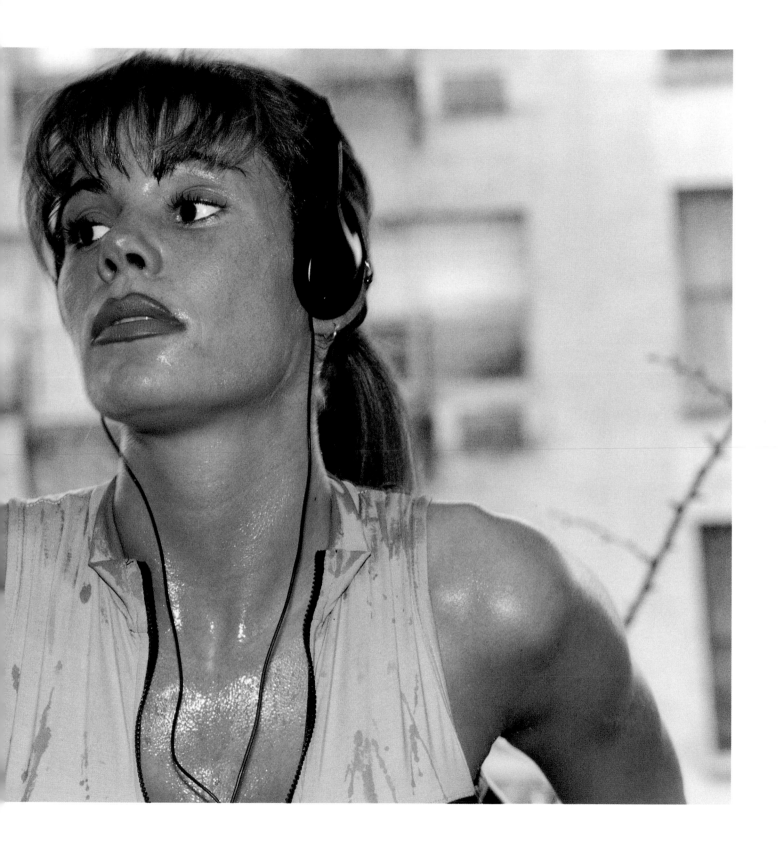

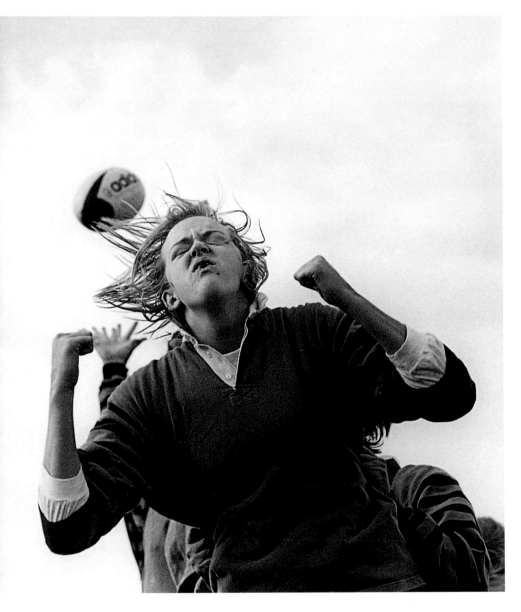

Game Face
Athens, Ohio
Penny De Los Santos, 1996

Spanish Bronze
Barcelona, Spain
Julian Gonzalez, Detroit Free Press, *1992*

In Olympic kayaking, slalom singles racer Dana Chladek won a bronze medal in 1992 in Barcelona and a silver medal in 1996 in Atlanta.

"I'm not a big thinker. I just paddle."
—Dana Chladek

Action

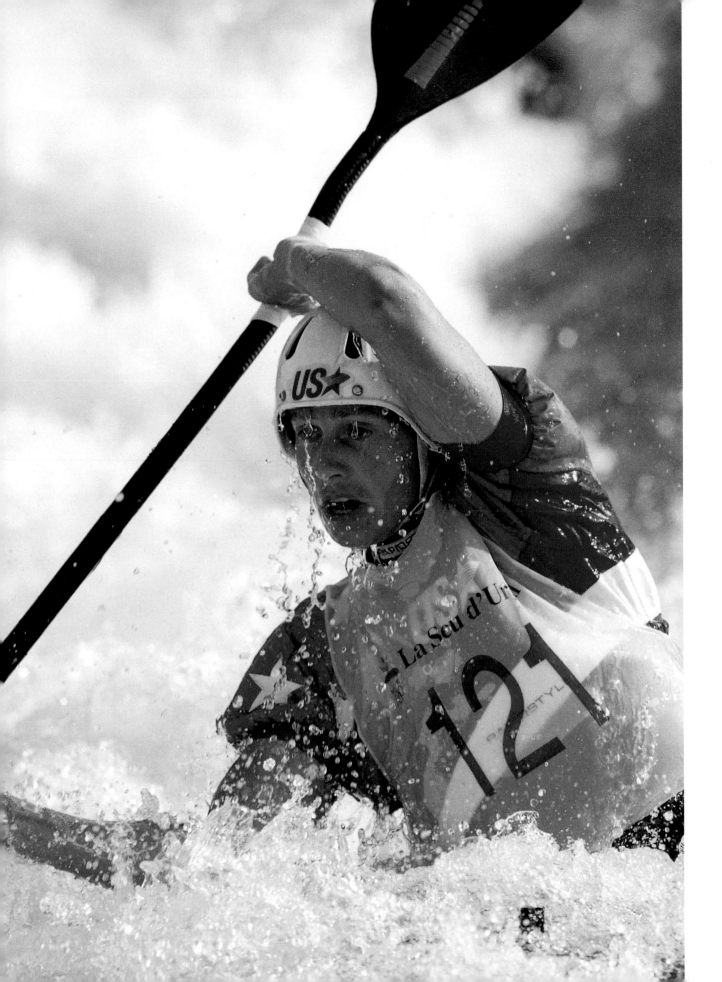

This Little Spark
That Made Her Want
to Conquer Something

Alison Carlson

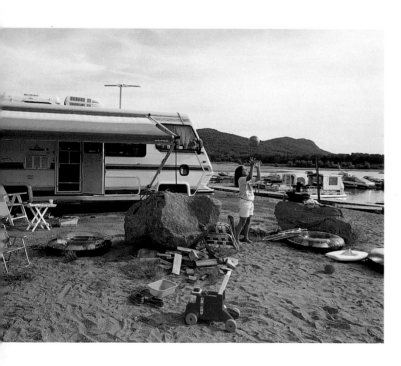

Untitled, The Oxbow
Northampton, Massachusetts
Sheron Rupp, 1993

Action

People say to me, "Don't you get bored teaching beginners?" 'cause most people want the pat on the back that comes with teaching tennis to the very best juniors. To me, that's like baby-sitting. I cannot tell you how exciting it is for me to get these awkward beginning women, usually older housewives who have never in their lives done anything athletic.

I had this one woman—Diane. She was thirty-five and she had been to a succession of four male tennis pros who told her not to even bother to learn. She was sad and upset and about to give up. And she came to me and she started crying and said, "Look, I'm just going to try and take lessons with a woman." She didn't think I could teach because I was a woman, you see. She wasn't putting me down when she said it. We grew up with that bias . . . that a male coach was more serious and you couldn't trust a woman coach. I felt it too.

She took classes three times a week with me. We worked our asses off. And for two or three months, she couldn't make contact with the ball at all. I said to myself, "OK, she doesn't learn the way a little boy or a little girl learns." So we broke it down into Fred Astaire steps. We just practiced one move at a time.

She was not the least bit connected to her body. She walked around with her shoulders hunched and her hair was dirty. She had no self-esteem. But when she started making contact you could see this woman's life change. She started standing up straight. She washed her hair. She was beautiful. I get tears just thinking about it sometimes. She played every day and it changed her life.

She put a lot of money into it, and she told me it was the most important thing that had happened to her in her adult life. *I* would have paid *her,* because I got the benefit of seeing what happened to her when she started hitting backhands and playing games. She belonged someplace. She asked people to play. She even started playing tournaments.

She had something that saved her. She had this little spark in her that made her want to conquer something. She must have, because to go through four male teachers who gave her the same message, "Don't bother," and to still want to do it, she must have had some kind of preserving spark. She diligently stuck through six months of lessons before she could function on the court in the most basic ways. I think she had some sense that she deserved it, and I think that what also got her through was that I loved her and felt for her. She was a woman my age and I could relate to her. I felt angry that she was treated badly by the other pros, and I knew I was a good teacher and that I could teach her. It was a challenge for me.

Teaching tennis is like math or science: If you add two and two you're going to get four. I knew I could get her to learn. If you can get accident victims to walk again, you can get somebody to play tennis.

Alison Carlson was a tennis teaching pro for sixteen years and taught the game to students from age three to age eighty. As a Stanford student in the seventies, she helped start the women's gymnastics and lacrosse teams.

Pat McCormick
Helsinki, Finland
Ralph Crane, 1952

Unbeatable on the springboard and platform, Pat McCormick was the first woman in the history of diving to achieve a "double-double" in back-to-back Olympics, winning two gold medals in 1952 in Helsinki and two more in 1956 in Melbourne.

"I was raised by an older brother, so I always felt comfortable with boys. When I was ten years old and I was playing football, someone said, 'Block that dame!' And that's the first time I realized I was a girl."
–Pat McCormick

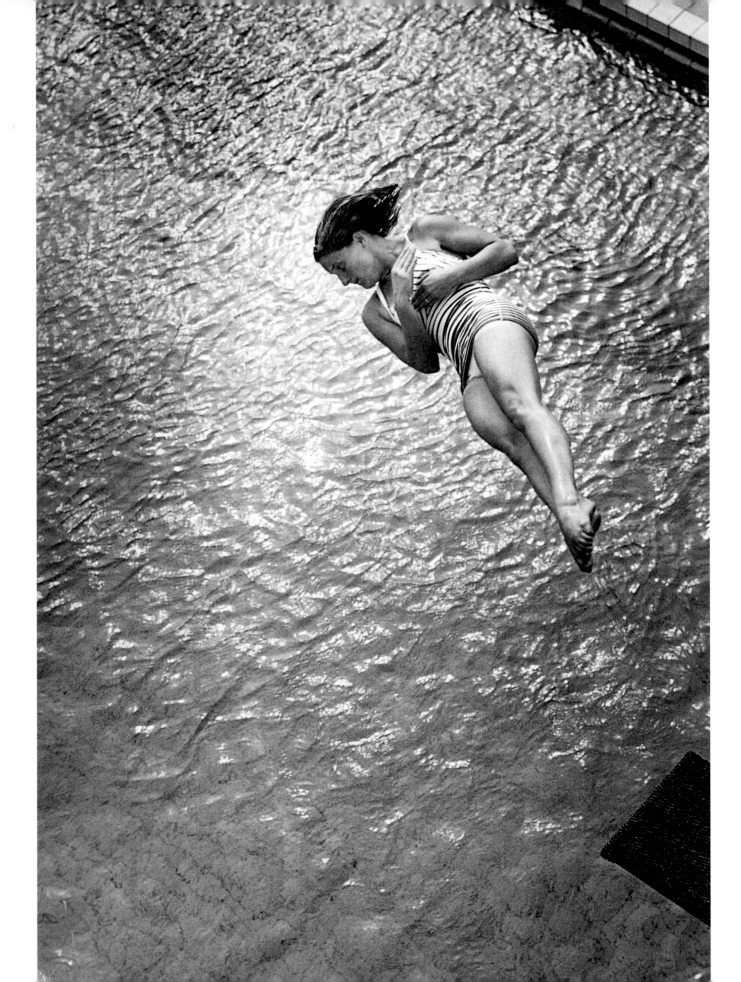

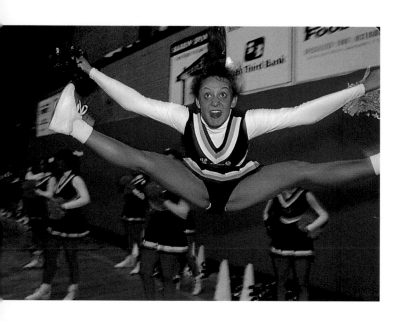

Cheerleaders, Henry Clay High School

Louisville, Kentucky
Arlene Gottfried, 1994

Action

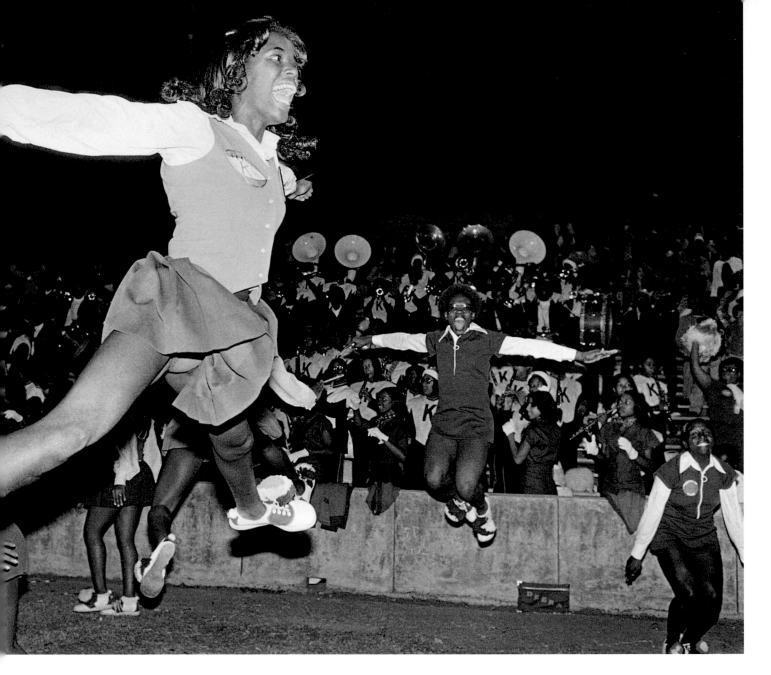

Houston Kashmere vs. Houston Reagan
Houston, Texas
Geoff Winningham, 1978

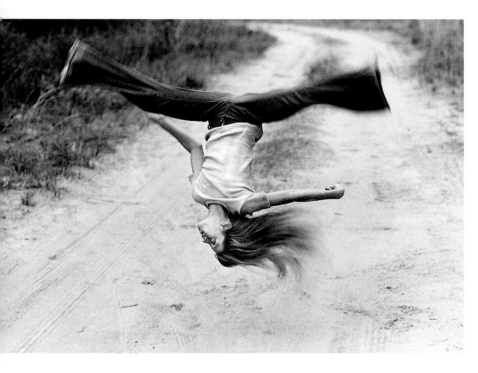

Payson's Leap
Susie Fitzhugh
Florida panhandle, near Seagrove Beach, 1974

Lily Yip, Singles/Doubles
Atlanta, Georgia
Annie Leibovitz, 1996

Lily Yip competed in the 1992 Barcelona and 1996 Atlanta Olympics for the United States.

"My kids look at me like a hero, like, 'Oh, my mom is an Olympian and I want to be like her.' They are both No. 1 table tennis players in their age group in the U.S. I am very proud of them." –Lily Yip

Action

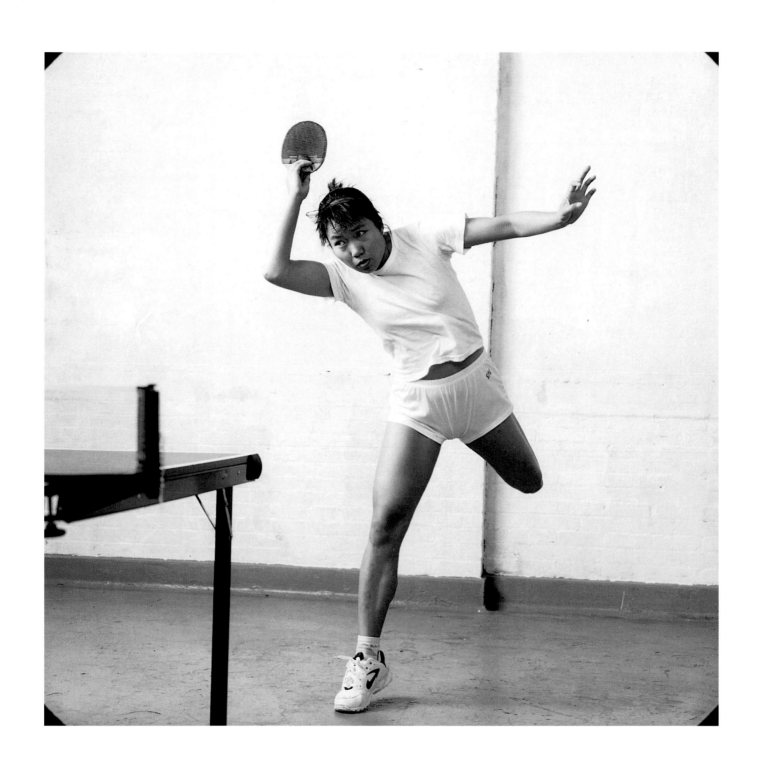

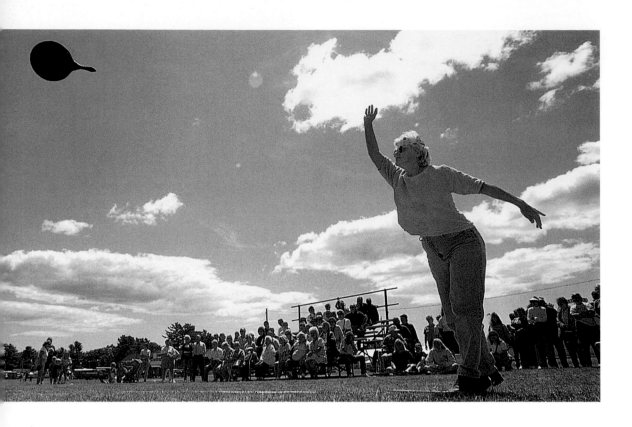

Flying Skillets in Maine
Topsham, Maine
Robert Bukaty, AP/Wide World Photos, 1999

From the Associated Press– "August 10, 1999:
A frying pan toss yesterday in Topsham,
Maine, had Sharon Probach of Bath, above,
hurling a skillet 30 feet, but Lisa Higgins's
68-foot toss later won."

The Magnificent One
Atlanta, Georgia
Eileen Langsley, 1996

Jaycie Phelps won a team gold medal at the
1996 Atlanta Olympics.

"Each person is born with a gift."
–Jaycie Phelps

Action

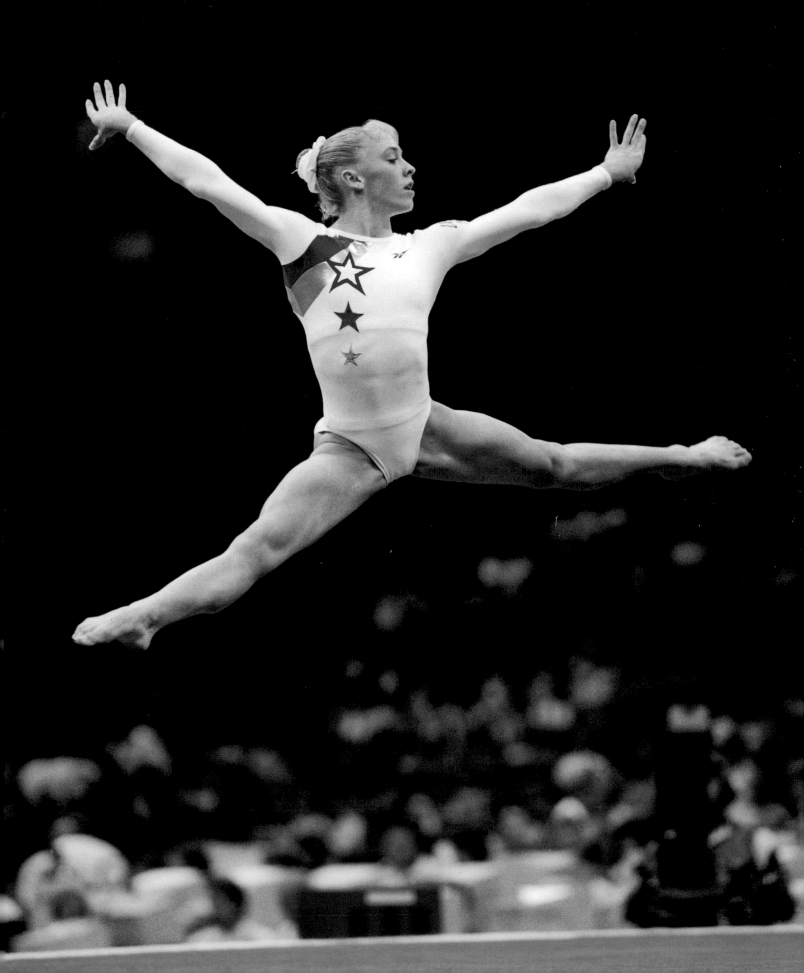

The Varsity Coach Smiled

Lakia Washington

I grew up playing basketball, and I understood the action when I sat by the TV with my father and brother when the Knicks or Lakers were on. Watching football was different because I'd never played. My dad had been a running back through high school. So I'd ask all kinds of questions, like, "What's going on? What's a first and ten? What's this? What's that?" And they'd brush me to the side. They'd say, "Be quiet, be quiet. We're watching TV." So I'd watch just to be with them, but other than a touchdown, I wouldn't understand anything.

Watching football was again a bonding ritual for me when I went to Groton, a boarding school in Massachusetts. Where I was from in the Bronx, people thought you went to boarding school because you were bad and did something wrong. But all different economic backgrounds, social backgrounds, came to this school, and football games were the event that brought people together. I still didn't understand the action on the field, but I watched anyway, because I wanted to see the competition and hitting.

My freshman year, I asked if girls had ever wanted to play. The coaches said, "Yeah, but they never went through with it." I mentioned to my father that I was thinking about playing football, and he said, "If you want to do it, do it." He was proud of my drive to play sports and my stature as an athlete. He said I took after him. Still, I don't think he took me that seriously when I said I was thinking about playing football.

I went to soccer practice sophomore year but I kept looking at the football field. Something was drawing me there. I kept saying to myself, "I want to." I asked my male friends to teach me how to throw. My adviser, who was also the athletic trainer, made sure I took the necessary physicals. Once I let the goal become real in my mind, I had to do it. I would have been embarrassed to myself, not to anyone else, if I had set the goal and then backed down.

That first day, about sixty jayvee and varsity players and coaches were in the gym. The varsity coach was at the front, talking, and

Football Player
Central Park, New York, New York
Abigail Heyman, 1972

Action

everybody else was sitting down. The athletic trainer had just outfitted me, so I had all my pads and my helmet. I was the last one to enter, so I tiptoed in, but everyone turned around and all these eyes just looked at me. People who knew my plans, like the varsity coach, smiled, happy to see I was going for it. But some people were just shocked; then like, gasped.

We did a lot of hitting drills in practice, and the jayvee coach told me I hit better than some of the guys. Being hit was another thing. The guys were scared to hit me. I was a running back, but I really didn't know what it felt like to be hit, even when we got close to the actual season. In practice I'd get hit but it wasn't hard. I asked the coach, "Is this how hard I'm gonna get hit?" Because I just didn't know. My teammates said, "Lakia, you're a girl! We don't want to hurt you." And I said, "No, you have to do it because if I get on the field, the other team's gonna hit me anyway. They're not going to know I'm a girl. You really have to hit me like you would hit an opponent so I can get used to it." So they said, "As long as you know we're not trying to hurt you." And I said, "Fine." Then we ran a play and I got the handoff and I was running when one of the best players, who made it to varsity the next year, gave a real good, solid hit. I was winded and lay there for a minute catching my breath. My teammates stood over me asking if I was OK, and the coach, with whom I had developed a playful relationship, said, "Are you ready to quit now?"

I enjoyed practices, but when it was time for our first game, I was scared. Right before the game, in the training room, I was worried. The coach said, "I'm going to start you," and I was like, "Uh-oh." I couldn't do it. At that point, I got very nervous. I said, "I think I'm going to pee in my pants," and he said, "Don't do that." I said, "I'm really scared," and he said, "You can do it. Just do everything you've done in practice." So I kept telling myself to visualize as if I were in practice, and to think of myself as the only person on the field.

When the game started, I finally understood it, not just the nuances of the action, but the intense love people have for football: It's the adrenaline. In the many sports I've played, I've never experienced anything like it . . . the rush you get from all that contact, all that hitting, all that competition and maneuvering. It's the adrenaline.

I ran the ball many times in that first game. Then the coach said, "I want you to score a touchdown. Get the ball and just keep on running for daylight." Then he called a play where I got the ball, and I just kept running, running, running, and before I even realized it, I made a touchdown, the guys were all over me, patting my helmet, cheering. It was an amazing thing. The next day at roll call, in front of the whole school, the coach presented me with the game ball signed by everyone on my team.

After my team realized I was good, they were very proud to have me. They liked that people wouldn't know I was a girl because I didn't play any differently. They enjoyed that sense of "We just beat you, and you didn't know a girl was running the ball against you, scoring touchdowns." So during games they'd say to me, "Don't take your helmet off. Let people be shocked after the game." And I wouldn't take my helmet off. Later, when we'd shake our opponents' hands, and my helmet would be off, the other players did double takes. After running all those plays against them, they knew my number. When they'd see me, it was like, "What's going on?"

Another person was shocked: my father. He and my mother came up to school for parents' weekend, and the typical thing is to go to the football game. I hadn't told them I'd actually gone out for the team, so when they came up, planning to watch the game with me, it was I-have-something-to-tell-you time.

Lakia Washington attends Columbia University. A South Bronx native, she works at A Better Chance, the scholarship program that led her to the Groton School, where she participated in football, basketball, lacrosse, crew, and soccer, and graduated with honors.

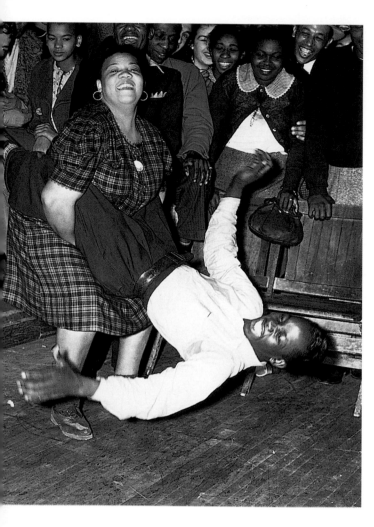

Jitterbugging Couple in Dance Marathon

Los Angeles, California
Photographer unknown, 1939

Action

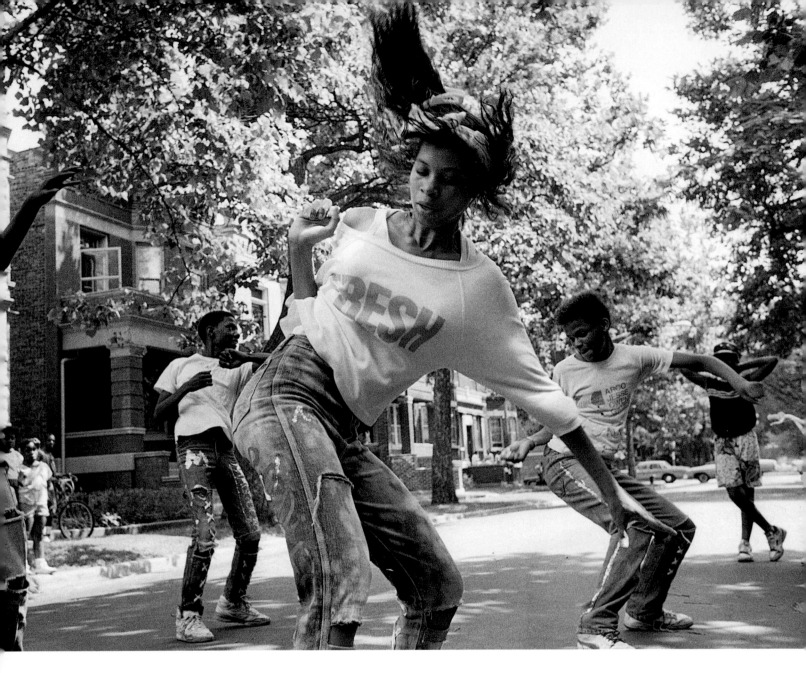

Untitled,
from *The Black Trans-Atlantic Experience*

Chicago, Illinois
Stephen Marc, 1988

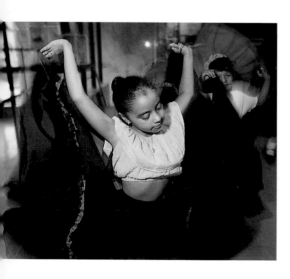

Folklore Dance
Chicago, Illinois
Paul D'Amato, 1995

Untitled
Horseneck Beach, Massachusetts
Sheron Rupp, 1993

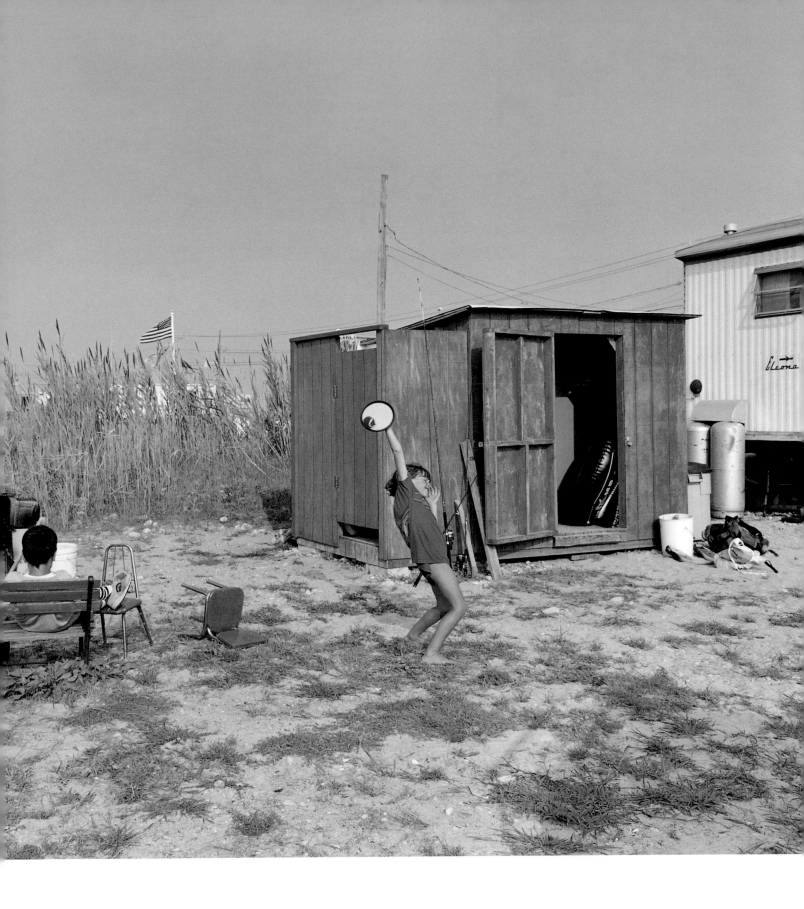

Untitled,
from Songs of My People
South Carolina
Jeffery Allan Salter, 1990s

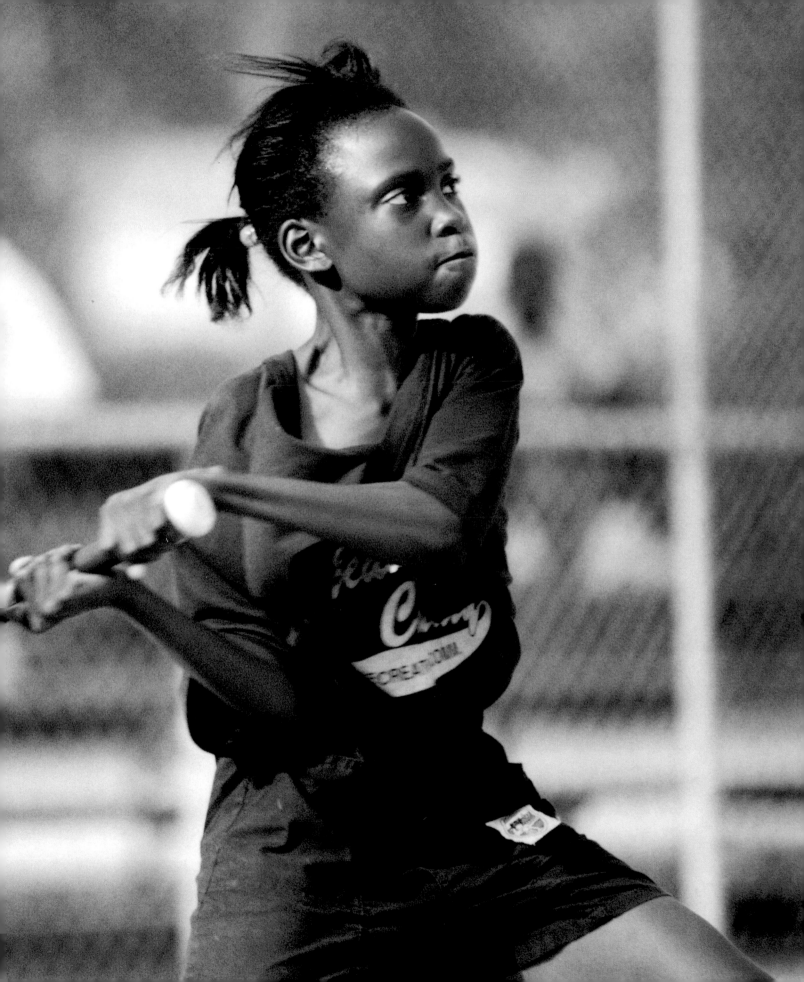

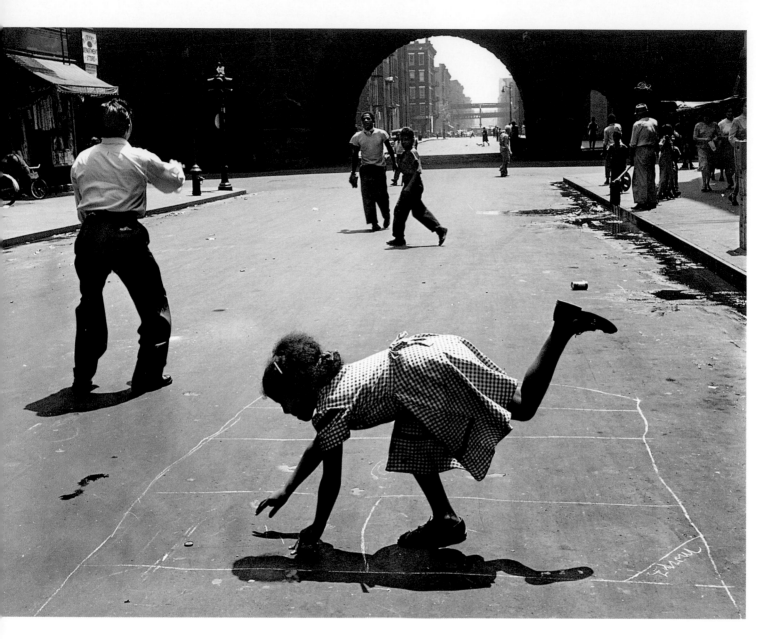

Hopscotch

East Harlem, New York
Walter Rosenblum, 1952

Action

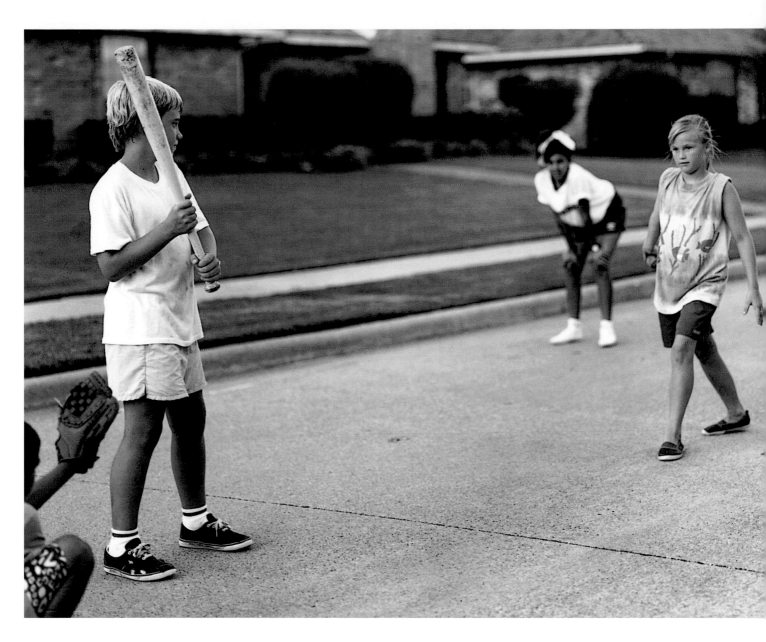

Street Ball

Plano, Texas
Patricia D. Richards, 1989

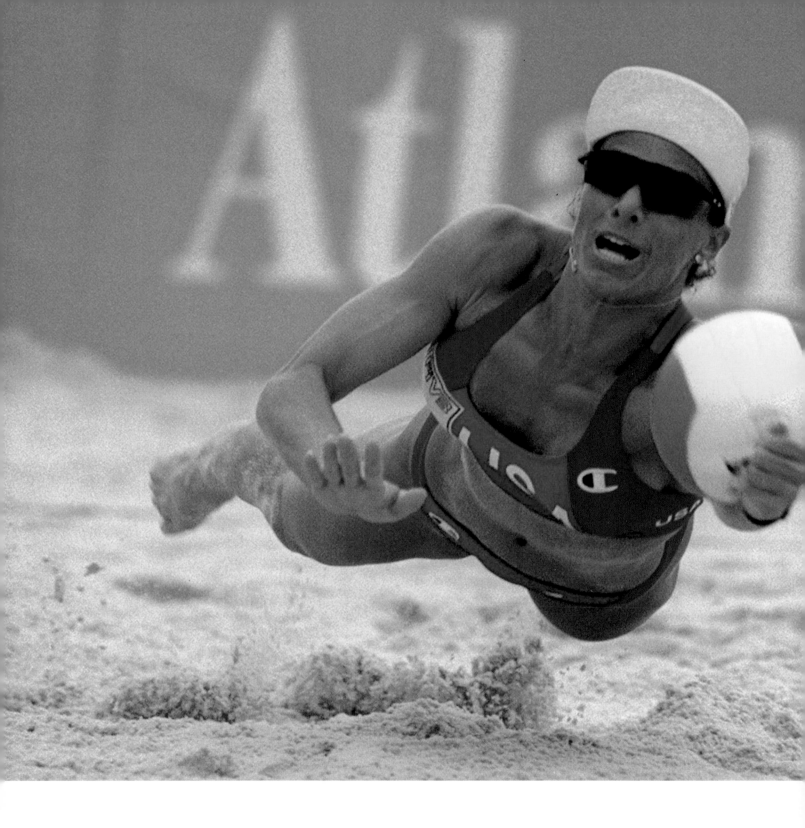

Action

Digs
Atlanta, Georgia
Anacleto Rapping, Los Angeles Times, *1996*

Holly McPeak played professionally on the beach for ten years and won fifty-four event titles. She has also been awarded five Most Valuable Player awards by her peers.

"Pictures can inspire and cause people to dream." –Holly McPeak

Trampolinist Jennifer Parilla
Long Beach, California
Mary Ellen Mark, 2000

Jennifer Parilla was the only American to compete in the inaugural trampoline event at the 2000 Sydney Olympics.

"It's just you and your body, nothing else." –Jennifer Parilla

You Should Have Been a Boy

Renee Cox

It was a battle. It was a fight. It was crazy. They did not want to let me on the boys' basketball team. I think I was maybe thirteen years old. It was a private school. The team was pretty small already. It wasn't like you had seven-foot guys. It was a pretty normal high school team. Nothing special. They refused to let me on. At that point, I was playing at my peak. I had practiced through heat waves in city parks playing basketball all summer long. I played rough after practicing so much. I played much better than the boys. It was so obvious.

So they tried two strategies. One was to say "Oh, why weren't you born a boy?" to make me feel bad and the other was to just try to squash it, to say "Oh, you're a dyke." And that was never the issue. Me playing sports has absolutely nothing to do with my sexuality. It's just I like to play sports. They, the students—my colleagues and future teammates—just tried to squash it. Call me names, this and that. I didn't really care. I was like, "OK, fine. Here's five dollars, let's play a game of one-on-one."

That was my first incident at school with that kind of behavior, reaction, from boys. I wasn't deterred by that, though, because when I was at the parks playing I had to deal with that all the time. The guys would come to the court, they'd see a girl playing, and it's almost a given that you're supposed to pick up and leave type of thing. And I'm like, "No, I'm not leaving. I have the court. I'm on the court. You come to the court, you have to include me in your game. I'm not saying I'm going to stand up here and play by myself, but we have to play a game and I have to be on somebody's team. Let's shoot for it." And we'd shoot for it from the foul line, and somebody would have to take me.

But then came the school administration. "We can't have a girl on the boys' team, duh, duh, duh, duh, duh." And that's when I thought, "I have to take my thing to the press." At thirteen I was pretty savvy in some ways. So I called the *Long Island Press* and I spoke to one of the sports editors. I said, "I'm at this school in

Action

Bayside and I play really well and I want to be on the boys' basketball team. I've beaten the guys on the team in one-on-one many times and they're on the team and I'm not on it." The editor is like, "That's an interesting story. This is interesting." So he came to my school and he did a little story on me. And the coach is quoted saying, "I don't have a problem with her playing. It's the school regulations." After that, they let me play. It's the power of the press, every time.

Renee Cox is an internationally known artist and photographer.

Iowa Girls High School Basketball Tournament
Des Moines, Iowa
Jeff Jacobson, 1979

Janet Evans in Practice
Mission Viejo, California
Heinz Kluetmeier, Sports Illustrated, *1988*

Swimmer Janet Evans won four gold medals
and one silver medal in two Olympics, in 1988
in Seoul and in 1992 in Barcelona. Growing
up, she idolized Nadia Comenici, a Romanian
gymnast who won one team gold and three
individual gold medals, including the all-
around, at the 1976 Olympics in Montreal.

"Personally, I never felt gender bias, but I
know that's the result of the work done for
equality in the 1970s. I was definitely a by-
product of Title IX. My mother can't swim
and here she is with a daughter who aspired to
be an Olympic swimmer.

"I was terrible at gymnastics, but originally,
before swimming, I wanted to be like Nadia
and have that gold medal and be so ecstatic. I
had a baseball trading card of Nadia and I car-
ried it around in my pocket and I'd pull it out
and look at it and say, 'I want to be like
Nadia.'" –Janet Evans

Action

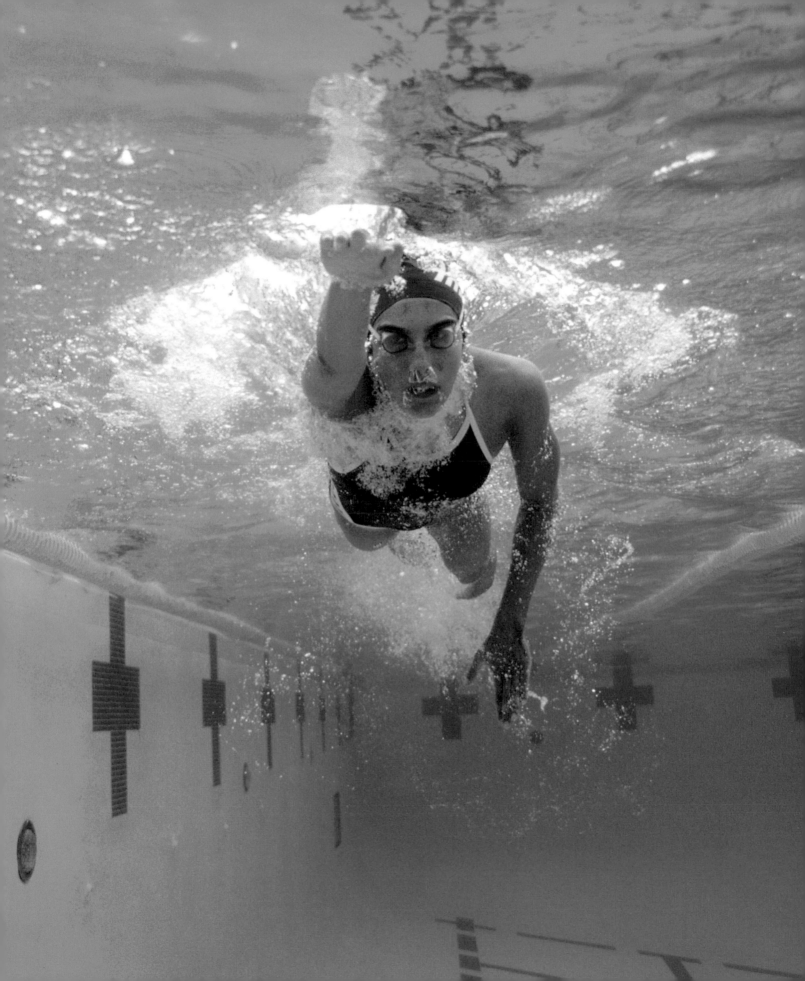

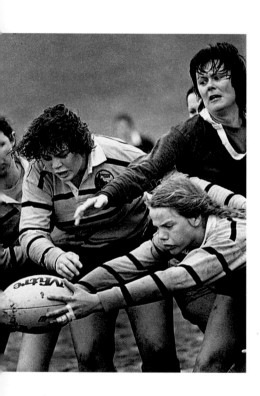

Women's Rugby
Baltimore, Maryland
April Saul, 1980

A Shot on the Spanish Goal
Atlanta, Georgia
Bob Galbraith, AP/Wide World Photos, 1996

Tracey Fuchs played field hockey in the 1988
Seoul Olympics and the 1996 Atlanta
Olympics, and has appeared in a record 187
international field hockey games.

"I was probably thinking, 'Get the strong
shot keep it low and shoot for the corners.'"
–Tracey Fuchs

Action

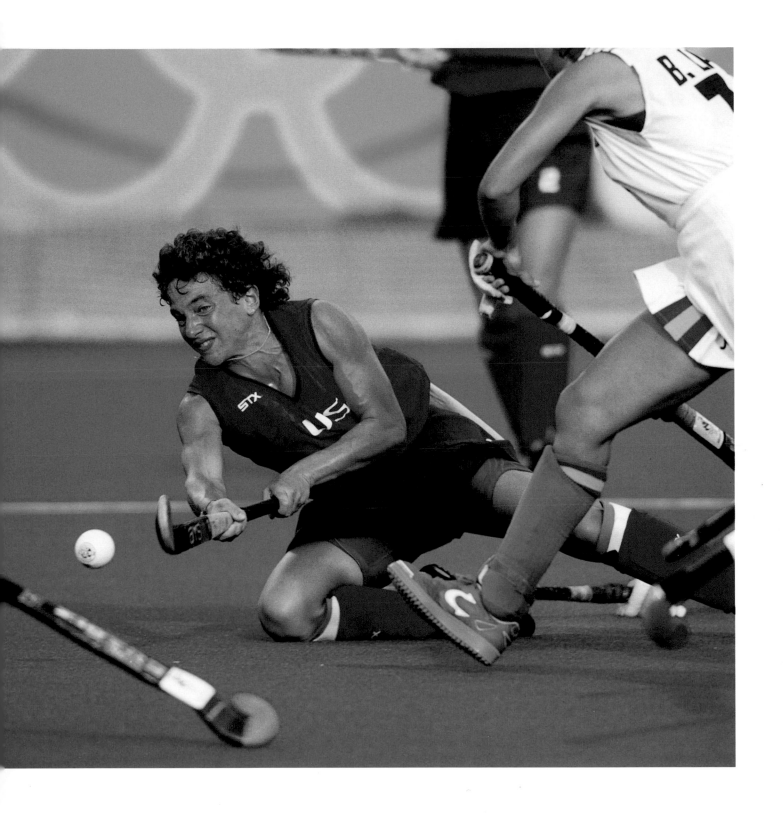

Face of Determination

Irvine, California
Al Schaben, Los Angeles Times, *1996*

Breaststroke specialist Amanda Beard won a
gold and two silver medals at the 1996
Olympics in Atlanta and a bronze medal at
the 2000 Olympics in Sydney.

"Pushing the edge of physical pain is
exhilarating." –Amanda Beard

Action

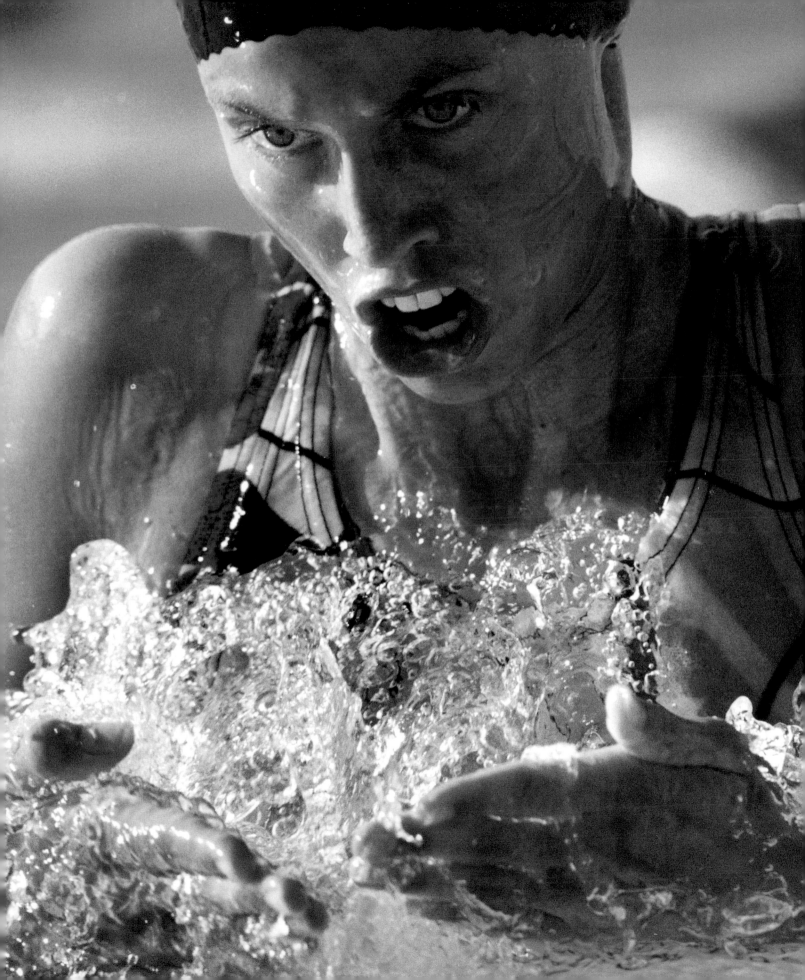

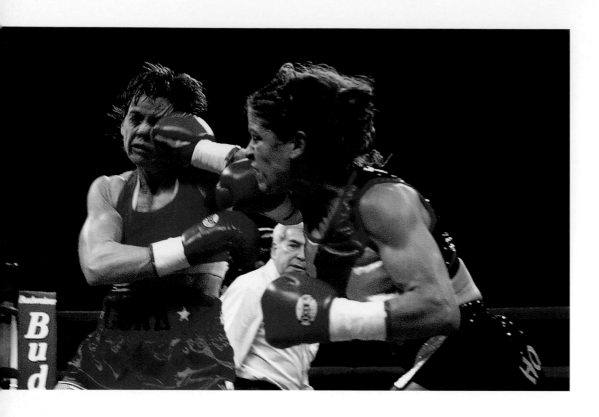

Salamone vs. Webber
New York, New York
Chang W. Lee, The New York Times, *1999*

Surrounded by Gophers
Minneapolis, Minnesota
David Brewster, Star Tribune, *1983*

At the University of Wisconsin, Faith Johnson scored more than 1,000 points. Now head coach at Minneapolis North High School, her record is 122 wins and 15 losses in five years, including back-to-back state championships.

"A friend of ours won't talk basketball to me now because I've got a baby. He says, 'You're a mother now and you're not into this anymore.' As a female athlete, I just say, 'Uh huh, you just wait.'" –Faith Johnson Patterson

Action

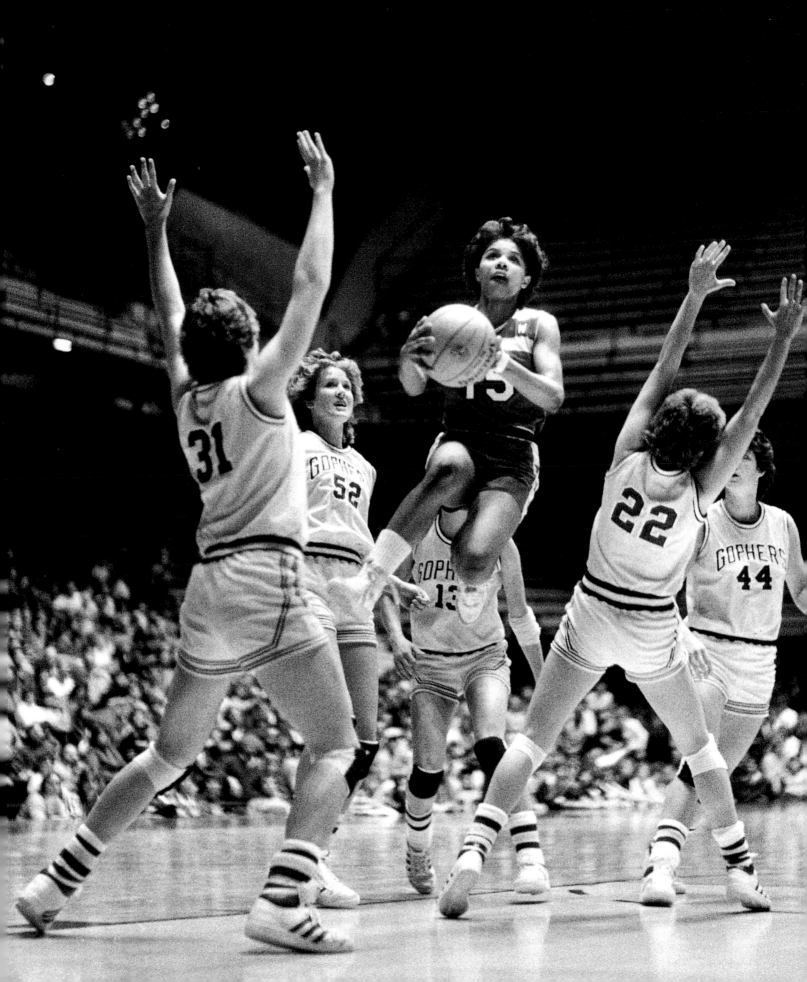

Portable Cribs and Bags Filled with Toys

Carla Overbeck

The plan had always been that I would take a little time off after the '96 Olympics, have a baby, and be back for the next major event, the '99 World Championships. But once I was actually pregnant and on the sidelines, in the back of my mind I was thinking, God, can I still compete at that level? Especially seeing the younger kids coming through, and they were playing that whole time while I was watching. At twenty-nine, there was no guarantee I'd be able to get back in the kind of shape it takes to play international soccer.

One of the most difficult parts of being pregnant was having to hold back in training. The basis of what you do in a workout is get your heart rate up and keep it up for as long as you can, but the doctor didn't want me to get my heart rate up over a certain level because it's not good for the baby. I was seven and a half months along when I had to quit running.

I was due in August of '97, and the team had a tournament in Germany in early October. Mentally, it became an imperative for me to make sure I was on that trip. Jackson was ten days early, and for two weeks I wasn't allowed to do anything. I didn't feel like it, either. But then I started running, lifting, and sprinting again. I may have come back a little too fast, but I had only five weeks to get fit enough to play at national team level. You can't go to a tournament if you don't think you're really ready to play, because if you're going, it means someone else isn't. And every time you're

Breaking the Barrier
Plano, Texas
Patricia D. Richards, 1991

with the team, whether it's a training camp or a tournament, if you don't perform, you don't go to the next one.

I wanted to take Jackson with me, but my doctor wouldn't let him travel till he was eight weeks old. Spending ten days without him was just weird. I felt lost after having him by my side twenty-four hours a day, seven days a week for seven weeks. I worried. Not that my husband wasn't capable of taking care of a child, he's very, very capable, but I just worried. My phone bill was astronomical. The good part was I picked up with the team where I'd left off. The people I'd always enjoyed playing with, I still enjoyed being around them. I didn't need to prove myself to them again. Sheryl Swoopes of the WNBA had had a son and continued playing, and that had done some work breaking down preconceptions about women remaining elite athletes after having children. Within our own team Joy Fawcett traveled with a three-year-old and an infant when Jackson joined the tour. Seeing Joy and Sheryl continue playing helped me with my decision.

At first, Joy and I brought one of our moms or a friend to be a nanny, and we'd have to pay for their hotels, their plane tickets, and their food. But when we redid our contract with the soccer federation, we stressed that it would be helpful if they covered some of those costs. They said that if we got the person, they'd make them part of the official party, and their travel and food would be covered. It made our jobs a lot easier. So Jackson, he's now three, has been all over the world with me. He's been to Portugal twice, Germany, Norway, Australia, all over the place. Our team is quite a sight coming and going at airports; not only do we have our personal bags, our equipment bags, and our balls, but we also have strollers, car seats, portable cribs, and bags filled with toys.

We joke and laugh about the little guy waking up in a different place every day, but he doesn't mind being in hotels. He goes with the flow. We bring a lot of books along and stuff to color, and when they make pictures we hang them up in the hotel rooms. We try to make it as normal as possible. In between practices and games, Joy and I get the kids outside whether it's kicking the soccer ball or playing in parks or a playground. This is their childhood.

Sometimes I think, God, am I doing the right thing dragging him around the world, not getting him on a schedule. We'll get to a new place and it can feel like the middle of the day where we live, but it's late and there's a practice the next day. I just turn out the light. Sometimes he sleeps, sometimes he doesn't. I still have to play the next day with no excuses. You just deal with it. And at times I feel bad that I have Jackson with me and my husband is missing out on the day-to-day of his growth. At the same time he is extremely supportive of my career in soccer and he understands Jackson is around all these great, wonderful people who care so much about him. He doesn't worry. The love and attention my teammates give Jackson is like mother's love. They're my friends, and they see I have so much love for him. Every single person can tell when I'm tired and run-down, and they're very, very good at saying, "Hey, Carla, we'll take the kids, it'll be mom's day out, you and Joy go to the movies," or "We'll take 'em for a walk and you take a nap."

When you come back from a hard practice or a game that you wish you could have won but you didn't, you see Jackson and the other kids, it's like they don't know what has just happened, and they really don't care. When they come running up to you smiling and happy, it just makes you realize that yeah, soccer's very important to me, but it's not the most important thing in my life. Having kids just kind of puts things into perspective for me—for my teammates, too.

Carla Overbeck was captain of the United States national soccer team that won the Women's World Cup in 1999 and the Olympic gold medal in 1996. At the University of North Carolina from 1986 to 1989, she played on four national championship teams.

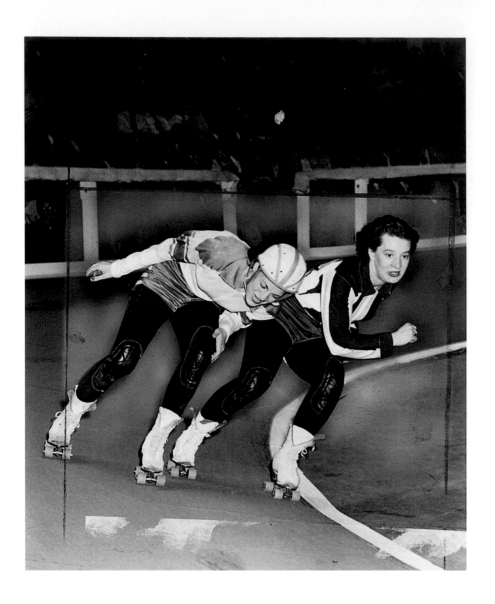

Swinging Down the Track
New York, New York
Photographer unknown, 1950

World Record Time
Hamar, Norway
David Brauchi, AP/Wide World Photos, 1993

Cyclist Rebecca Twigg is a six-time
world pursuit champion.

"I just got into the rhythm and cadence of
my pedaling. My coach gave me signals on
each lap to either keep pace or go faster.
I didn't want to have to do any thinking at all.
I just wanted to know if I should keep
pace or go faster." –Rebecca Twigg

Action

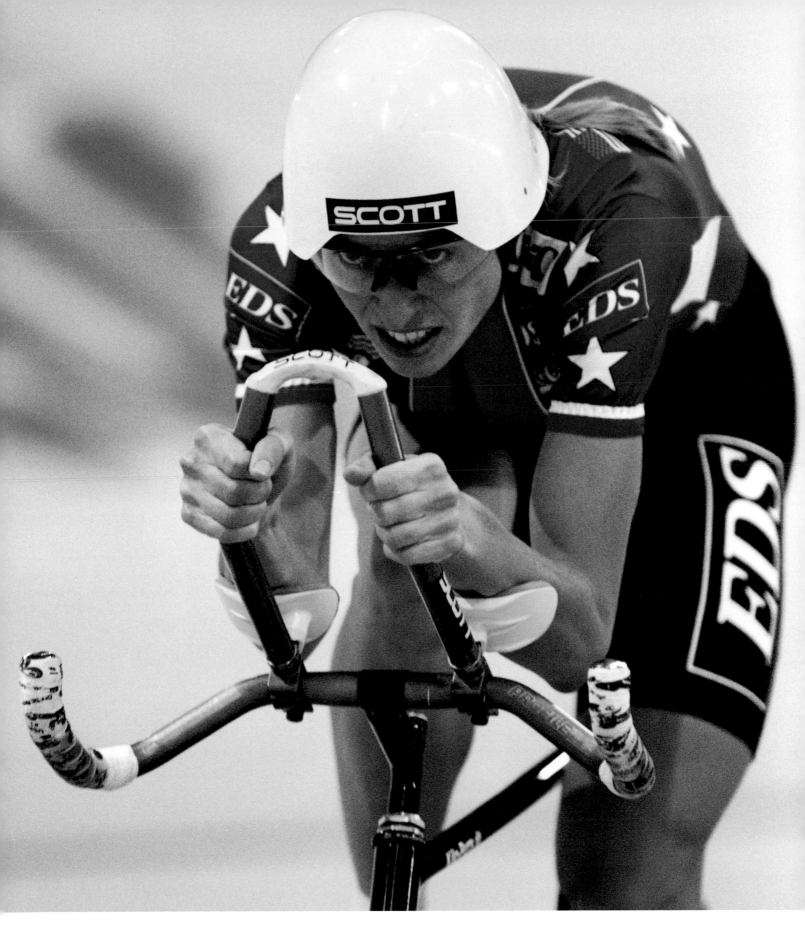

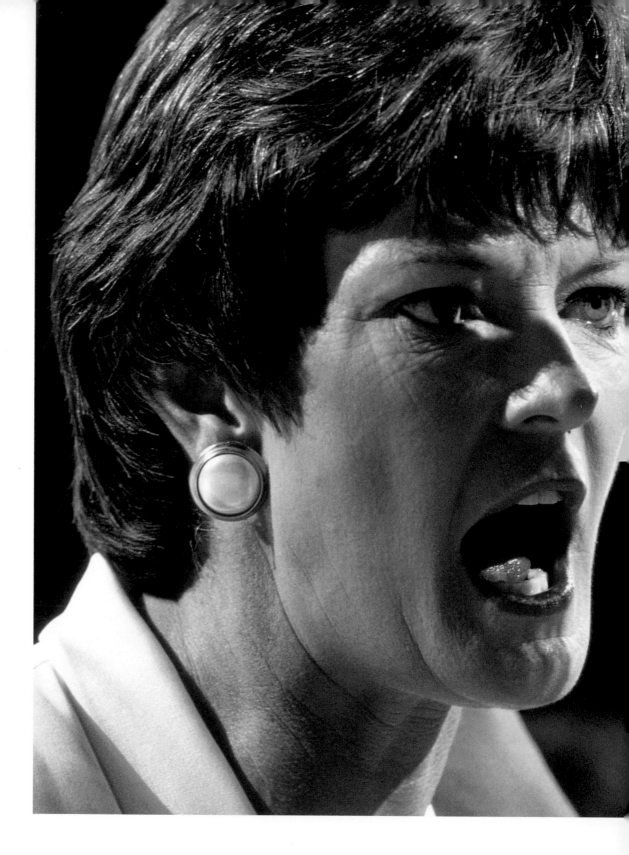

**Pat Summitt with
Chamique Holdsclaw**
*Cincinnati, Ohio
Heinz Kluetmeier,*
Sports Illustrated,
1997

Action

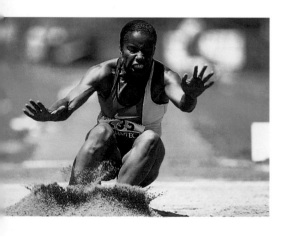

Impact
San Jose, California
John Freeman Todd, 1996

Michelle Akers (#10)
East Rutherford, New Jersey
George Tiedemann, Sports Illustrated, *1999*

In her fifteen-year career in international-level soccer, Michelle Akers was an anchor on the 1991 and 1999 World Championship teams and on the 1996 gold medal–winning Olympic team in Atlanta.

"I am going to smash through this girl to win this head ball." –Michelle Akers

Action

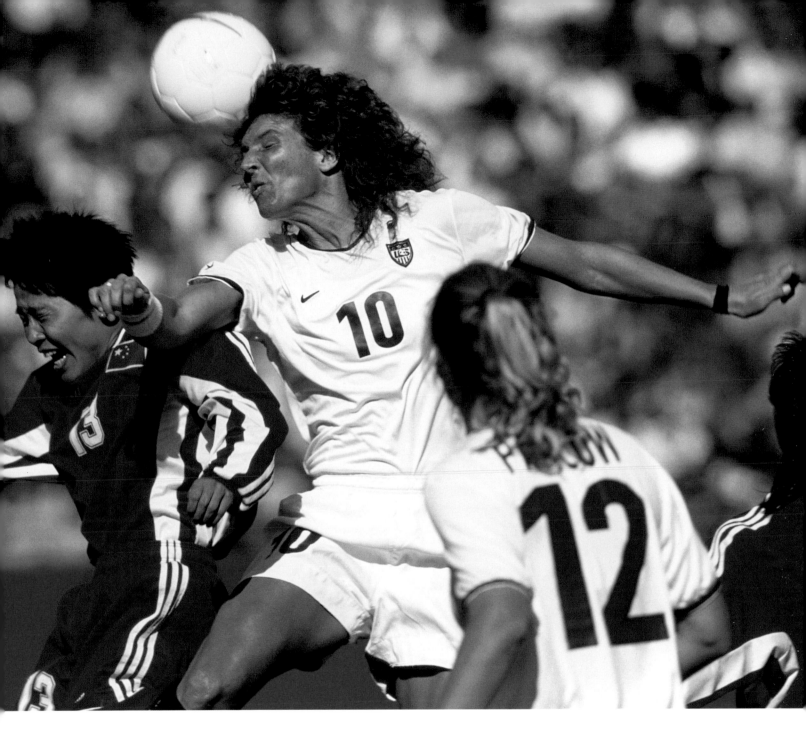

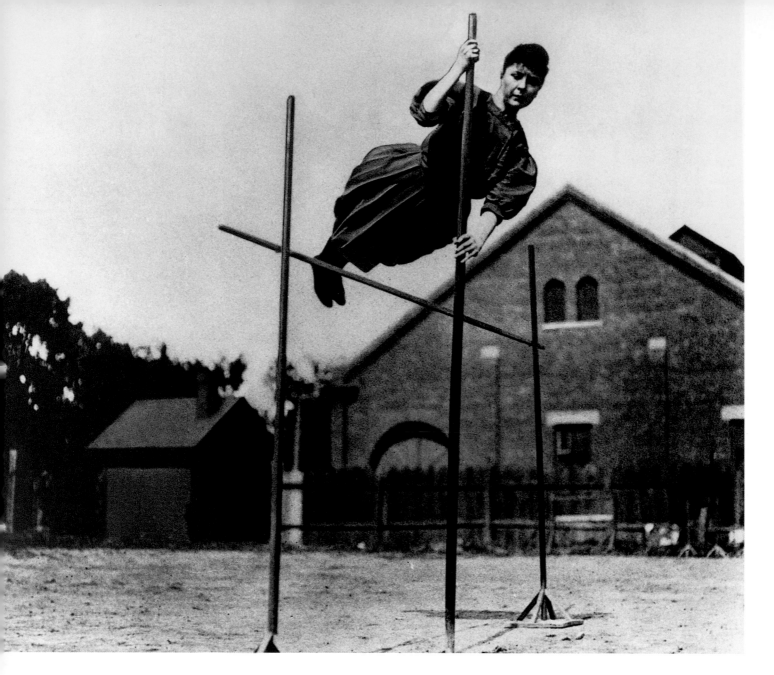

**Ina Gittings Pole Vaulting,
University of Nebraska**
Lincoln, Nebraska
Photographer unknown, 1906

Action

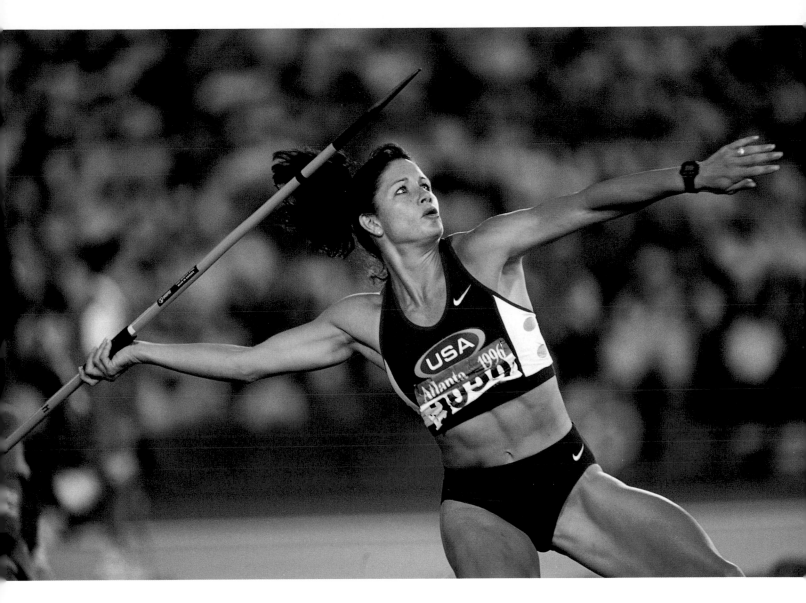

Women's Heptathlon

Atlanta, Georgia
Tony Duffy, Allsport, 1996

Sharon Hanson competed in the 1996 Atlanta
Olympics and placed ninth in the heptathlon.

"When I was in junior high, I was called a
jock and I couldn't stand that word. When I
ran on the street, people would yell out the
window, 'Come on, honey, pick it up, run a
little faster.' Then, times changed."
—Sharon Hanson Lowery

But I Watched Her

Ernestine Bayer

My own mother was very disappointed in me. She was born in 1870 and she wanted me brought up the same way she was. She was the only woman I ever knew who changed her clothes twice a day. She played the piano beautifully; she cooked beautifully; she dressed beautifully. She was a lady and I was a tomboy, and that disappointed her terribly. I liked to keep my body in motion. I would roller-skate every day as a kid. I liked to run, I liked to swim, I liked to dance. I liked to do all those things I wasn't supposed to do. It was a different day and a different age.

In 1927, when I was eighteen, I worked at the Fidelity Trust Company, a bank in Philadelphia. My friend Betty wanted me to meet her brother. She knew that I liked to swim, so we made a date, Betty and I, to go swimming. Lo and behold, instead of her coming to the house to get me, her brother Ernest came, and he said, "Betty couldn't make it tonight, so I'll go swimming with you." That's how I met my husband. He wasn't that good a swimmer, but he was a darned good oarsman. He was training for the 1928 Olympic team, a year away.

Well, we decided to get married, but we couldn't without Ernest losing his spot in the crew. You see, in those days, people felt a married man lost his strength, having sex. He felt that if his team knew he was married, they wouldn't want him in the boat. So we eloped and we got married in a little church in New York City, but we kept it a secret. We were married, but he lived at his house and

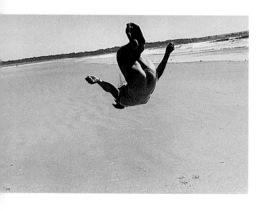

Mirah Moriarty's Roundoff
Kennebunk, Maine
Peter Moriarty, 1990

Action

I lived with my family. When he came back from the Olympics with a silver medal, we made an announcement and we had a second wedding ceremony, in Philadelphia.

After the Olympics, he became captain of the Pennsylvania Barge Club. It was and still is one of the institutions on Boathouse Row, a line of rowing clubs along the Schuylkill River. It was *the* place for rowing in the United States. Each day, Ernest took his crews out and I sat on the back porch. I watched crews go out from all the clubs, and I'd sit there and I'd wait.

One day, in 1938, I saw this girl get in a single out of the Fairmount Boat Club. I didn't know who she was but I watched her get in a boat and row upriver. I almost fell off my chair, because my husband had told me girls don't row. So on the way home I said to him, "You told me girls don't row." He said, "No, they don't." And I said, "Well, who was that gal I saw getting in a single and rowing upriver?" He said, "She's the girlfriend of Tommy Farrell, and that's his boat." So I said, "Well, why can't I take a boat out from here?" He said, "We don't own a boat."

He didn't want me to row because it would upset the applecart. Girls didn't row. There was no such thing. Maybe a girl would row individually here or there, but there were no organized women's clubs and nowhere did women race. He could have put me in a work boat, a wider boat you can't fall out of. But I guess you'd say I was from the old school. I was obedient.

One of the officers at the bank was a member of the Philadelphia Skating and Humane Society. They had a building right there on Boathouse Row, and this man used to talk rowing to me because he knew my husband was an oarsman. The building wasn't used much, and one day I asked him about it and he told me they were moving their main operation out of that facility. Well, I jumped on it right away. I rented it for something like forty dollars a month. I went to that gal I'd seen rowing and asked her if she was interested in starting a club for girls, and she said yes. Then I went to

other gals whose boyfriends were rowers, and they were interested in rowing, too. We all got together for a meeting, and the Philadelphia Girls Rowing Club was created. I was the first president. I was twenty-eight and the rest of the girls were eighteen and nineteen. It was 1938, and that's how the PGRC started.

When the men found out we had that house, they were very, very angry. Remember, Boathouse Row was *the* place for rowing and we had dared to come into their territory. They said if they'd known the building was available, they would have bought it. When the PGRC starting rowing and then racing on the Schuylkill, the reaction on Boathouse Row was divided. Half the men didn't mind and half the men were up in arms.

I couldn't get it in my brain and I can't today, why men objected. They all came around, but it took awhile. My husband did an about-face. He even got into the act, helping out and coaching us. He took it on the chin from other men. So did we. I remember a man named Bill who was the stroke of an Olympic gold medal eight. He was a handsome tall guy, and he rowed out of Vesper Boat Club. I was walking down Boathouse Row one day as he was walking up, and he stopped me. He couldn't have gotten any closer to me if he'd tried, and this was not with love. He looked down on me from six foot four and he said, "Girls shouldn't row and you shouldn't either." And I said, "That's what you think, Bill," and I turned around and walked away. I have never forgotten it, but I have to tell you the rest of the story. When he left Philadelphia he came up to New England and he started coaching girls. He married one of the girls from his crew.

Born in 1909, Ernestine Bayer has created opportunities for women to row for more than sixty years. In 1984, she was the first woman inducted into the Rowing Hall of Fame.

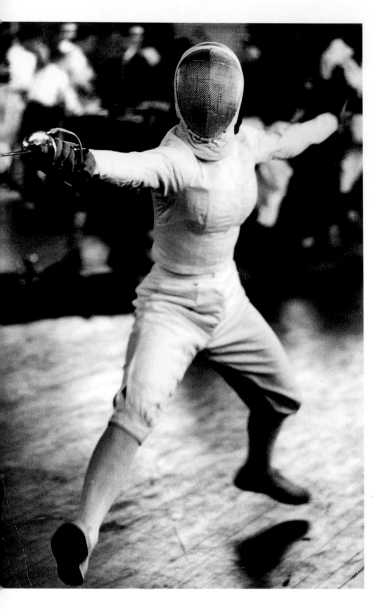

Pan American Games

Chicago, Illinois
Art Shay, 1959

Action

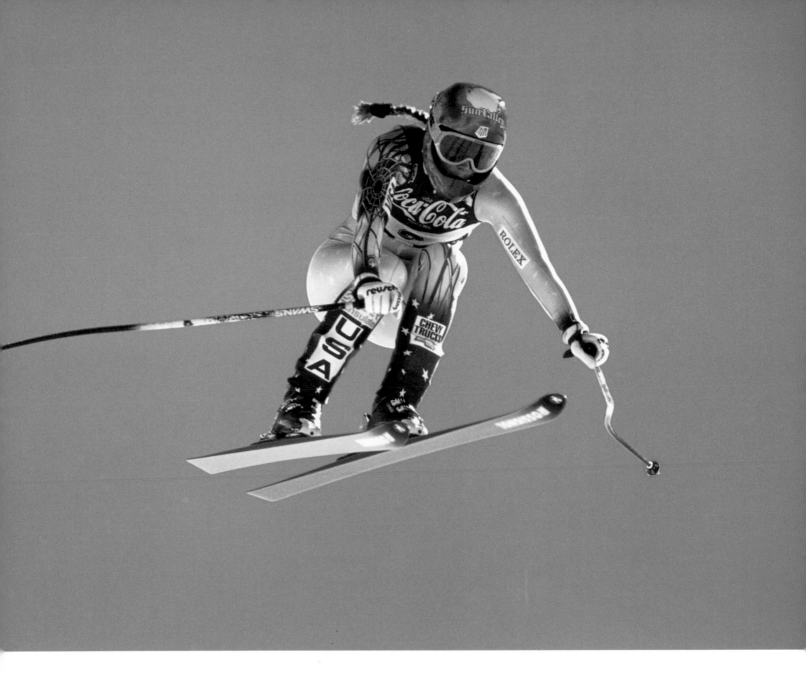

Downhill Racer
Sierra Nevada, Spain
Carl Yarbrough, Sports Illustrated, *1996*

Picabo Street is a two-time world champion
in the downhill. In the Olympics, she won a
silver medal in the downhill in 1994 in
Lillehammer and a gold medal in the Super G
in 1998 in Nagano.

"The mountain is like a dog. It's going to
smell that fear and it's going to get you. It's
going to bite you." –Picabo Street

Big Drop

Half Moon Bay, California
Pete Burnight, 1999

Sarah Gerhardt is the first woman to surf
California's big waves, known as Mavericks,
which don't break unless they are at least
twenty-five feet high.

"I love it all. I love the smallest, junkiest day
out there by myself. I love head-high waves. I
love big waves. I don't care. I'd surf in my toi-
let bowl if I could." –Sarah Gerhardt

Action

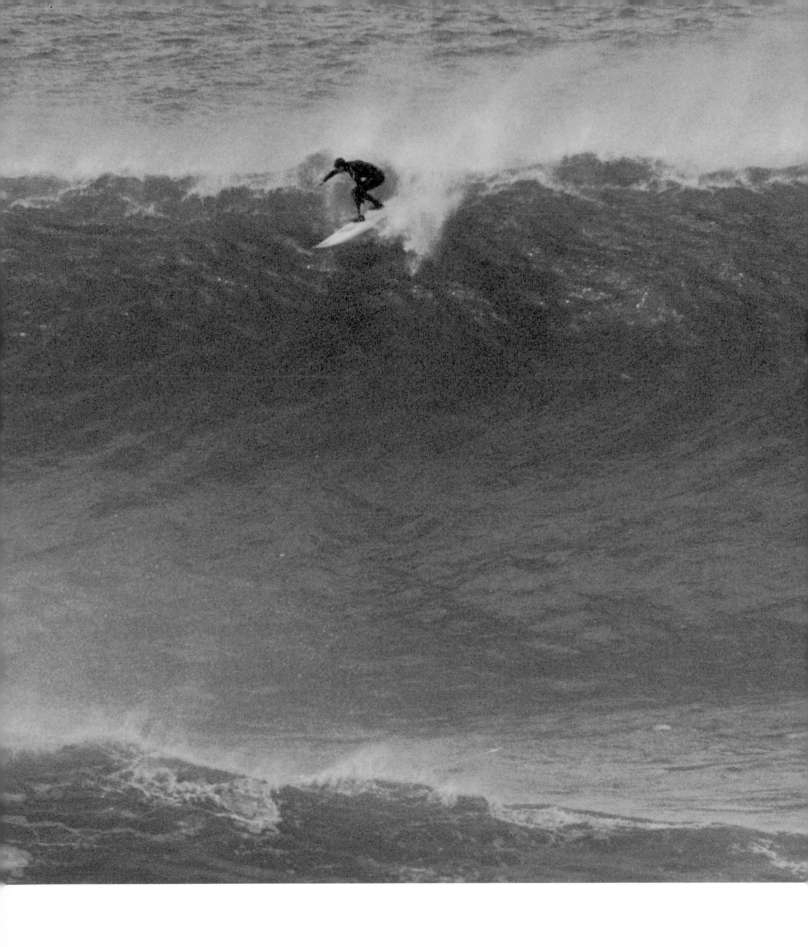

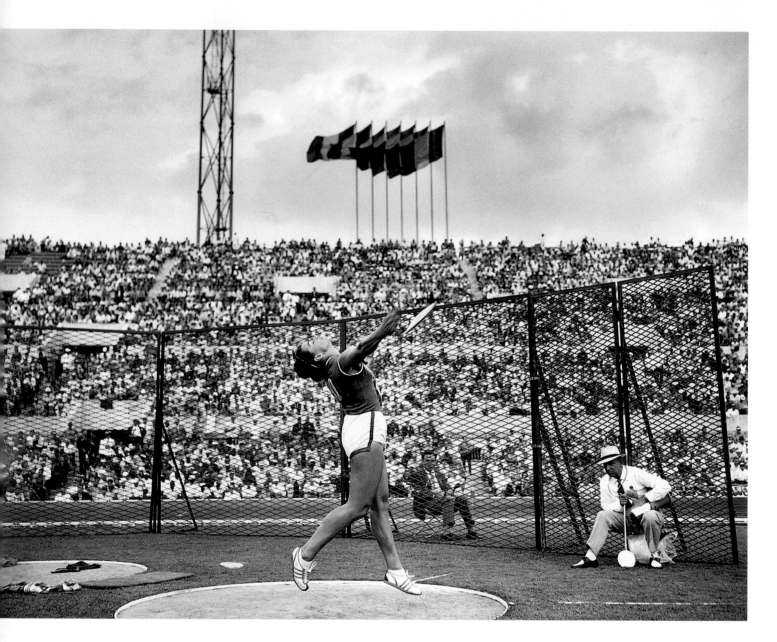

Discus Final

Rome, Italy
Photographer unknown, AP/Wide World Photos,
1960

Olga Connelly competed in five Olympics,
starting in 1956 in Melbourne, when she won
the gold medal in the discus.

"When I came to the United States in 1957, at
my first meet people came up to me and asked
if they could touch my muscles."
–Olga Connelly

Action

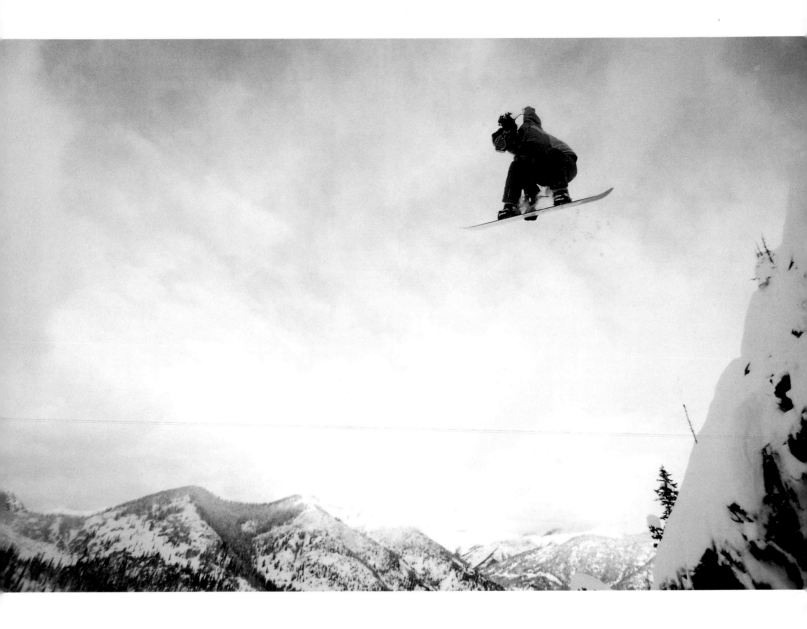

At Island Lake Lodge
Fernie, British Columbia
Mark Gallup, 1990s

Tina Basich placed second in the Big Air
competition at the 2000 Snowboard World
Championships.

"We used to get respect for trying, now we get
respect for being a good snowboarder. It's not
the token women anymore, it's the women's
team." –Tina Basich

Mutton Busting,
Crawford County Fairgrounds
Girard, Kansas
Raymond L. Brecheisen, Morning Sun, *1987*

Action

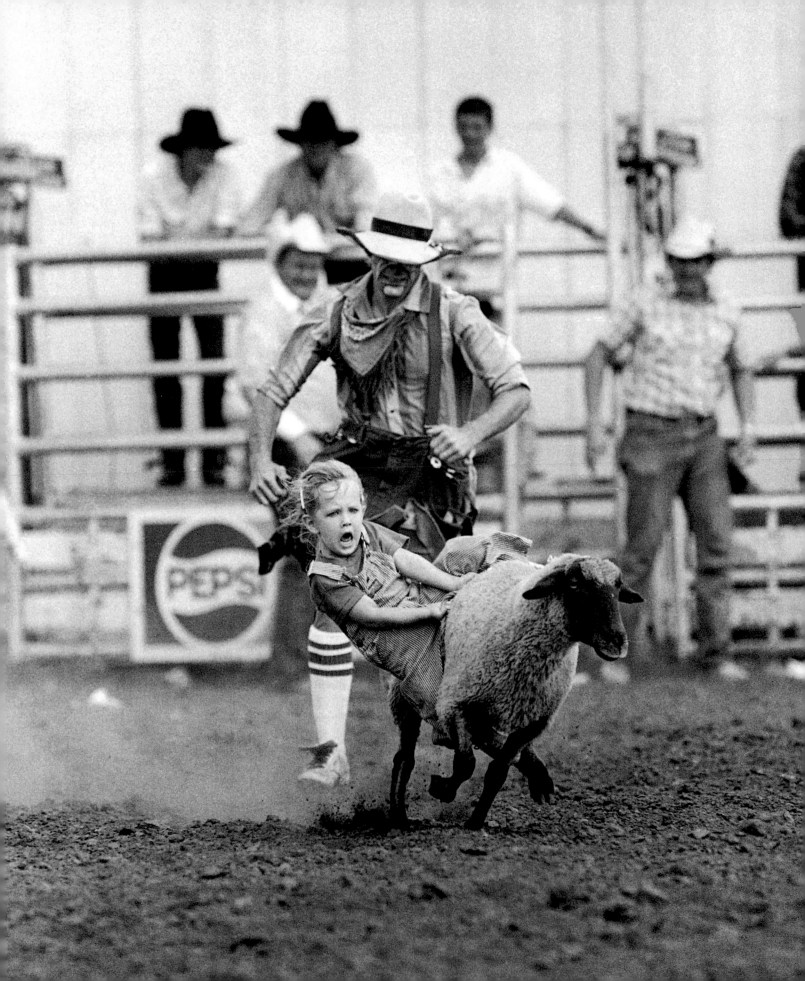

Some Traditions

Pam Gill-Fisher

In 1976, I was part of the fund-raising effort for building Rec Hall, a state-of-the-art multiuse sports facility. No state money was involved; the funds came from donations and student money. When building-use policies came out, I went to the athletic director, Joe, and said, "My players have to arrange their classes. When should I tell them practice is scheduled?" He looked at me funny and said, "Well, you're not in Rec Hall." I said, "The policies say basketball is in Rec Hall." He said, "Well, they meant men's basketball." I said, "Wait a minute. You mean we're in the old gym while the men have this new facility? Do you think that's fair?" He said, "The work group that set the policies don't think you draw enough fans, so you should stay in the old gym." And I said, "Have they ever heard of Title IX? Do they realize that every one of the students on my team pays as much money to go to school here and contributes to Rec Hall as much as any male?" He said, "You want to fight this?" And I said, "Yeah, it isn't fair."

So he went back to the work group that had people from all over campus, including the medical, law, and veterinary schools. He said, "I think we should let the women practice and play in Rec Hall." They recited their whole song and dance about women not drawing fans, not generating interest, not being exciting. And Joe said, "Have you ever heard of Title IX?" And they said, "No." And he said, "How many of you get federal funding?" And they all raised their hands. Then he said, "If you'd like to keep it, I suggest you let the women play in Rec Hall." So that's how we got into Rec Hall.

Then came a situation with the band and cheerleaders. The band used to come into Rec Hall and warm up for the men's basketball game while the women's team was still playing. They'd sit in the stands, right at the end where the basket is, blowing their horns to get them in tune. They had no idea if we were ahead or behind or if the game was close. They'd crash their cymbals and toot their tubas when people were making free throws or down with an injury. It was like this other event was happening at the same

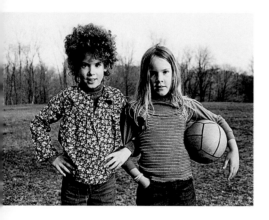

Ready for Anything
Baltimore, Maryland
Susie Fitzhugh, 1975

time we were playing. It felt like they were blasting the message, "When the *real* game starts, we'll be prepared to perform."

So I went to the band and said, "You know, it's really distracting for you to come in and warm up while we're playing a game. It would be nice if instead of us using a tape for the national anthem, you came to the beginning of our game and started playing then." The response? "We don't have enough time to stay for the men's and women's games. There aren't as many fans for your games and we don't think it's as important to support you. We want to perform for a larger audience." So I said, "That's fine. But if you don't want to come in and play for us the entire time, then stay out of the building until we're done. We'll get a high school band to play for us each game. They would be thrilled to be here at the university performing in Rec Hall." They said, "You can't do that." I said, "Watch me."

The band's faculty director called the athletic director, outraged that I was making promises to keep them out of the building. The athletic director asked me, "You think that's what should happen?" and I said, "Absolutely." He said, "Let me handle this." So he went to the band officials and said, "You should support the women's team." And the band director said, "Traditionally, we've never done that, and there aren't enough fans." Then the student director said the same thing. Joe, who's African American, said, "Traditionally, they used to hang people like me in the South. I think it's time we change some traditions around here. If you don't want to participate for both teams, we don't want you for either." That's when we started getting the band.

It felt like a constant battle, or maybe negotiation is the better word. It wasn't just improving your team but creating fairness and opportunity. It was a major step when women's teams progressed to wearing bona fide uniforms after years of playing sports in pinnies over starched white shorts and button-down blouses. But that meant we had one set of uniforms for *all* the women's teams. No home and away uniforms—one set of navy-blue uniforms that every team shared. I mean the volleyball team wore them, the basketball team wore them, the softball team wore them, the track-and-field team wore them. Heaven forbid if you were on the jayvee team, because you got this tight polyester uniform that a varsity player had just peeled off, all sweaty.

The men's team not only had uniforms but practice clothes, bought by the university and laundered each day, including jocks and socks. I went to Joe and said, "You're buying jocks for the men, giving them clothes, washing them every day. You don't even give us clothes, let alone a bra, nothing." He said, "There are still a lot of other things to fight, like practice times, coaching staff size, and so on." So I backed off. He said, "The other reason we do those things for men is that they don't know how to do their own laundry. If we don't do it for them, there's going to be disease out there." I said, "OK, I guess laundry is a gender thing." I wouldn't have accepted it today, but I did back then. He said, "If they ever come out with an athletic bra, I'll buy it." I said, "You're on." Sure enough, about two years later, the Jogbra came along. Guess what? I put Jogbras on my budget. And he bought them.

People will read this today and say, "Oh, my God." Everything is the opposite now. One year, the band piled into a bus and drove forty hours from Davis, California, to Grand Forks, North Dakota, when the women's team played in the Nationals. They slept on a gym floor in order to be able to participate. When our team was eliminated, other teams wanted to rent our band. Our band was given the key to the city. Students in the band now would have no concept of not supporting the women's program. It wouldn't enter their minds.

For twenty-seven years, Pam Gill-Fisher has been part of sports at the University of California at Davis. She played five varsity sports, coached three sports, and is now associate athletic director.

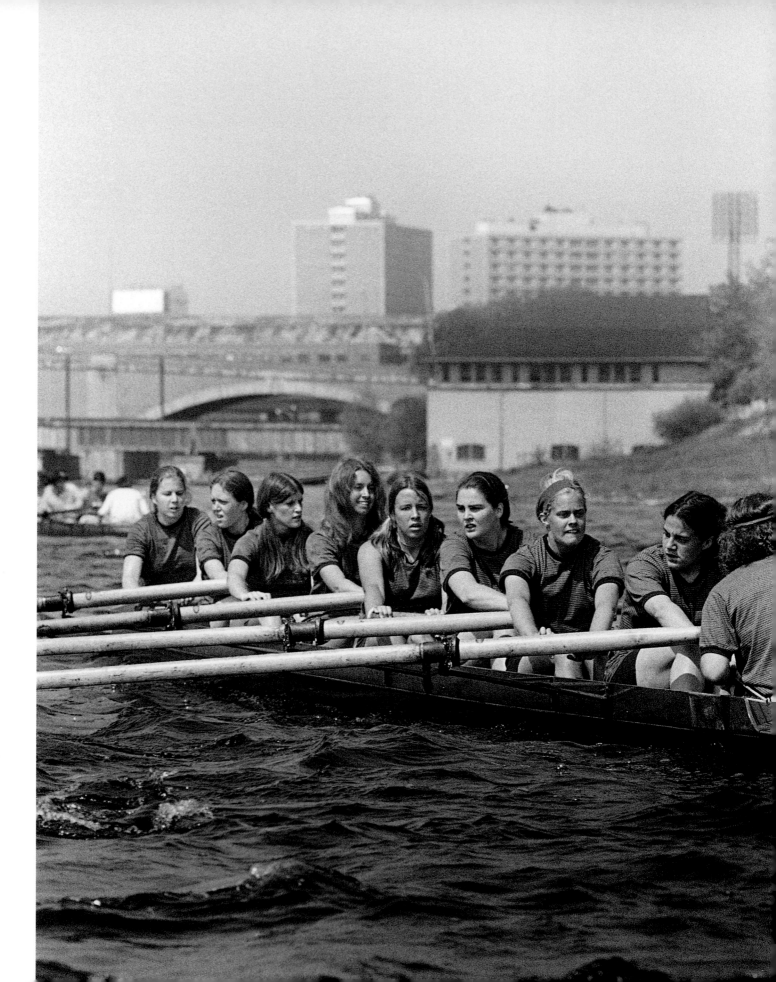

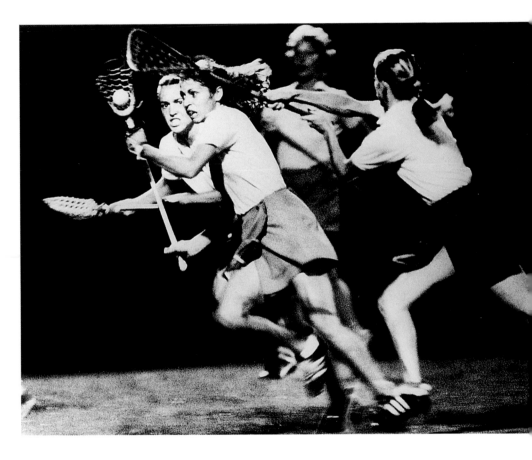

Radcliffe Crew
Cambridge, Massachusetts
Geoffrey Biddle, 1971

U.S. Women's Lacrosse Team in Action
Philadelphia, Pennsylvania
Gerald Williams, The Philadelphia Inquirer,
1982

Laurie Sutherland was a member of the
United States Lacrosse Squad from 1978 to
1982.

"My mother opened up doors for me in
sports. She played field hockey, basketball, and
softball. And though it breaks my heart that
my thirteen-year-old daughter is not playing
lacrosse, it's great to watch her thrive in soft-
ball. I see her confidence growing."
–Laurie Sutherland

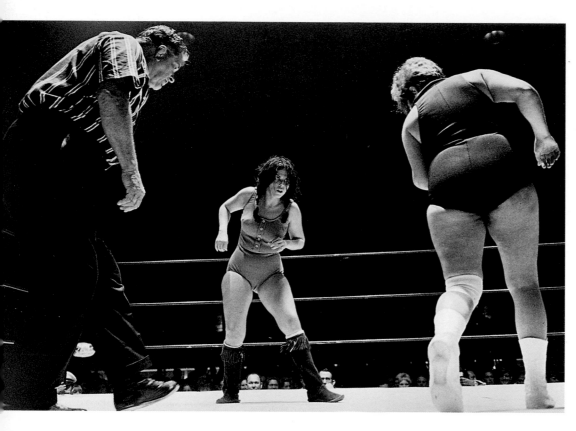

Wrestling
Houston, Texas
Geoff Winningham, 1971

Zappers Win the Call
Hutchinson, Kansas
Greg Peters, Hutchinson News, *1986*

Action

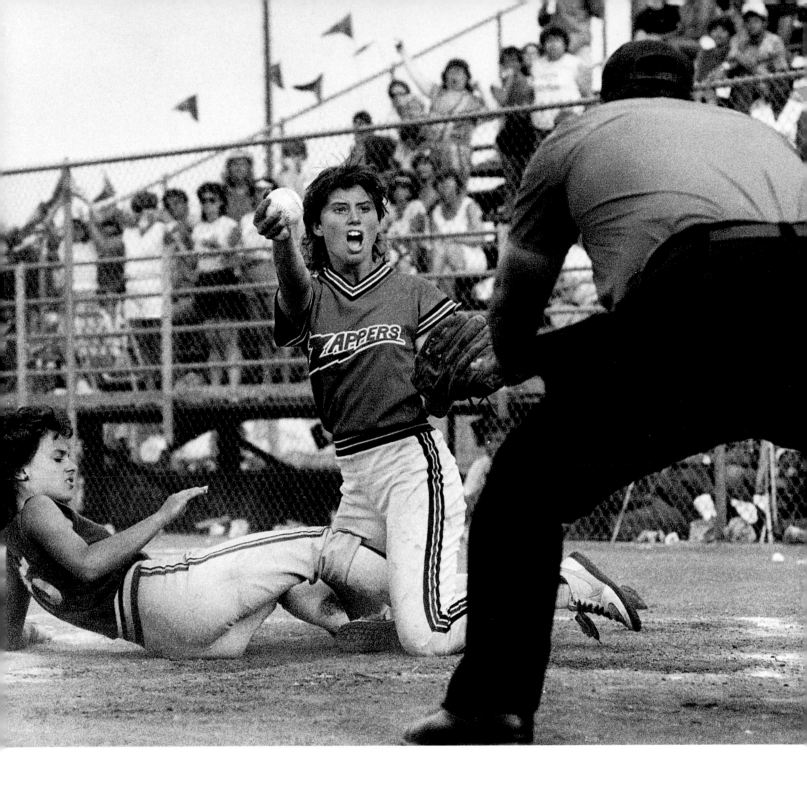

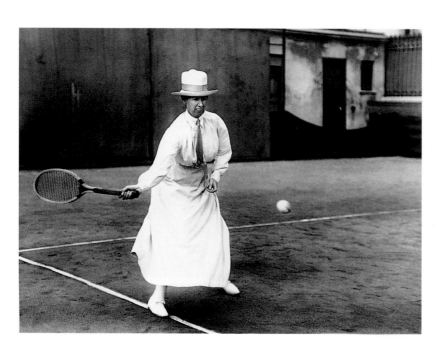

Untitled (lady playing tennis)

Photographer unknown, c. 1910

Kathy Switzer, NYC Marathon
New York, New York
Ruth Orkin, 1974

Entering the then men-only Boston Marathon as K. Switzer in 1967, Kathrine Switzer became the first woman to officially run the 26-mile, 385-yard race. She finished the race but not before race organizers attempted to physically force her off the course. Switzer then ran marathons in a dress to emphasize women's ability to run distances. The Boston Marathon invited women to enter in 1972.

"The guys were enthusiastic, but you can see on the women's faces, they were not particularly enthusiastic. Women were often the hardest people to win over in the battle for acceptance of women's sports." –Kathrine Switzer

Finish

. . . her dark eyes are ardent and wide open and completely seeing. The ball leaves her hand, her hand flops over at the wrist with fingers spread, the ball flies. She watches it go. It hits inside the hoop, at the back. It goes through the net. In the same instant, the final buzzer sounds. —Ian Frazier

By a Nose
Philadelphia, Pennsylvania
Norman Y. Lono, 1980

Victory Lap

Atlanta, Georgia
Amy Sancetta, AP/Wide World Photos, 1996

Gwen Torrence (right) with (from left) Inger
Miller, Gail Devers, and Chrystie Gaines won
the 4x100-meter gold medal at the 1996
Atlanta Olympics.

"We do things that give us more of a sense of
power than the average woman."
—Gwen Torrence

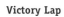

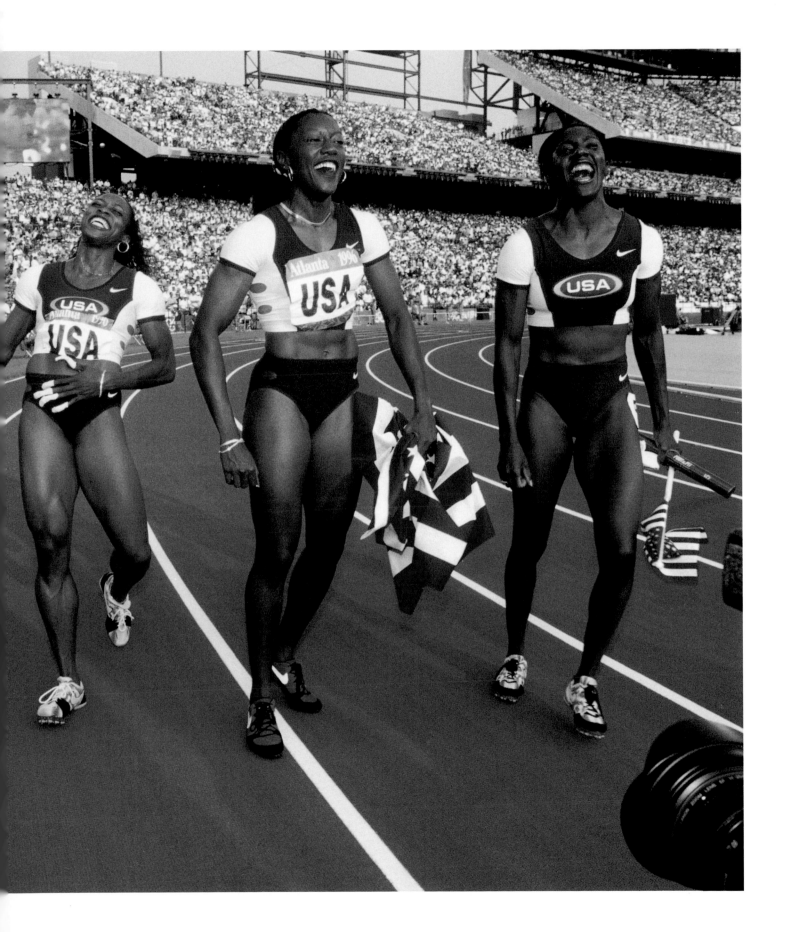

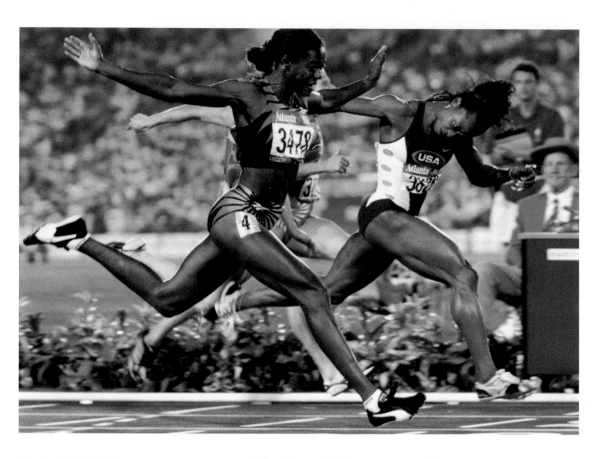

**Hundred-Meter Final
(Gail Devers, right, and Merlene Ottey)**
Atlanta, Georgia
Michael Probst, AP/Wide World Photos, 1996

Gail Devers ran in four Olympics, starting in
Seoul in 1988. She won gold medals in the
100-meter dash in 1992 in Barcelona and in
1996 in Atlanta, and in the 4x100-meter relay
in 1996.

"When I was a child it was not acceptable to
be a female athlete. Those females involved in
sports were considered masculine, so parents
did not encourage their daughters to compete.
Now I feel people see the advantages of sports.
They see it helps girls become strong, inde-
pendent, successful adults." —Gail Devers

Finish

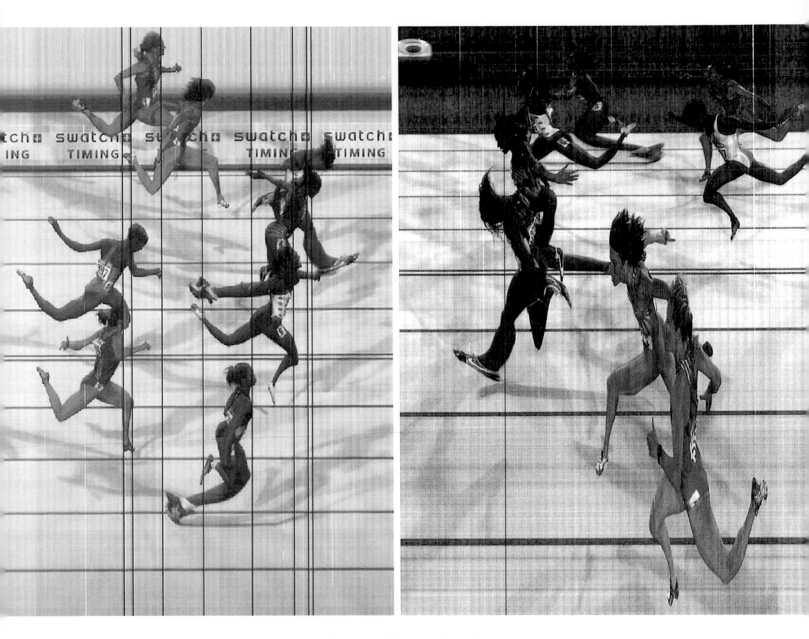

Photo Finish, 100-Meter Final

Atlanta, Georgia
Swatch Team, AP/Wide World Photos, 1996

From the Associated Press– "July 27: These two views show the women's 100-meter-final finish line seen from the stands, left, and from the infield camera, right, at the Olympics in Atlanta. Officials determined that Gail Devers of the United States won the gold by .005 seconds over Merlene Ottey of Jamaica. At left photo, Gail Devers is shown at top right, below her is Merlene Ottey, and below Ottey is Gwen Torrence. At right photo, Devers is at left with feet having already crossed the finish line, Ottey is seen at right above her, and Torrence is above Ottey."

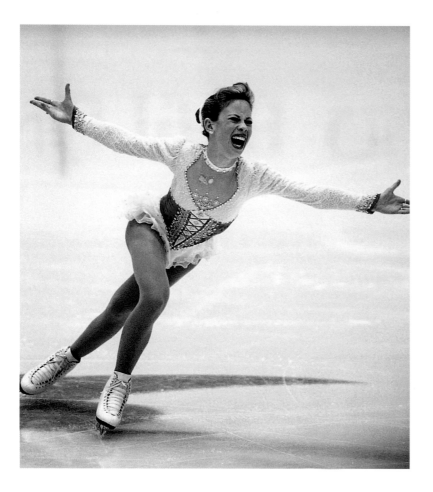

On the Way to Gold
Nagano, Japan
Chang W. Lee, The New York Times, *1998*

Tara Lipinski won the gold medal in figure skating at the 1998 Nagano Olympics.

"I didn't know if I had won here, but my dream of performing and skating well had come true." –Tara Lipinski

Tennessee Girl Wins 60-Yard Dash
New York, New York
Photographer unknown, AP/Wide World Photos, 1965

Wyomia Tyus was the first woman to win the 100-meter dash twice at the Olympics, in 1964 in Tokyo and in 1968 in Mexico City.

"Running was a male sport. Muscles were the ugliest thing on a woman. At Tennessee State the coach said, 'You may never be appreciated for going to the Olympics and winning gold medals.'" –Wyomia Tyus

Finish

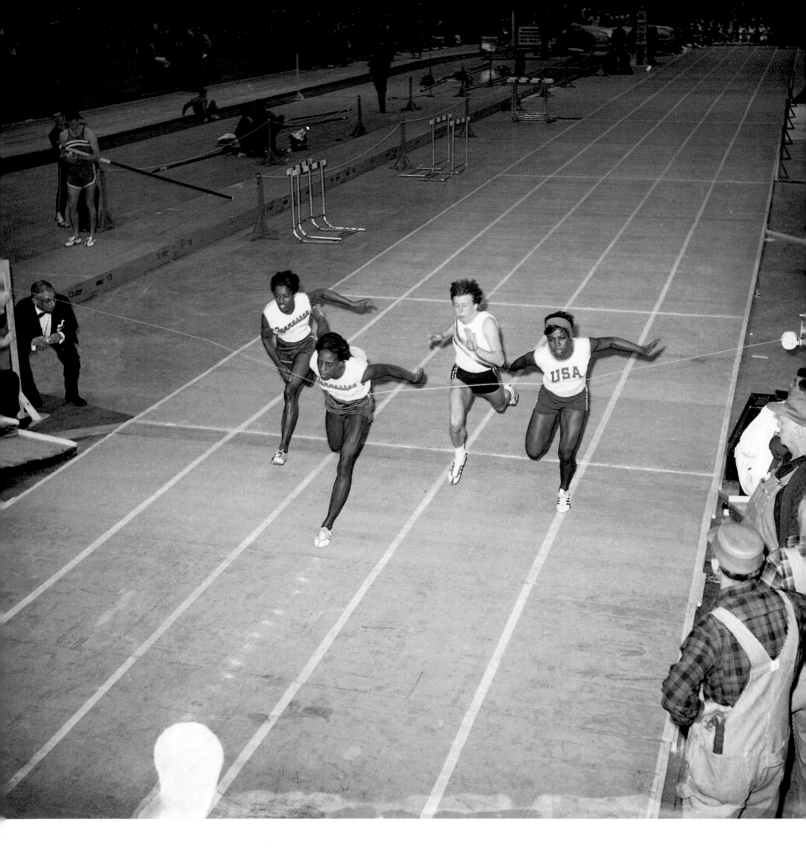

I Can't Sell Something Called Jock Bra

Hinda Miller

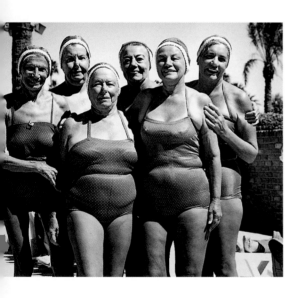

Sun City Aqua Suns
Sun City, Arizona
Etta Clark, 1994–95

The endorphins were intoxicating. I was running twenty, thirty miles a week because I loved the feeling of strength and power and health. There weren't shoes for women, there weren't shorts for women, there weren't bras for women, but everyone was doing it. It was the seventies' running craze. We wore bras, but they weren't made for running, so the straps constantly fell down. Some of us used shoelaces to tie the straps in the back. We ran with our hands close to our breasts for support. The bouncing felt so violent that some women went so far as to bind their breasts with the elastic bandages you use for a sprained ankle. It was all makeshift.

I was a costume designer at the time, aspiring one day to design costumes for a Broadway show. Lisa, another runner, and I were toying with the idea of making a running bra. The vision of a bra made by women for women was compelling, so we set out to create it. We bought regular bras—the "man"-made kind that pushed the breast up and out—and cut them up and sewed them together to try to improve them. One evening, she and I were sitting around talking about the samples we'd been making, what worked, what didn't, when her husband reached over to the laundry stacked up in the living room and grabbed a jockstrap. He held it up to his chest and said, "Hey, look, jock bra!" We said, wait a minute, maybe that's what we want to do, pull everything close to the body just like the guys have been doing all this time.

The next day I went out and bought two jockstraps, and a friend who was working in the costume shop at the University of Vermont sewed them together. Lisa put the thing on, and she and I went for a run at the track. She ran forward, and I ran backward, looking at her. I said, "It looks good," and she said, "It feels good." So we said, "Let's try to fabricate this." Three of us put up three hundred and thirty-three dollars each to buy fabric to make initial prototypes. At first we had a cross-your-heart design with the seam over the nipple. When we did the wear-testing, the nipple started to bleed, so we had to move the seam away from the

nipple. But the big news was pulling the breast mass into the chest wall closer to the line of gravity. The feedback we got from women runners just made the invention better and better.

My father lent us five thousand dollars and we had forty dozen bras made. We started calling mom-and-pop sporting goods stores, saying, "We have a product. It's a sports bra. Can we come and see you?" Back then it was sort of like the Wild West. People were looking for products. They would see you if you called them. Nike was young, Reebok was young, Moving Comfort . . . we were all young people, working as young manufacturers in this new industry. So when we went into a mom-and-pop sporting goods store, we went in with language that this was a piece of *equipment,* that a woman needed shoes and a bra to go running. We had to transform the idea of a bra from a piece of lingerie into a piece of athletic equipment. We sized it like T-shirts—small, medium, and large—because we knew we wanted women to buy this product where they bought their shoes, and we knew all the specialized sizing—32A's, B's, C's—would get people scared.

When I brought some in to sell to a store in Columbia, South Carolina, the woman who owned the store with her husband said, "The women who run here don't want to think of themselves as jocks, so I can't sell something called Jock Bra. You have to rename it." Lisa and I were northerners. We thought jock was great. But we agreed, "OK, we'll call it the Jogbra." The name Jogbra became our savior. It told everything there was to tell about the product. It created a category, and it was easily translated to other countries. The first logo for Jogbra had a little heart dotting the *j*.

We were missionaries. No one knew if women needed it or why. We had to stand up and say, "We know women need support because we're runners. We are those women." It became symbolic; a store carrying Jogbras signaled that they understood women's needs. It was radical, it was core, it was intimate, and frankly, many of the male store owners had to get over their inhibitions about carrying bras along with bats, gloves, and all the rest. With sales reps we used to joke, "You have to say nipple without smiling." The reps had to know the anatomical components of the breast and how it works. We heard a lot of breast jokes and guffaws, but when you start generating business for an account, they become believers. One very enthusiastic general manager of a large chain said if his salespeople could sell a woman a bra, they could sell them anything. We called him Jogbra Jim.

Now sports bras generate over $500 million at retail. It's a big category. About 6 to 8 percent of all bras are sports bras. It's part of every woman's wardrobe. For me, seeing real athletes at the Olympics, in marathons, in high schools, in dance groups—seeing them depending on this product is very rewarding. An article in *The Washington Post* said the invention of the Jogbra was as important for women's sports as Title IX. I feel privileged that I was the person picked to channel this great thing for women. The body-mind-spirit unity starts with the body, and I'm thrilled to have played a role in allowing women of all sizes to feel unselfconscious about their bodies as they engage in physical activity.

When I was a graduate student in costume design I used to go to the Metropolitan Museum of Art in New York and sketch farthingales, corsets from Elizabethan times. We used to talk about underwear and how it reflected the moral and political temperature of an era. Now an early prototype of our Jogbra is in the permanent collections of the Metropolitan and the Smithsonian. That's very cool.

Hinda Miller, Lisa Lindahl, and Polly Palmer Smith invented the Jogbra in 1977. Later that year, Miller and Lindahl founded Jogbra, Inc. and sold the company in 1990, though Miller remained president and CEO until 1997. She is a consultant to women-owned businesses and is a certified yoga instructor.

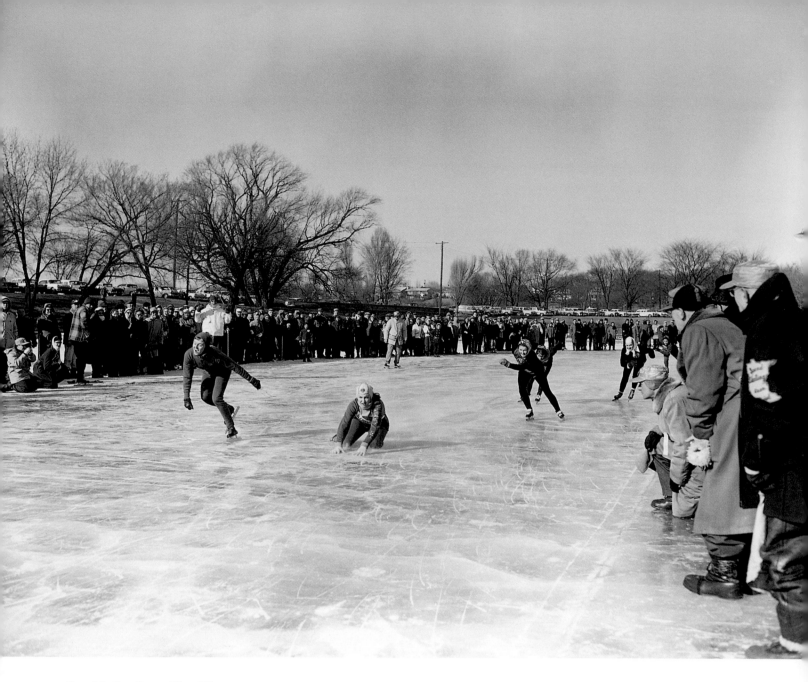

Speedskating Champ Wins 220

Minneapolis, Minnesota
Photographer unknown, AP/Wide World Photos,
1959

Finish

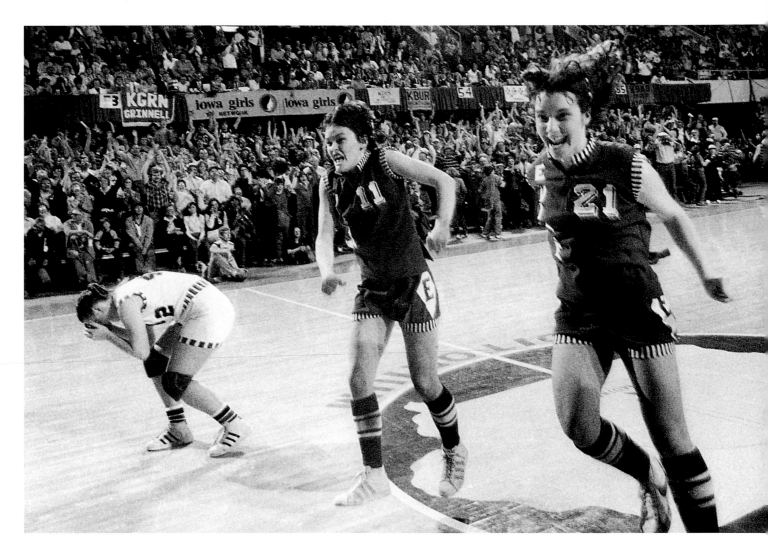

Iowa Girls' State Basketball Championship
Des Moines, Iowa
David Peterson, The Des Moines Register, *1982*

Finish

Ironkids Triathlon
Nashville, Tennessee
Mary Ellen Mark, 1989

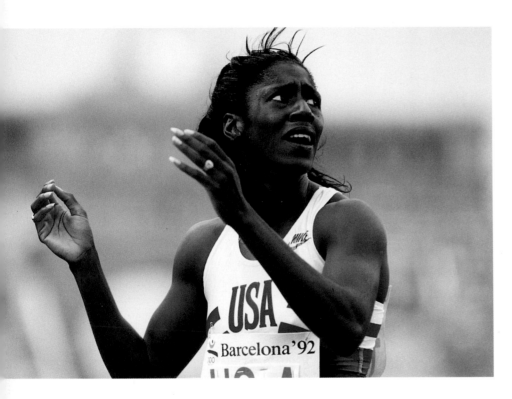

Moment of Doubt
Barcelona, Spain
Jerry Lodriguss, The Philadelphia Inquirer, *1992*

One Hundred Meters in 10.75 Seconds
Sydney, Australia
Barton Silverman, The New York Times, *2000*

At the 2000 Sydney Olympics,
Marion Jones won gold medals in the 100-
meter dash, the 200-meter dash, and the
4×400-meter relay, and bronze medals in the
long jump and the 4×100-meter relay.

"My ultimate goal is to be mentioned
in the same sentence as Michael Jordan,
Muhammad Ali, or Pelé." –Marion Jones

Finish

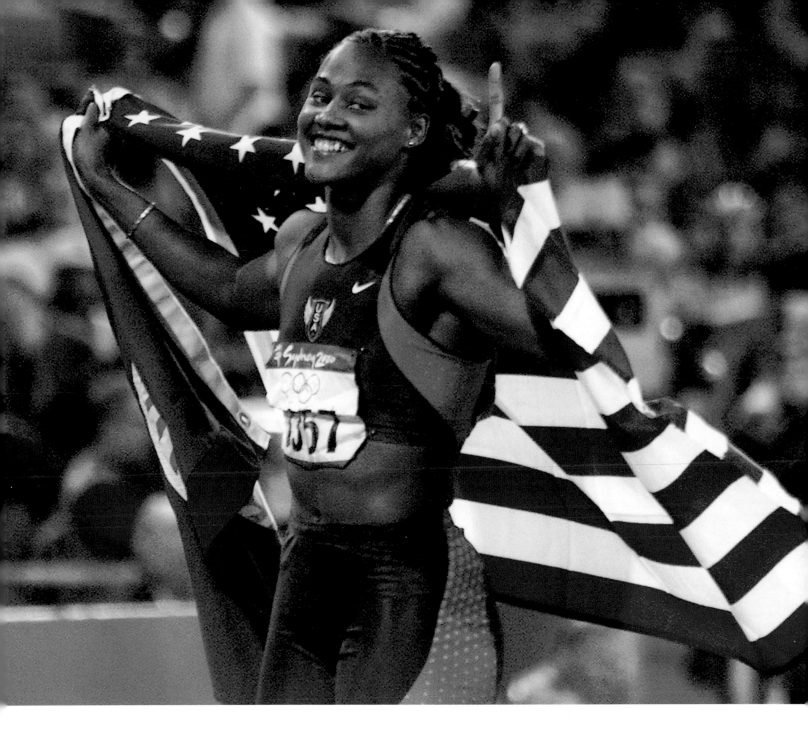

You Just Hope and Pray

Carole Yamaguchi

The first time Kristi saw figure skating, she fell in love. She was four. We were shopping one Saturday morning at our local mall, and there was a skating rink and a recital was going on. For something like a dollar we bought a ticket and watched. She said, "I like that. I want to do that." She was my middle child, and I was very busy. I said to her, "Why don't you wait. You're just starting kindergarten and you have to learn how to read." When she was six she said, "I can read now. Remember, you promised to take me skating." I don't know if it was the lights or the costumes, but there was something magical about it for her. Neither my husband nor I knew anything about skating. Fourteen years later, 1992, we were sitting in Albertville, France, watching her skate in the finals of the Olympics.

I wasn't able to buy a seat with my husband and our other daughter, but I didn't mind sitting alone because I get so nervous. When Kristi competes, I don't see the total picture. I'm so concentrated on what she's doing technically that I have a really hard time hearing the music or seeing anything other than what she's physically doing on the ice. It's nervousness, I guess, but the technique is just so important.

It was hard for me to watch the twenty-five skaters who went before Kristi. She was in the last group of five to skate, and she was the first of the five to perform. The anticipation had been building all night. She skated to *Malagueña,* Spanish music that gives her a strong look. Kristi did seven triple jumps, but she made a mistake on one of them in the middle of her program. She put her hand down on the ice coming out of a triple loop. Kristi

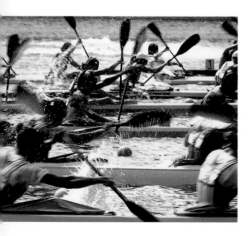

Five-Hundred-Meter Kayak Race
Lake Lanier, Georgia
Ruth Fremson, AP/Wide World Photos, 1996

said afterward she was so into her skating that she didn't realize she was going down until she heard the audience go "Ohhhh." Skaters' bodies are so well trained for their programs they just go into automatic pilot because they've done it over and over and over again. She told me she said to herself, "Wake up! You're competing!" My first reaction was, "Gee, you see her over and over in practice do that jump well. She skated so beautifully to that point and then she gave it away."

Then the other four skated. I was familiar with the skaters from the different countries because I had seen them at all the major competitions. I knew their programs. Kristi was in the lead, and of course I wanted her to win, but I never like to see other skaters make so many mistakes that they take themselves out of the running. You want to see everyone perform good, strong programs. Midori Ito of Japan missed her triple Axel on her first attempt. The French girl was the last skater and she didn't do well at all. I felt sorry for her—so much pressure skating in her own country.

When Kristi won the gold medal, I was in disbelief, just taken aback. You always see the Olympics on television, and here we were. I thought Kristi would do well because she was the world champion the year before, but in figure skating you just never know. It's a subjective sport. They're not racing against a clock. There's no control over what anyone else does. You just hope and pray that your skater can produce the program they've trained for.

So when it was over and Kristi had won, my immediate thought was to get to my family, and I had to fight through the crowds. There was so much excitement. The building was just so full of energy. Strangers handed us American flags. An American hadn't won the ladies' gold since Dorothy Hamill in 1976.

When things calmed down, and the flags were raised during the awards ceremony, the whole family broke down. My husband was overwhelmed. He never cries in public, but he was crying because he was so proud of what Kristi had accomplished for herself. We never told her she couldn't go to football games or any of the other high school activities kids do. She's the one who made herself go to bed early so she could wake up early to go to training. To see our child go beyond her goals made us overjoyed for her. We were just so happy to be there and share that moment with her.

It was really emotional for me because I was proud, but I was sad, too, because my father wasn't with us. He had passed away in 1989, and I flashed back to all the times he came to Kristi's competitions, cheering rambunctiously. He wanted everyone to know she was his granddaughter. He took a lot of pride in the fact that she was American-Japanese and she was being recognized. For him, that was very special and represented our heritage as Americans. He'd been born in San Diego and he served in World War II, fighting in Germany, while his wife and family were in a Colorado internment camp. Then he experienced a lot of discrimination after the war. He was very eager for us to assimilate. He didn't give his kids Japanese middle names, which is a custom. He just wanted to blend in.

Kristi won the gold medal fifty years after the war. He would have been so proud.

Carole Yamaguchi's daughter Kristi won the gold medal in figure skating at the 1992 Olympics in Albertville, France.

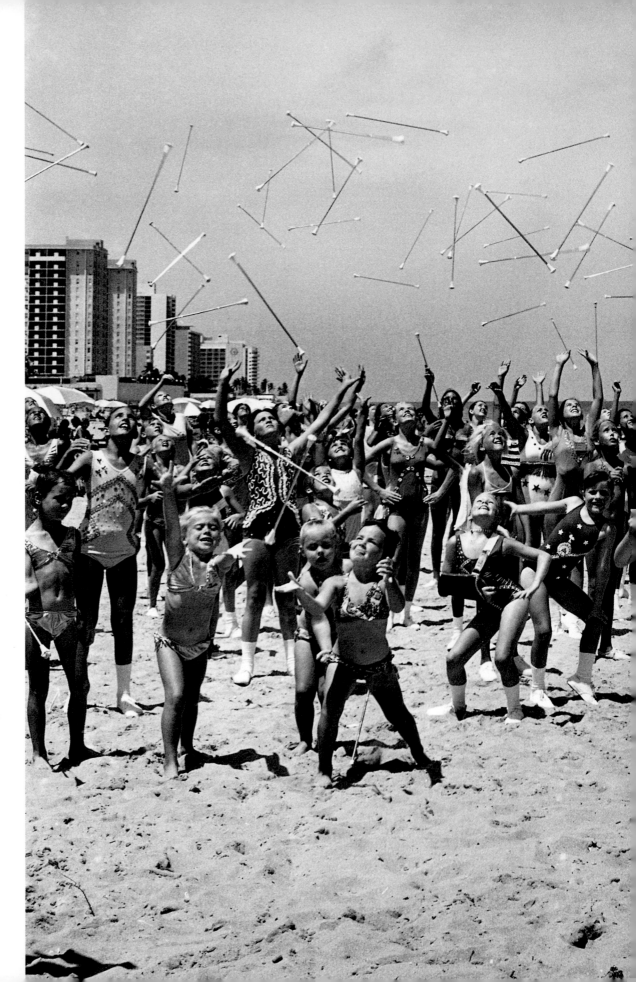

Batons Away!
Miami Beach, Florida
Photographer unknown,
AP/Wide World Photos,
1976

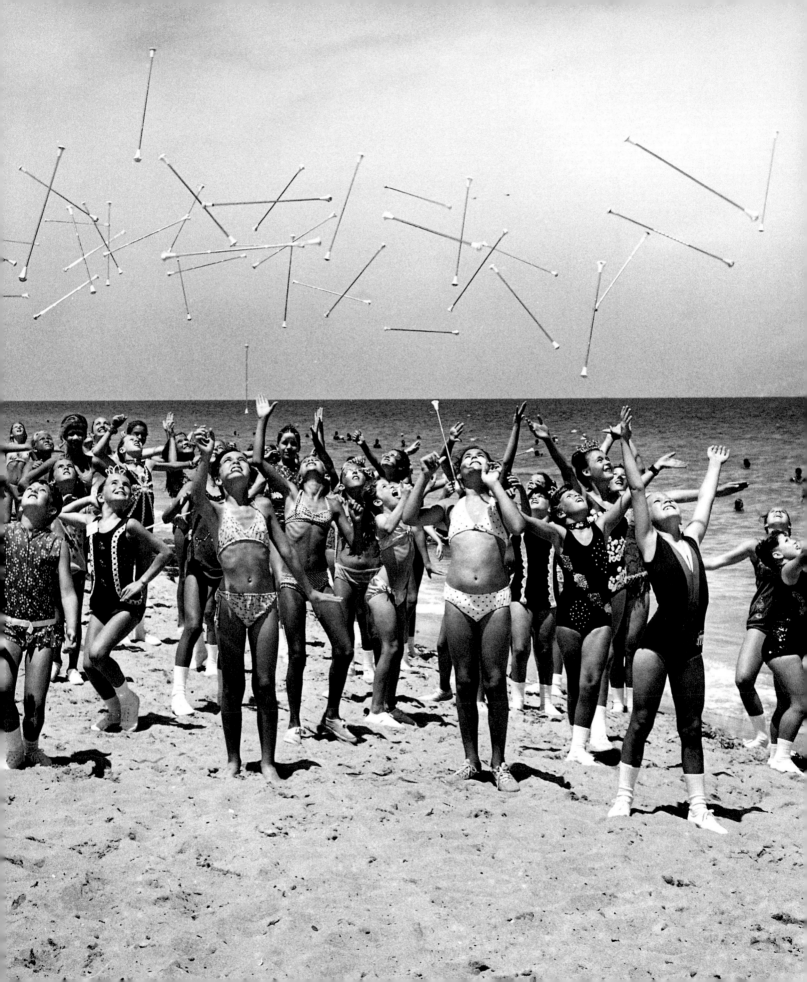

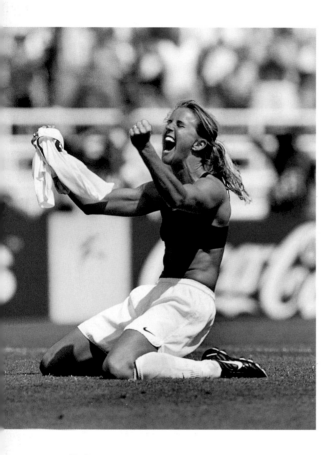

Yes!

Pasadena, California
Anacleto Rapping, Los Angeles Times, *1999*

Brandi Chastain played on the U.S. national
team that won the World Cup in 1991 and
1999 and the Olympic gold medal in 1996.

"If you've ever been given the opportunity to
satisfy a goal you've had your whole life, this is
the reaction you get. It's from deep down in
your soul." –Brandi Chastain

We're Champions!

Norfolk, Virginia
Lui Kit Wong, 1990

Finish

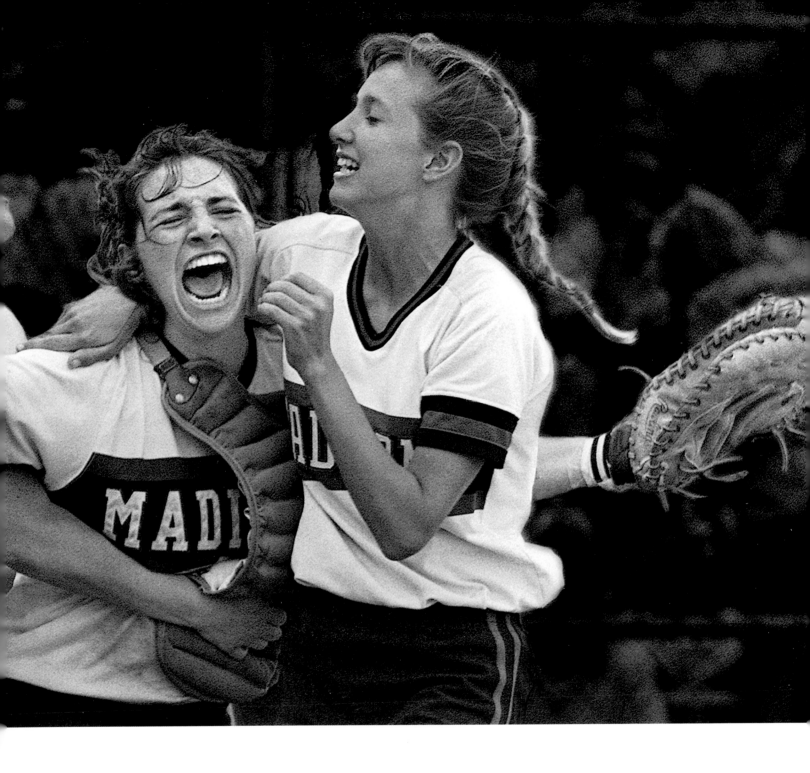

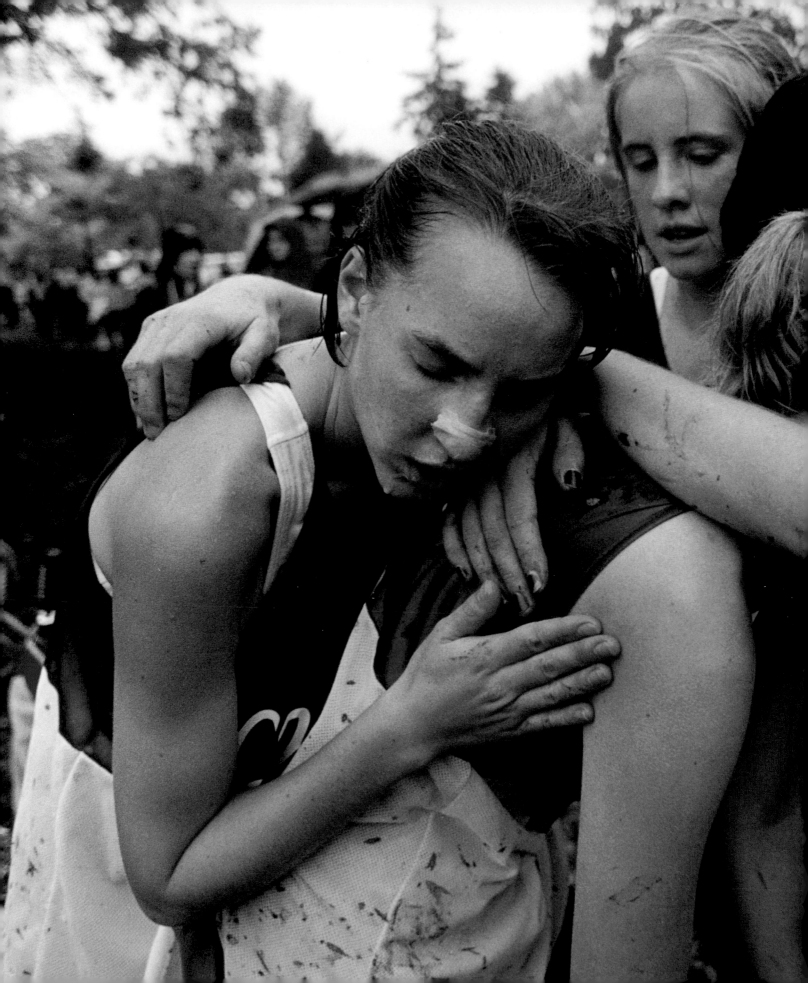

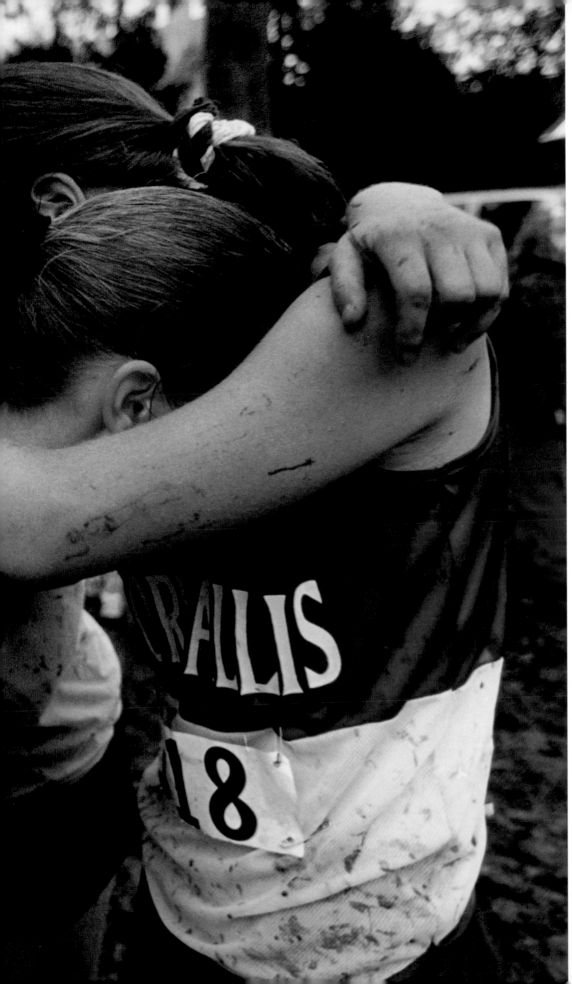

**Corvallis High School Runners,
Valley League Championships**
Salem, Oregon
Cheryl Hatch, 1995

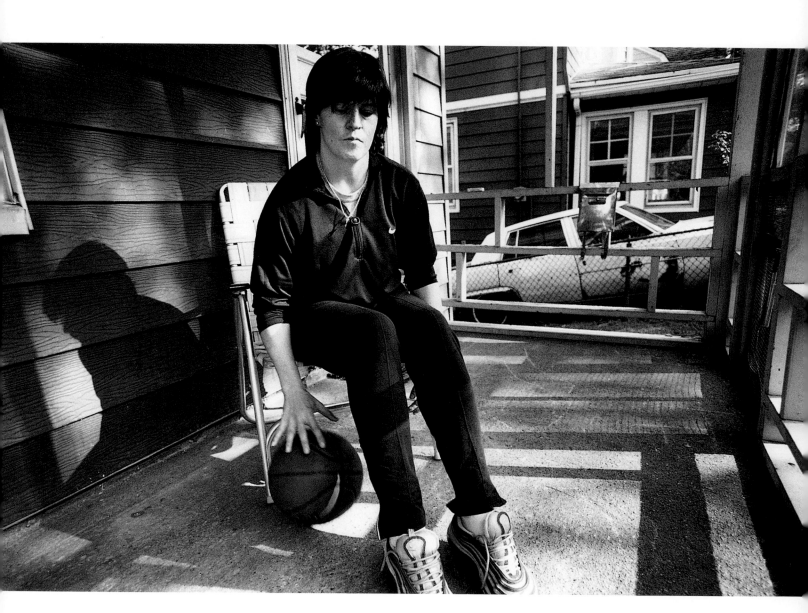

Applauded only by the mosquitoes and the crickets, she would

take the ball and pound it on the asphalt and set up and shoot.

Despite the noise from the bugs and the drone of traffic on

Route 116, she heard nothing except the thud of the ball and

the pulsing inside her chest, the steady beat of pride and ex-

haustion, the old brag of the athlete's heart. —Madeleine Blais

Sheila Tighe, Starting Over
Staten Island, New York
Lynn Johnson, 1998

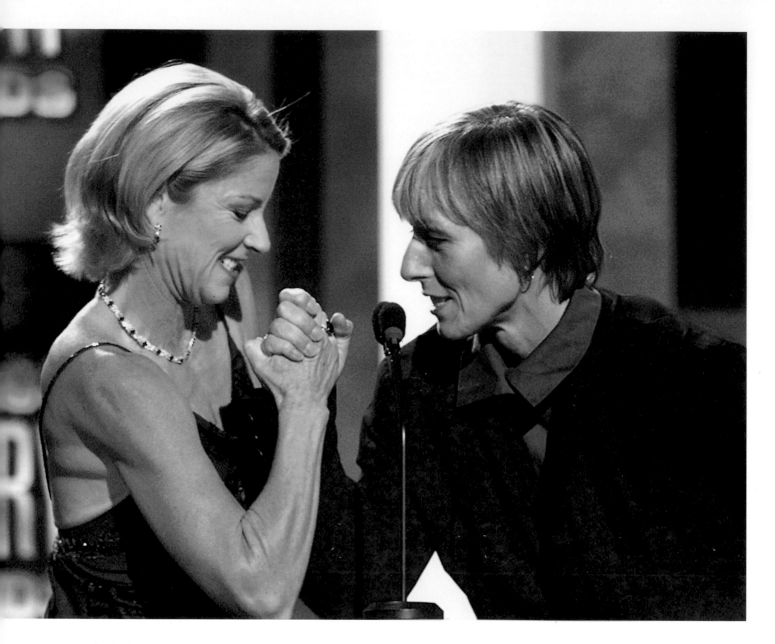

**Tennis Rivals Chris Evert, left, and
Martina Navratilova at the *Sports Illustrated*
20th Century Sports Awards**
New York, New York
Mark Lennihan, AP/Wide World Photos, 1999

Between 1973 and 1988, Martina Navratilova
and Chris Evert played against each other
eighty times, with Navratilova winning forty-
three times to Evert's thirty-seven. They each
hold eighteen Grand Slam singles titles.

"We were comparing our record and then we
started saying things like, 'You want to go out-
side and settle this?' We decided to arm wres-
tle instead." –Chris Evert

"I should have worn my tank top."
–Martina Navratilova.

Aftermath

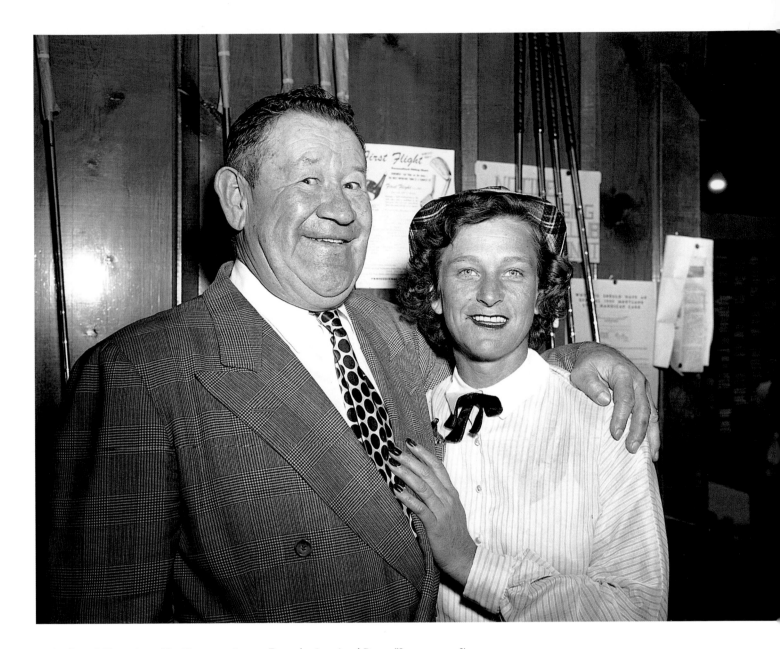

A Meeting of Champions, Jim Thorpe and Babe Didrikson Zaharias

Washington, D.C.
Photographer unknown,
AP/Wide World Photos, 1950

From the Associated Press— "June 4, 1950: Jim Thorpe puts an arm around the shoulders of Babe Didrikson Zaharias as they meet in Washington during the fourth annual Celebrity Golf Tourney. They were chosen last winter by the Associated Press Poll as the top male and female athletes of the first half of the century."

Fans

Colorado Springs, Colorado
Kenneth Jarecke, 1996

Aftermath

Groupies

Sue Macy

I fell into this group that took off for the weekend and went to women's tennis matches—Boston, New York, Philadelphia, Washington. We'd crash with friends, stay in motels. We were complete groupies, but we were also like a community. Tournaments were in small arenas and we'd just go and hang out. When you went to get a soda, the players were in line in front of you. The players didn't know you were hanging out with them, but you knew you were. It was a little kooky. You're out of college, you're working in this big company, you need to break down your world so you can find out where you fit.

One of the women in our group, Maggie, was a corporate librarian and she indexed all of *womenSports* magazine for free. Billie Jean King started the magazine in 1974. It was a kind of who's-doing-what-in-women's-sports magazine that focused on coverage for fans. It was a little activist—it encouraged you to play sports by talking about other women who played. Indexing it, Maggie made some contacts in women's sports, and we all got a kind of entrée into that world. We weren't insiders exactly, but we felt close. The movers and shakers of women's sports felt immediate and accessible. The scale of things was much smaller than it is today.

At matches, you sat close enough to really focus on the player, and you could analyze their psychological makeup. You could see when they were going to screw up and why. You knew that Evonne Goolagong was an incredibly wonderful athlete, but she had these walkabouts where she would just lose her concentration. You knew that nothing could psych-out Chris Evert, but Wendy Turnbull, who was a terrific serve-and-volley player, sometimes just couldn't close out a match. Martina Navratilova was so unashamed of her strengths. Billie Jean King was very intense— and a bit of a loose cannon. She would yell at herself all the time when she played. One time she screamed out "Chopped liver!" I think she was trying to call herself a chicken, like chopped chicken liver. You never knew what to expect with her, but I loved that she was aggressive and played a serve-and-volley game.

Jackie Joyner-Kersee
St. Louis, Missouri
Lee Friedlander, 1997

One year at the U.S. Open, on a Saturday, Wendy Turnbull played like a hundred games of tennis in about five different matches—singles, doubles, and mixed doubles. She wasn't so good at singles but she was a great doubles player, and I loved watching doubles because the teamwork was something I never had. We watched all one hundred and four games, from eleven in the morning until eight at night. It was incredible for us. The experience is imprinted on me to this day. And I can tell you Martina's score in any match from '78 and '79. I have all the programs. She was the embodiment of "the athlete," and athletes had something I needed or wanted.

Becoming a tennis groupie had less to do with who the players really were, than with what they were doing in public. My little brother got to play Little League even though he threw up before every single game. He was kind of frail. I was just sitting there dying, wishing I could play. In my day . . . a girl growing up, you had to conform. Like I would go out with a guy and I would think, "How would my name look with his?" It was the sixties and that's how you were supposed to think. I hated that. I needed some other kind of role model, people who showed their strength.

Sue Macy was voted Best Athlete at summer camp in 1970, which before Title IX was the most many girls could achieve. She writes books about pioneering women athletes, including Winning Ways *and* A Whole New Ball Game.

To the Victor (Tonya Harding)
Minneapolis, Minnesota
Larry Salzman, AP/Wide World Photos, 1991

Karate Tournament
Staten Island, New York
Arlene Gottfried, 1978

Aftermath

Winners, Second Place
Philadelphia,
Pennsylvania
Norman Y. Lono, 1982

6–2, 6–0
Brooklyn, New York
Catherine Cobb, 2000

Aftermath

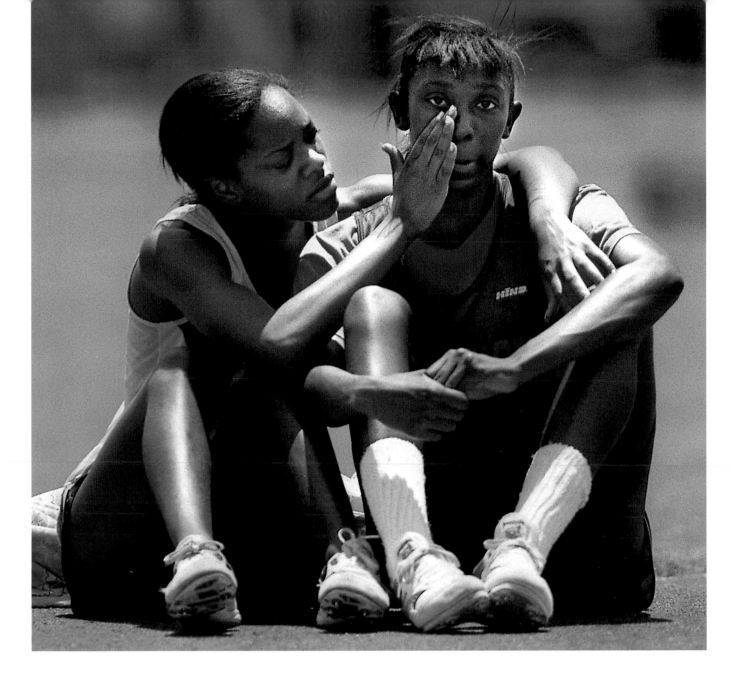

Winner Comforts Loser
Memphis, Tennessee
Steven G. Smith, The Commercial Appeal,
1996

All My Tears
Went into the Water

Susan Casey

When I was really young, every time I walked by a pool I would be mesmerized, hypnotized by it. Especially if it was dark and the pool was lit up. I would always want to jump in. We had a cottage near a lake, and there were crayfish on the bottom and you could see them. The crayfish were like unicorns to me, they were so mysterious. The water was haunting and sort of mythical. I was simultaneously terrified and fascinated by the water.

I have two brothers, but I was the one being forced to take piano lessons, and I just hated them. My mother had decided that I was going to be the pianist. I had absolutely no interest in music. Instead, one day I came home and announced that I was going to join the swim club. I didn't even know what a swim club was, but the girl who lived up the street had joined a swim club. I honestly could not swim. But I showed up at the workout and I watched her swim. I was eight, and I decided right then and there that I was going to master this.

I was small. I was always small for my age. The club would put you in what they called a development group. They would give you all the basics and then you would move up to the slow group. Most people stayed in the Development Group for two weeks. I was in there for a year! And the guy who taught kept saying, "I can't believe you're coming back! Why do you keep coming back?" He was such a sadist. Because we got to train only once a week, I

Mad Dash
Rhinebeck, New York
Ken Bizzigotti, 1987

Aftermath

would go home and swim on my bed! And I was certain it was really helping. I was absolutely obsessed with it.

Meanwhile, my mother would not let me stop taking piano. When I started training two times a day, I would come home from the night workout and sit in the basement with the piano. The piano teacher would go, "Did you practice?" and I'd go, "Nope!" And he would sit there and play for twenty-five minutes. My mother would think it was me, and he would leave.

I never went to a single dance in high school. I don't even remember high school, except that people used to laugh at me because my hair was always wet. When it dried, it was really white and broken off. My eyes were very red. I must have reeked of chlorine, and I was so proud of that.

I'm a much better competitor now at thirty-four than I was at fourteen. I was stressed out because, at the time, making a team, not making a team . . . it was social. It was like all your friends are on the team and you don't want to be this loser who's not. At one point I was dropped off a relay at Nationals. All of my friends were on the relay, and it was going to do really well, and I was dropped off. I had to swim off for the last spot with this girl, and I actually beat her, but the coach decided she was on the relay instead of me. The way I wrote about it in my journal, you would have thought my life had ended. There is so much happening at that age. You confuse having a bad season with not being a worthy person. Now I get on the blocks and it doesn't matter how I do.

The flip side is that I'm never going to make it to the Olympics. I just can't get used to thinking that I'm not going to go in this lifetime. I just never had what it took. I'm not used to thinking that there is something you can't have even if you work hard. Still, to me, sports is justice. Particularly in swimming, because it's nonjudged. It's totally objective. It's who's at the end of the pool first, and if you're going to work hard, you're going to do well. There is this very simple cause-and-effect relationship. To me, that's justice. What's not justice is the least worthy people in society getting the most power. Or people who have climbed over other people to get to the top. Or the people who feel like they're owed something. There's so much injustice . . . maybe injustice is the wrong word, but there's so much that doesn't make sense, that doesn't have that same simple cause-and-effect relationship.

My grandmother was a swimmer too. She tried to commit suicide twice by swimming out into Lake Erie. The first time, she was rescued by a fishing boat. The second time, my grandfather figured out what was going on and went out and got her. She was something like two thousand yards out into the lake, swimming straight. When she died years later, it was the first time anyone I loved had died. I had this total compulsion to go swimming when I heard the news. I just cried into the water. All my tears went into the water.

I can't live without swimming. The water takes something out of you. I put stress, anxiety, tension into the water. The water takes it. I've had a dream a few times that I was swimming through the air. I felt it very, very, very, very viscerally. And I have this fantasy that every place is like Venice, and all the streets have water. Instead of walking from place to place, you have to swim. I've always thought that would be the best thing.

Susan Casey is an editor at large for Time Inc. *and was formerly creative director of* Outside *magazine. She has been swimming competitively for twenty-seven consecutive years.*

Women's World Series of Golf
Springfield, Ohio
Walter Iooss, Jr., Sports Illustrated, *1966*

With eighty-two victories, Mickey Wright ranks second in all-time career LPGA wins. In 1999, she was named Female Golfer of the Century by the Associated Press. In 2000, the largest winner's purse in women's golf was $500,000. The largest winner's purse in men's golf was $1,080,000.

"The money that's out there today, it boggles my mind. This $10,000 check was big stuff in 1966. It was the biggest first-prize check that had ever been put up for women's golf. Before that we'd make $2,000 to $2,500, if that, for winning a tournament." –Mickey Wright

Aftermath

Serena! Serena!

Flushing Meadows, New York
Chang W. Lee, The New York Times, *1999*

At the 1999 U.S. Open, Serena Williams
became the first African-American woman in
forty-one years to win a Grand Slam tennis
tournament.

"It was an accomplishment not just for me
but for everyone. I was told that people were
actually crying." —Serena Williams

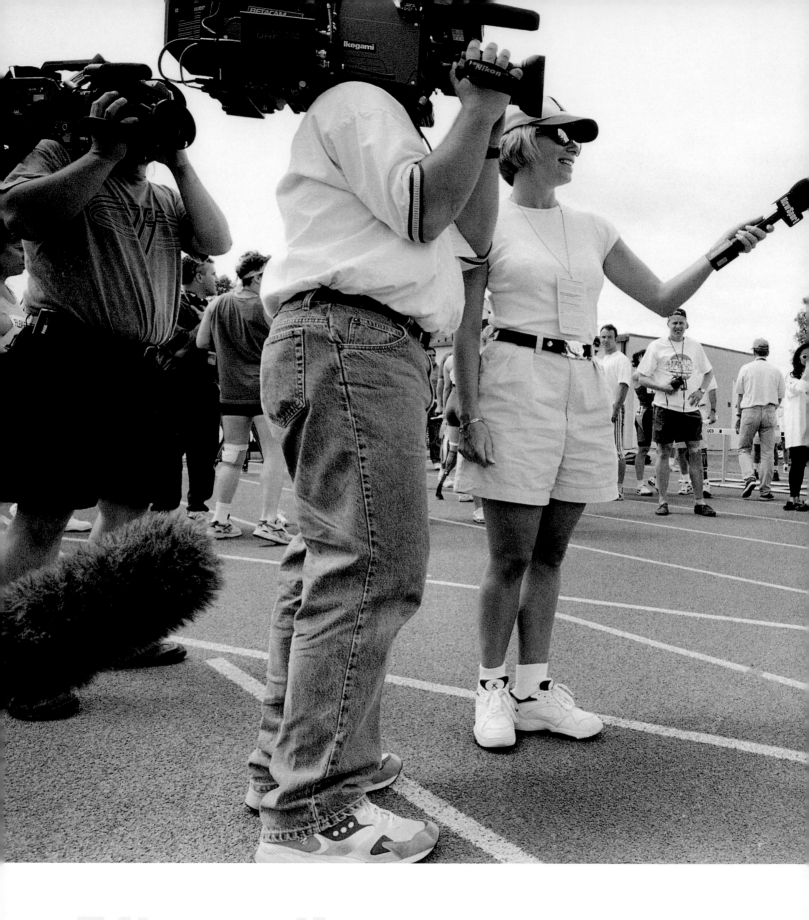

Aftermath

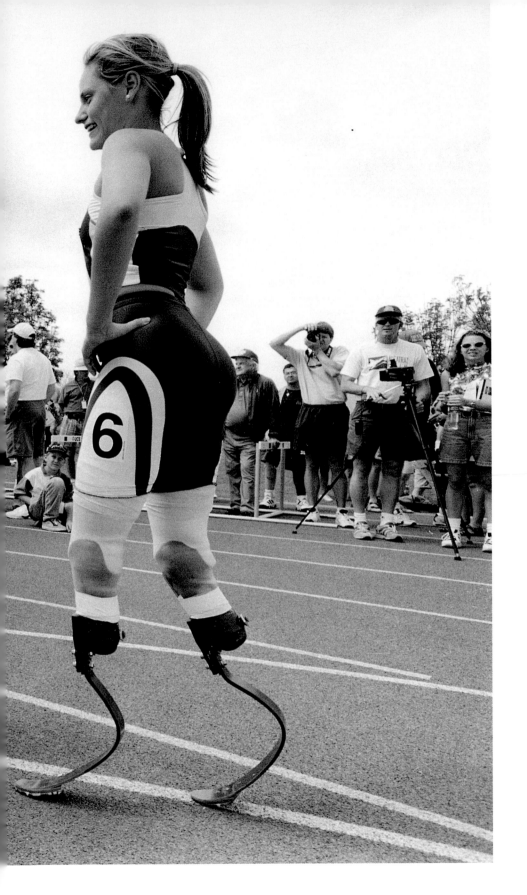

Aimee Mullins

San Diego, California
Lynn Johnson, 1997

Aimee Mullins competed in NCAA Division I track at Georgetown University and set Paralympic records in 1996 in Atlanta in the 100-meter dash and the long jump.

"The functioning human body is beautiful."
–Aimee Mullins

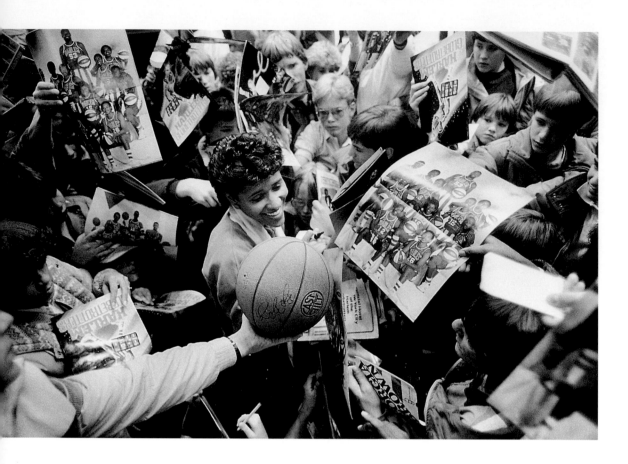

Globetrotter Faithful Welcome Woodard
Fort Collins, Colorado
Judy Griesedieck, 1985

Lynette Woodard, a four-time All-American at
the University of Kansas, was captain of the
gold medal–winning 1984 Olympic team. In
1985, she became the first woman to play for
the Harlem Globetrotters. In 1997 and 1998, she
played in the WNBA.

"As an athlete, I am relentless energy."
–Lynette Woodard

Golden Gate Victory
San Francisco, California
Victoria Sheridan, 1989

Aftermath

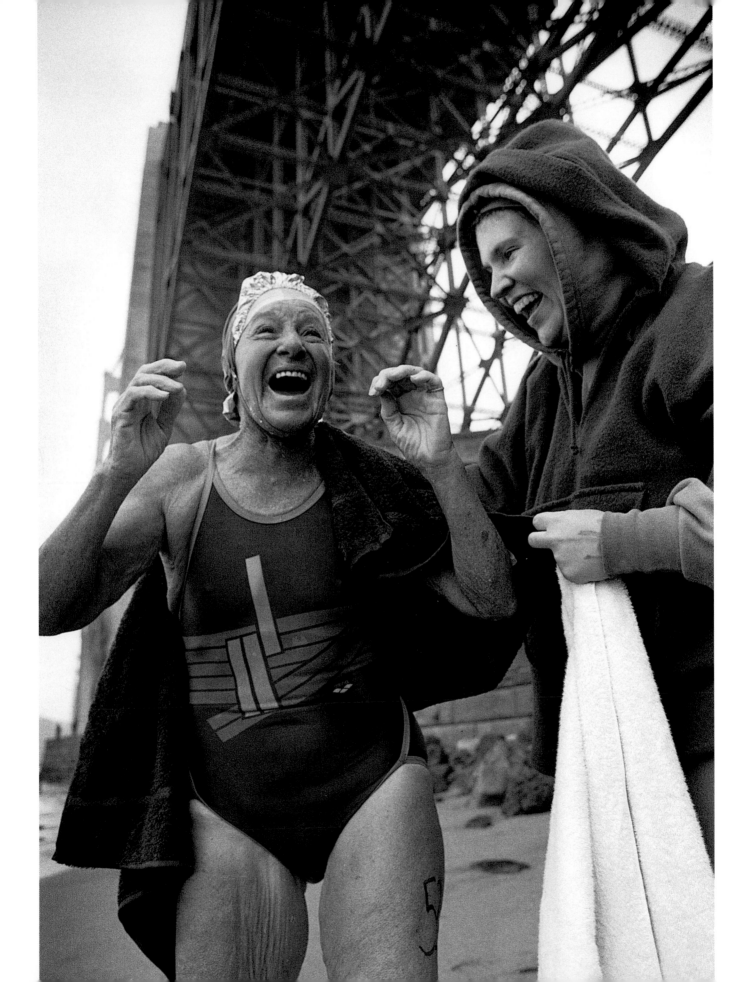

12pt Buck
Virginia
Justine Kurland, 2000

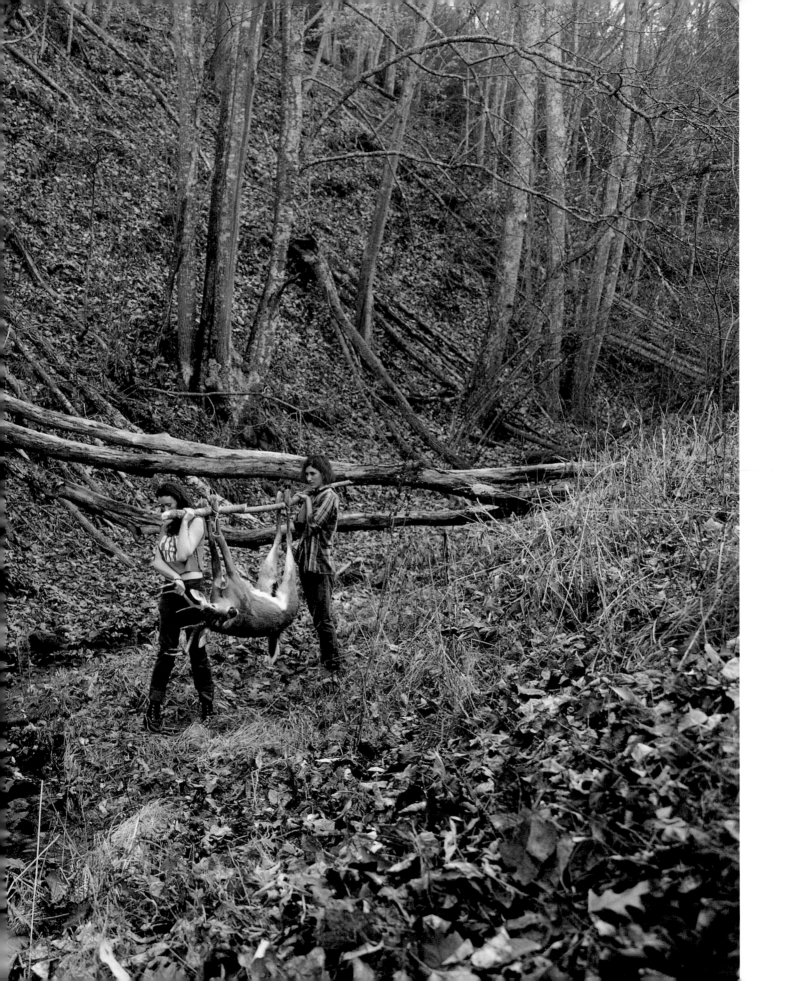

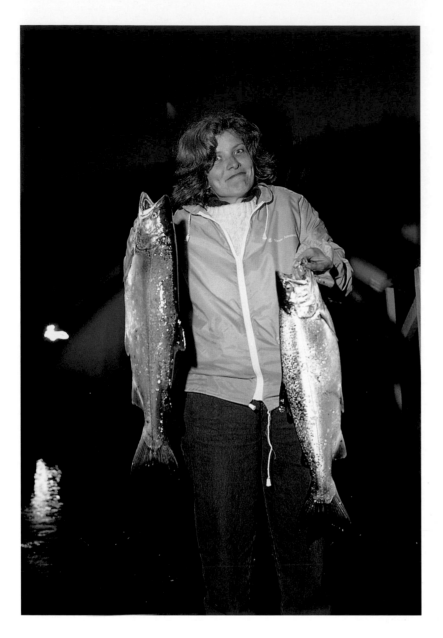

Two Salmon
Newport, Oregon
Jeff Jacobson, 1982

Olympic Champion Wyomia Tyus
Los Angeles, California
Brian Lanker, 1988

Aftermath

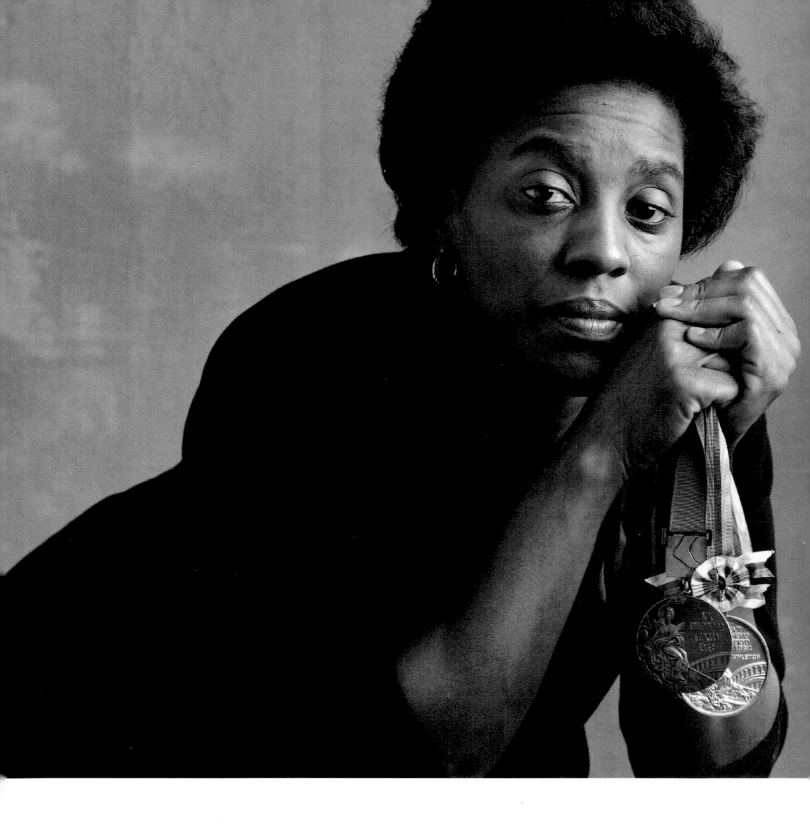

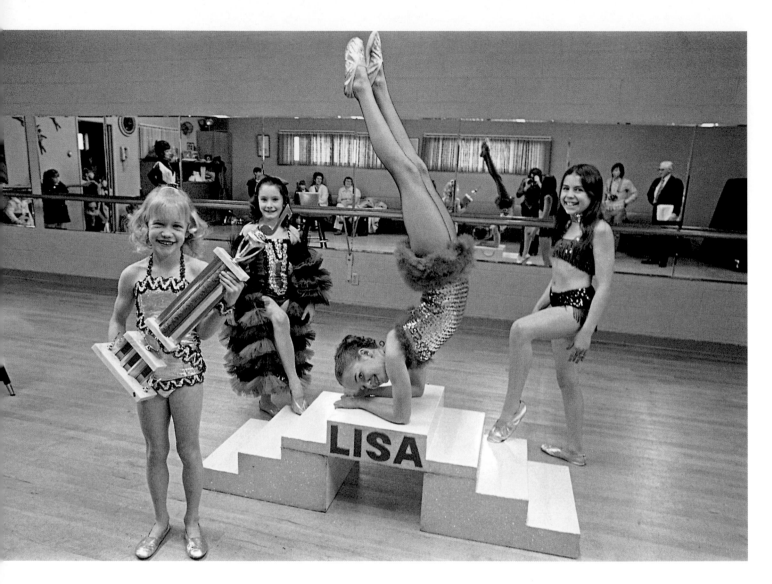

Dance Competition Winners
Livermore, California
Bill Owens, 1970s

Aftermath

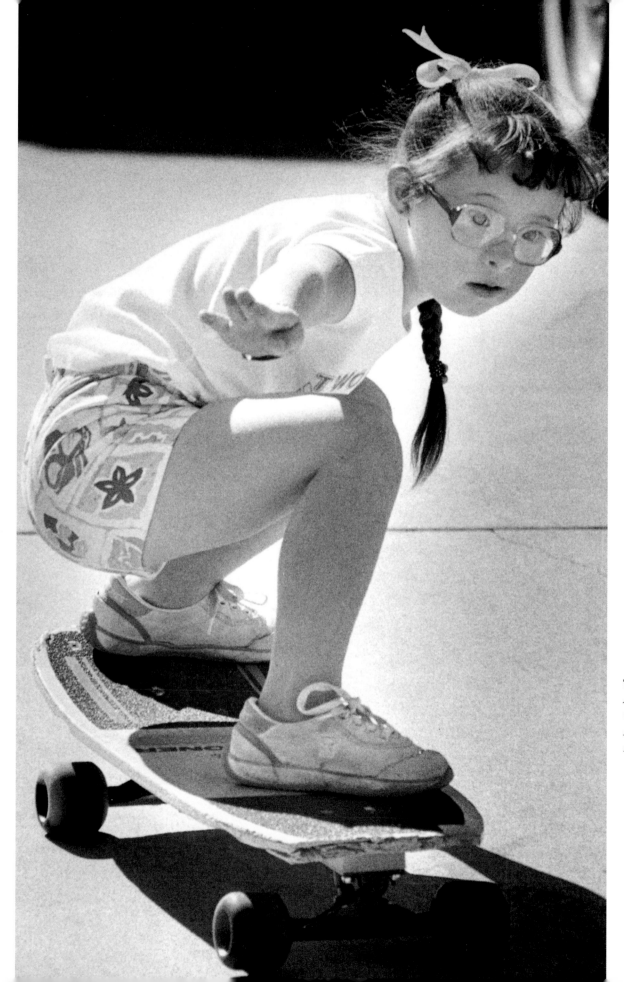

Tomboy
Antioch,
California
Meri Simon,
1987

All That Intensity

Jamila Wideman

Twelve-Year-Old Catcher
Paterson, New Jersey
Lisa Kyle,
North Jersey Herald and News, *1998*

I love the game. It's fun to play, period. I love running around and getting sweaty. I love trying to lead my team. I love facing the challenge of another team that's better. How are we going to win? It's like a chess match. As mental as it is, I love pushing my body to the limits and realizing I don't have any limits. I love being in a team situation where you go through a whole lifetime with people in the course of a game. You find a way to get on together. You're not best friends with everybody, but you find a way to have a working relationship. Those are lessons I haven't learned anywhere else in my life.

Winning, losing . . . there's no greater joy, but there's no greater pain, either. In a way, there's not quite a difference between the two. What makes it so special is the depth with which you feel. When you talk about an injury and the kind of depression you go through, it's not just because you're out of shape and you can't go out and play. You're missing a part of you. That's what's painful. That's what hurts. You live for that high and you live for that low because it just feels good to feel something that deeply. I think it only comes from choosing to invest your whole self into something, whatever it may be. For me, it's basketball.

The game has always been about expressing who I am, what's inside of me, what drives me. You sit and watch a game, you watch me play, you walk away and you know a little bit about me, without ever having spoken to me, said a word, had any kind of

contact except sitting there and watching me play. It's truly a way to dialogue with people, because I don't share myself, my feelings, my emotions in an open way. Playing became the outlet where I could do that. I could focus my energy and attention and pour all that intensity somewhere. I think everybody needs a place to express. Women don't always think of sports as being that place. I did because basketball was a family game, we all played together, games were always on TV, sports magazines were always around. It surrounded me, so I knew it was an option, but I don't think that's the case for a lot of girls.

And girls aren't less coordinated. Coordination has a lot to do with experience. If you grow up with a ball in your hands, you're going to have a feel for it. Some are better endowed than others, but everybody has the ability to be coordinated. I'm left-handed and I was not coordinated the first time I tried to shoot a right-handed layup. I was completely off, and it felt awful. A year later, I could do it. Does that mean I was uncoordinated? No, it means I was coordinated and I needed to coordinate in a different direction.

I played on an all-boys team till seventh grade because there was no girls team. That was not very cool at the time. I mean, I had girls who wouldn't talk to me because of it. I had guys who called me names, would never pass me the ball, just made it absolutely miserable to be out there. I had adults who would say to me, "You know, you should really find something more appropriate for girls to do." This is somebody attacking my passion, my love, and they're telling me I shouldn't continue? What are they, crazy? But it's hard as an eight-year-old kid to hold tight to that dream.

All my life, basketball was going to end the day I played my last college game. It didn't. Do I have a responsibility to those who struggled before me? It's so obvious. For some, it's empowering to say "I don't want to be seen as a woman athlete. I just want to be an athlete." But that's not what I personally feel, because society forces you to evaluate who you are and what role athletics plays in your life in a way that male athletes don't have to. Out of that

understanding I gained an appreciation of what it means to play. I want to take full advantage of the opportunity I have. There is no taking for granted that women can play ball professionally.

There's still such a taboo. You think that we've come so far and attitudes have changed, but I guarantee that in three out of four interviews I give I get asked, "How can you still be feminine if you're an athlete?" What does it mean to be feminine? Does it mean I go to the locker room and change into my prom dress after a game? One interviewer wanted me to say that after a game I get dressed up in a skirt. I said to him, "Personally, I wouldn't do that." He said, "Well, don't you want to show people you're a woman?" I thought, OK, so now we're equating my wearing a skirt with me really being a woman? You know, there's something very limiting about that image to me.

We're at a stage where we're beginning to understand and accept women's athletic participation. What's lagging behind and needs to catch up is accepting women who articulate their identity through the sports they play, who say, "This is who I am. My participation, my focus, my intensity, my sacrifice for my sport. This is who I am. It's not just something I do."

After helping lead Stanford to three consecutive Final Four tournaments, 1995-1997, Jamila Wideman graduated from college the year the WNBA came into existence. She has played for the WNBA in Los Angeles, Cleveland, and Portland, Oregon.

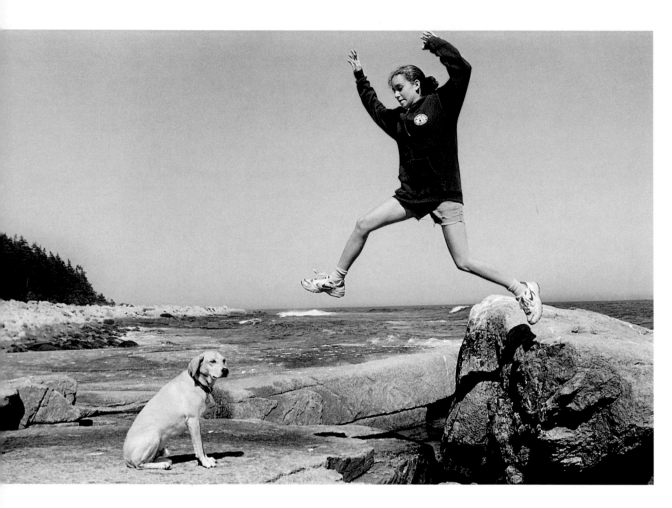

Eve Jumping

Mount Desert Island, Maine
Geoffrey Biddle, 1998

Aftermath

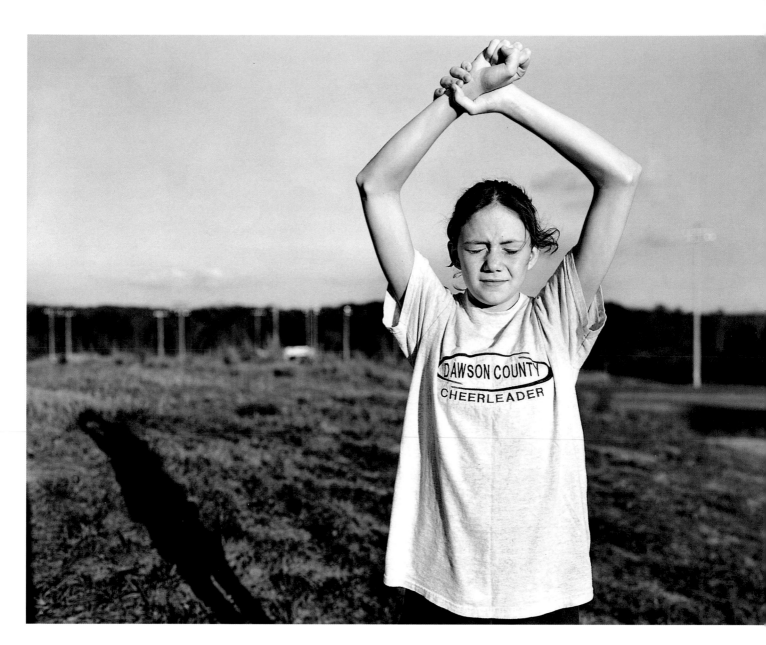

Cheerleader
Dawsonville, Georgia
Angela West, 1999

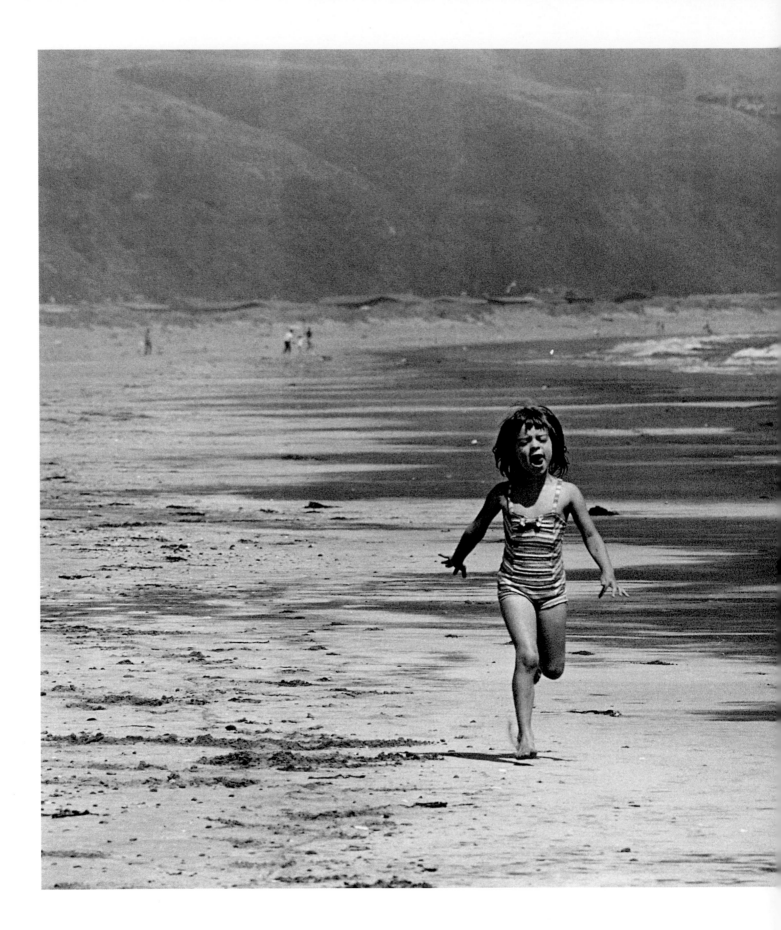

Untitled, from *To a Cabin*
(Dixons at the Beach)
Steep Ravine, California
Dorothea Lange, early 1950s

"In sports this century, women have gone from being Model T's to Ferraris." –Leslie Dixon, Dorothea Lange's granddaughter

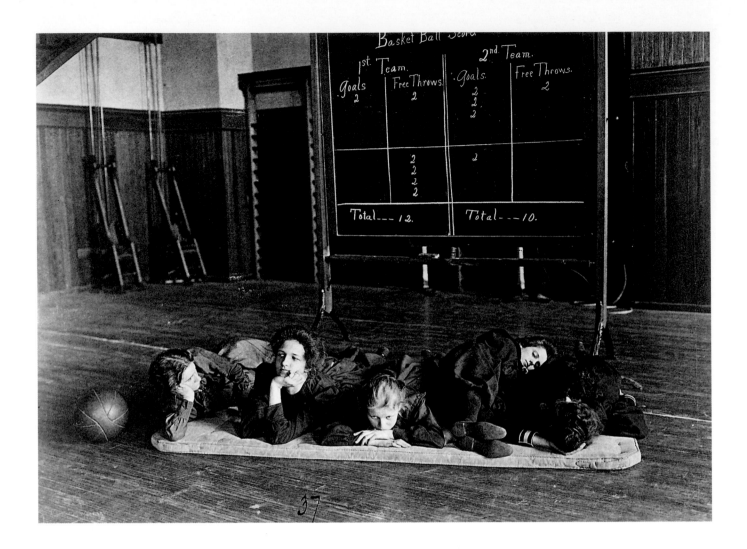

Western High School

Washington, D.C.

Frances Benjamin Johnston, c. 1899

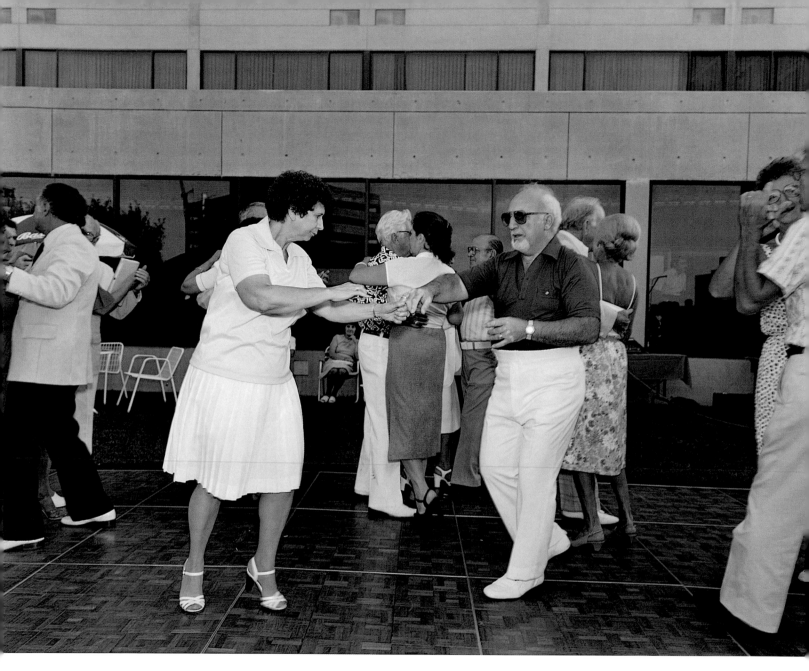

Couple Dancing

Mary Frey, 1979–83

Underwater Nymph
Louisville, Kentucky
Melissa Farlow, Courier Journal and
Louisville Times, *1979*

Nancy with Fins
San Francisco, California
Cristiana Ceppas, 1992

Aftermath

Veteran Bowler
Salina, Kansas
Photographer unknown, courtesy AP/Wide
World Photos, 1971

Eleven-Year-Old Vanessa Noble
with Her 9mm Ruger P89
Laguna Niguel, California
Nancy Floyd, 1996

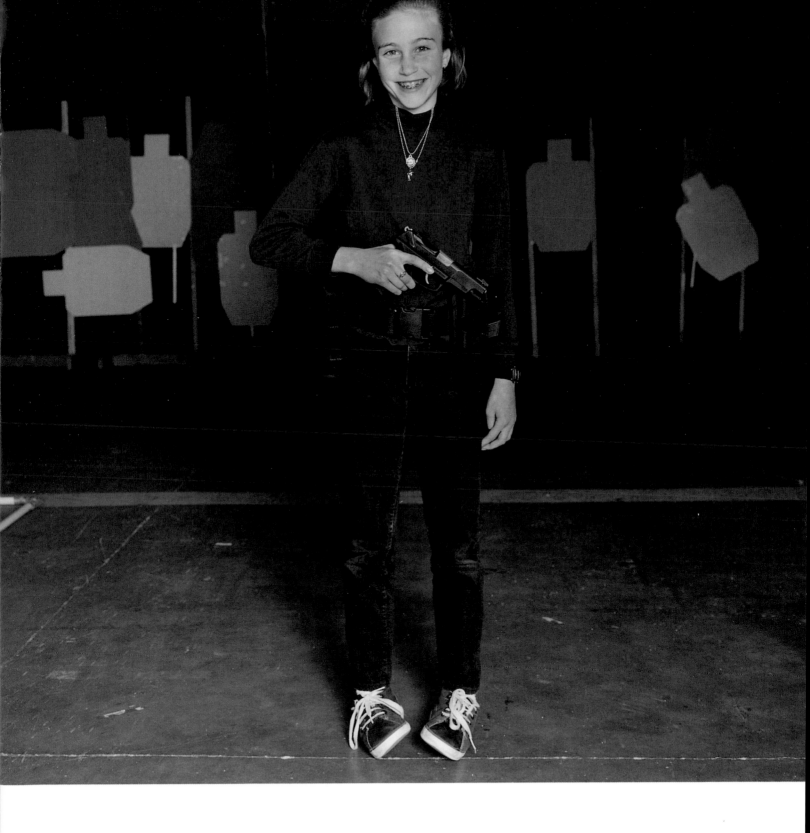

I Could No Longer
Feel My Feet, and I Was Fine

Elizabeth Glazner

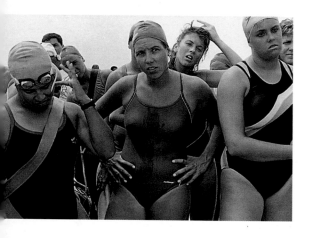

Lifeguard Contest
Coney Island, New York
Sylvia Plachy, 1986

Everyone secretly has a surfer inside of them. Riding a wave is the ultimate self-actualized position. It's a very heroic image and it's a very sexy image. Who doesn't love the idea?

A lot of women involved in surfing think of the ocean as a natural place to be. They get real ethereal about it: "It's like entering the womb." And there's the dolphin thing, the idea that genetically women love dolphins, that dolphins and women are one. All that stuff is probably a reaction to the fact that surfing was wrested away from women by marketing schemes, the promotion of surfing as the realm of shady characters in jalopies living that Moondoggie kind of life, all long hair, pot smoking, high school dropouts. It's a stereotype that had a lot of power. A lot of women didn't feel like it was their domain, and that's not true. I knew it the first time I surfed. I wasn't tossed out of the water, I was carried.

Some days, you enter the water and it spits you out, and I accept it. "OK, the water doesn't want me in her presence today." Other days, you go into the ocean and every wave is perfect, everything you do feels so right. Which doesn't mean surfing's not a very awkward experience when you start, because it is. Everything from putting the wetsuit on to learning how to deal with the surfboard, and the ocean, which is a powerful and scary element to begin with.

My first time, the water was freezing and my feet were ice cold, and my friend kept laughing, saying, "Don't worry, it'll go away." I was wincing in pain. I said, "How is it gonna go away?" and she said, "They'll turn numb and then you won't feel them and you'll be fine." The instant she said that, I could no longer feel my feet,

Aftermath

and I *was* fine. Then, lying on my board in five feet of water, I got tossed by a little wave and I fell off the back, and the board, being extremely buoyant, plunged down in the water but then shot back up. Gravity being what it is, when it came down, it hit me on the forehead, above my hairline. You know when you watch little kids and they fall down, the way they immediately look to the nearest adult to see if they're hurt, and if the adult looks scared, then they start crying, but if the adult says "You're OK..." then they get up and they're fine. That was exactly the experience I had. I looked to my friend and she said, "You're fine! Get back on." I said to myself, "I guess getting conked on the head is not supposed to be a big deal."

I paddled back out and was lying on my belly on the surfboard, facing toward shore. And my friend said, "Don't look behind you, just look at the shore." Then she said those terrifying words: "Here comes a wave." I remember being shot through with fear. And she said, "Don't worry. Just have faith and paddle, paddle, paddle."

Imagine trying to catch a moving train and you're just jumping on instead of taking a running start. Catching a wave is the same thing: You need momentum. You have to match the speed of the wave to be able to jump on. So I paddled, paddled, paddled and then suddenly I felt it pick me up. I didn't even try standing, yet I fully caught the wave and it carried me to the beach. It was over before it had begun, but it was the moment that you hear about surfers "having the stoke." You catch it like a fever.

So many times I'd sat on the shore while everyone else played in the waves. I'd say, "I just want to listen to the radio," 'cause I was afraid to get out there. So that day it was like . . . I hate to use the word *conquered,* but I really conquered something. Not the ocean, but something within me. I had matched the wave, I was part of the ocean. I immediately started plotting because I wanted to quit my job and be near the water.

At age thirty, I spent six months just learning to keep my feet under me. As a girl, I would have been really excited and happy to fall off my board, but as an adult, I couldn't let myself just go with it. More than the physical part of the challenge, it was my ego that struggled. It took me the longest time to get my body to do what my head was telling it. I'd never had that experience before. I was always one of the best female athletes, but surfing was just really hard. It was a year till it started to be second nature.

The thing with surfing is that you never really get there. There's always more to learn. Surfing depends so much on Mother Nature. You can plan to surf at eight on Saturday morning, and when you get there the wind is already up, so you're not going to get any waves. What are you going to do? Are you gonna go home and rent a movie? Or are you going to go out, paddle around, and practice duck diving, which is diving under waves? Sometimes you get in the water and there are dolphins out there. The next day the current is flowing a lot stronger and there are lots of riptides. The beach break moves around. The tide can be low or it can be high or the water can be totally flat. Last night's storm carved out the bottom, and there's a big bowl at the beach line that you have to avoid getting sucked into or risk being pummeled by backwash. There's all kinds of elements. Surfing is all of it for me. There's always something new.

Learning to ride waves at age thirty inspired Elizabeth Glazner to leave her newspaper job and launch Wahine, *a surf- and sports-lifestyle magazine for women.*

**Thoroughbred Racing's Most Successful
Female Jockey**
Monmouth Park, Oceanport, New Jersey
Susan Ragan, AP/Wide World Photos, 1987

Julie Krone is the only woman inducted into
the Horse Racing Hall of Fame. She won 3,545
races; her mounts have won more than $81 mil-
lion.

"As an athlete, I have an insurmountable
amount of desire. I'm ruthless, cocky, self-
assured, and almost always unbeatable."
–Julie Krone

Jean Sabatine, Skating Rink
Martin's Creek, Pennsylvania
Larry Fink, 1980

Aftermath

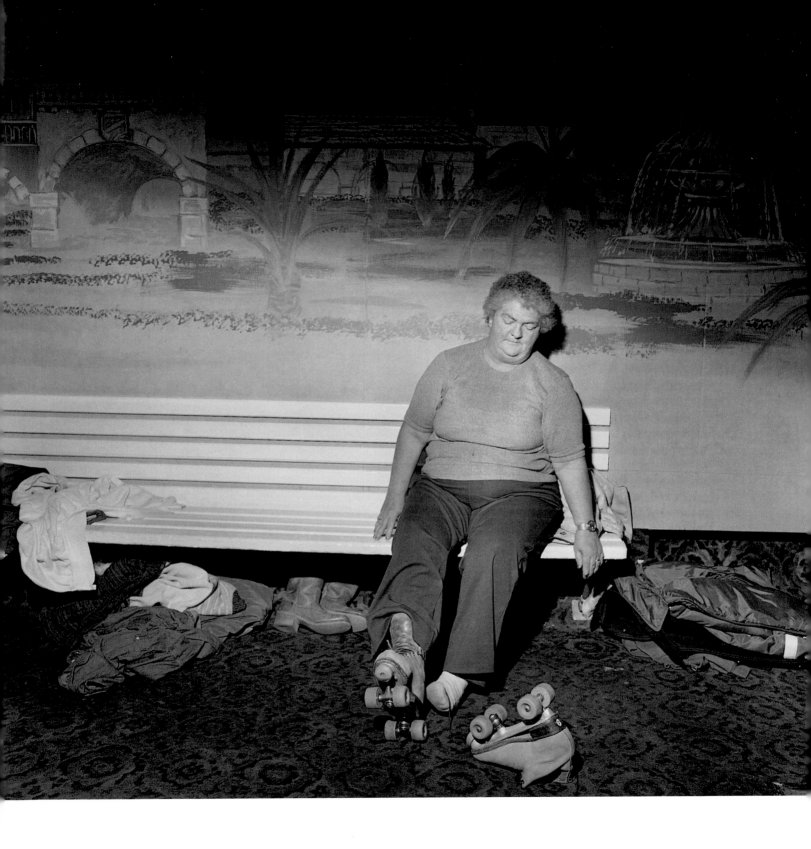

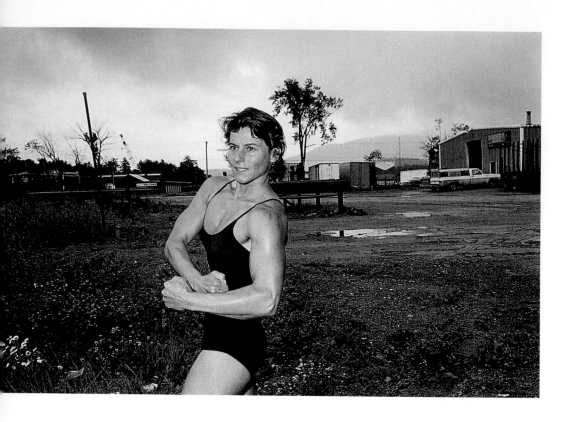

Mary Elfer, Body Builder
Morrisville, Vermont
Peter Moriarty, 1986

As a student at UCLA in the seventies, Lisa Lyon began weight training to get stronger for her practice of the Japanese martial art kendo. In 1979, she won the first Women's World Bodybuilding Championships. An activist for the fledgling sport, she served in 1980 as the first chair of the Women's Physique Association of the Amateur Athletic Union and in 1981 wrote *Lisa Lyon's Body Magic*.

"A mirror is not an objective witness." –Lisa Lyon

Aftermath

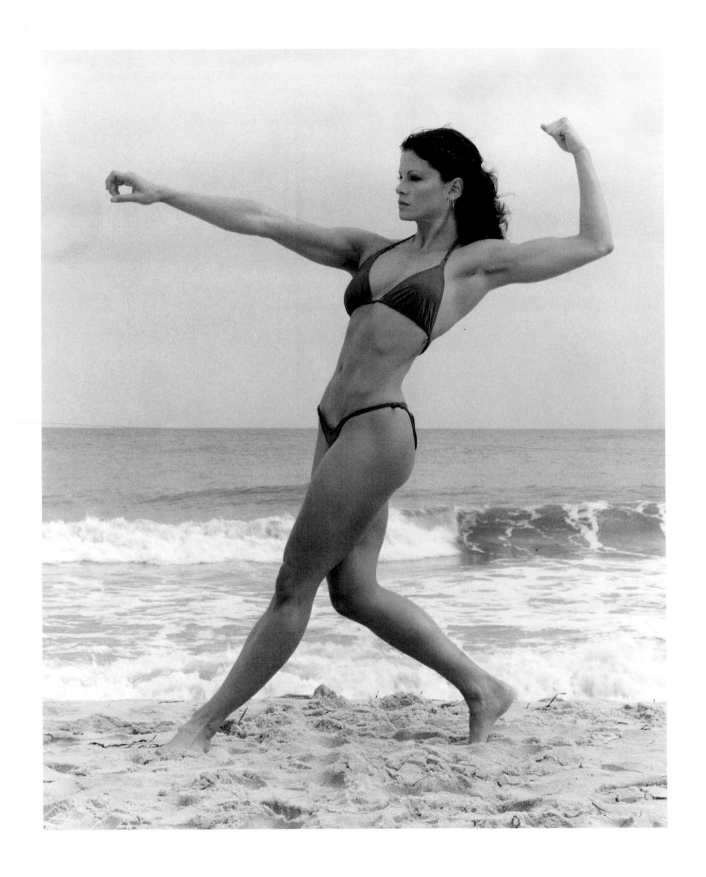

Girl on Swing, Pitt Street
New York, New York
Walter Rosenblum, 1938

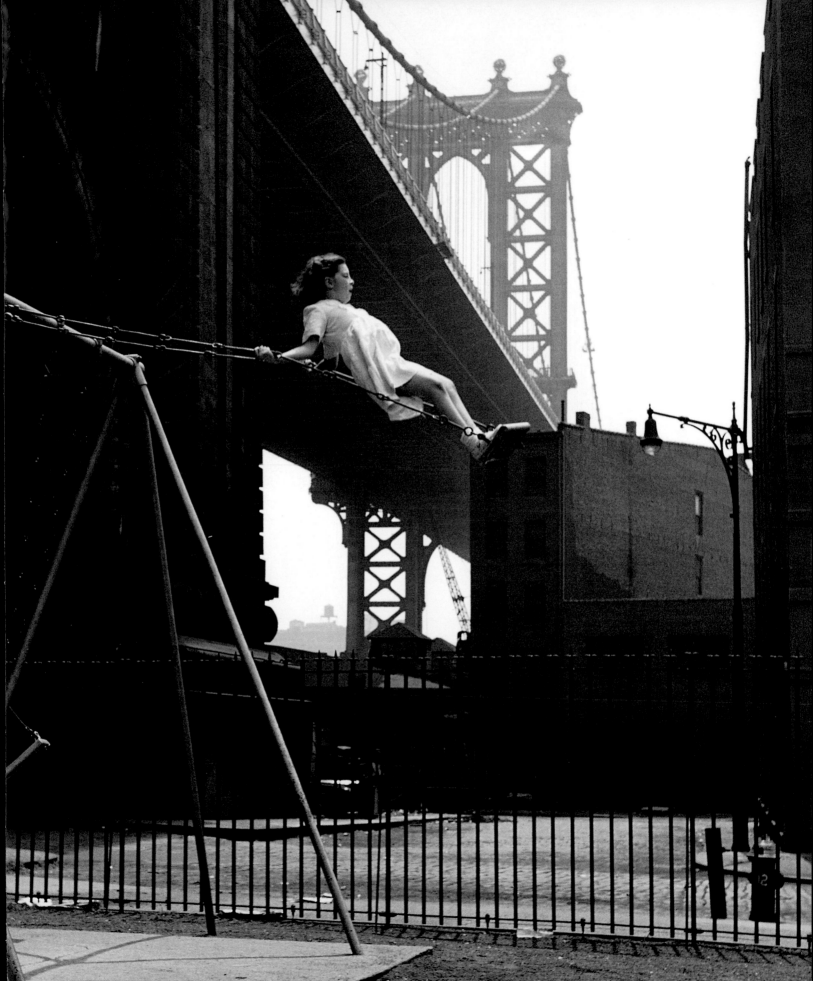

Snapshots from Women's Sports History

1827

"[When the body is] too much exercised, it likewise is apt to produce ganglions on the ankle joints of delicate girls, as wind galls are produced on the legs of young horses who are too soon or too much worked." —"Of the Exercises Most Conducive to Health in Young Girls and Women," *American Farmer*

1856

Catharine Beecher publishes *Physiology and Calisthenics,* which foreshadows the introduction of aerobics by promoting calisthenics for young women done to musical accompaniment.

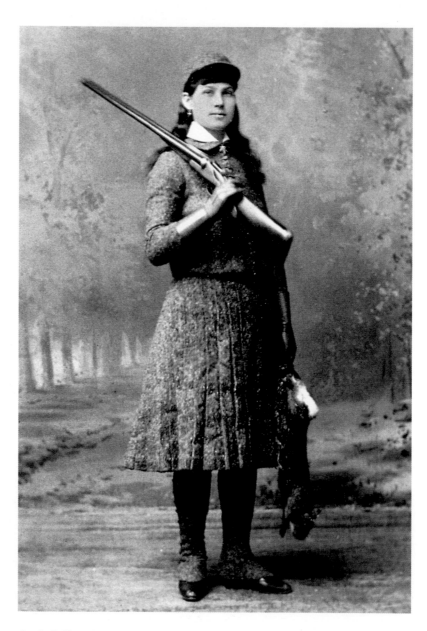

Annie Oakley
Greenville, Ohio
Photographer unknown, 1870s

1874

New Yorker Mary Outerbridge has customs officials scratching their heads when she returns from a vacation in Bermuda with lawn tennis nets, rackets, and balls. They finally let her through—duty free—and she convinces her brother to set up a court at the Staten Island Cricket and Baseball Club, thereby introducing the British-born game of tennis to the United States.

1875

Annie Oakley wins her first shooting match by hitting twenty-five out of twenty-five pigeons, beating Frank Butler, whom she eventually marries. Later, Hollywood scriptwriters would rewrite history, having Annie throw the match so as not to embarrass Frank (renamed Toby Walker) in the 1935 Barbara Stanwyck film *Annie Oakley.*

1879

Archery becomes the first sport to offer a national competition for women when twenty female archers enter the National Archery Championship. Each entrant shoots two rounds, twenty-four arrows standing at fifty yards and forty-eight arrows standing at sixty yards.

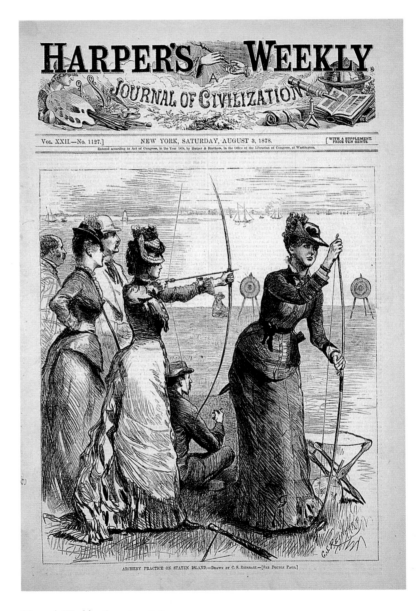

Harper's Weekly, *August 3, 1878*

1890

"In a word, nearly every sport pursued by men has become in the present day more or less a favorite with the ladies: and as far as these sports do not overtax their strength and the pursuit of them does not involve any loss of that grace and charm of femininity which when all is said and done is the crown and glory of woman, there can be no valid reason given why ladies should not be encouraged to benefit themselves by frequent open-air life." —F. C. Sumichrast, "Ladies at the Helm," *Outing*

1894

"Cycling is fast bringing about this change of feeling regarding woman and her capabilities. A woman awheel is an independent creature, free to go whither she will. This, before the advent of the bicycle, was denied her." —*Minneapolis Tribune*

c. 1900

"I was awkward as ever at games, and had never seen a game of [field] hockey, but I had to play something, and in time made the first team. I think that day was one of the proudest moments of my life." —Eleanor Roosevelt on her high school years at the turn of the century, in *This Is My Story*, 1937

Lady Golfer (lantern slide)
Photographer unknown, 1890s (?)

1909

"Any athletic girl, American or English, is not as apt to marry as young as the typical society girl. The society girl lives in the atmosphere of dancing, of music, of soft lights, and of flattery. I don't say that society isn't necessary to a girl's development, but I do mean that athletics are the best antidote for the poison of premature love affairs." —May Sutton, first American woman to win Wimbledon

1910

"At a number of schools girls' basket ball teams are coached by men and some of the athletic teams have men coaches and managers. It is a mistake—a serious mistake. Girls' athletics, from a coaching or a managerial standpoint, should be absolutely directed by women." —James E. Sullivan, in *Spalding's Official Women's Basket Ball Guide*

1912

"Can women be given access to all the Olympic events? . . . There are not just tennis players and swimmers. There are also fencers, horsewomen, and in America there have also been rowers. Tomorrow, perhaps, there will be women runners or even soccer players. Would such sports practiced by women constitute an edifying sight before crowds assembled for an Olympiad? We do not think that such a claim can be made." —Baron Pierre de Coubertin, founder of the modern Olympics

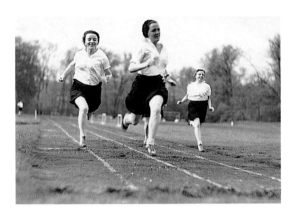

Four Girls Running
Photographer unknown, 1920s (?)

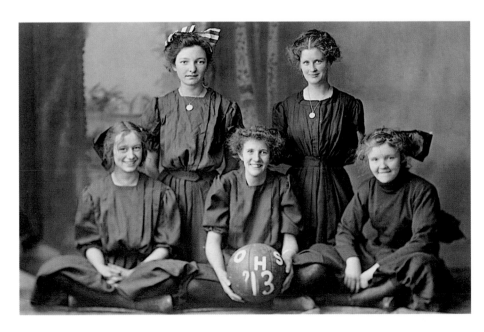

Onaway High School
Onaway, Michigan
Photographer unknown, 1913

1924

"The very evident emphasis placed by the audience on the importance of winning stimulates a girl to unusual effort, perhaps beyond the bounds that the condition of her heart can stand; perhaps beyond the limit where she can maintain emotional stability."
—Dr. J. Anna Norris, in *Child Health*

1926

Women make their mark in the "Golden Age of Sports" with two highly celebrated events. On February 16, the flamboyant French tennis star Suzanne Lenglen beats the cool, calm American Helen Wills in their only meeting. Newspapers hype the match daily, starting more than a month before. On August 6, nineteen-year-old New Yorker Gertrude Ederle becomes the first woman to swim the English Channel, and she does it in fourteen hours, thirty-one minutes, almost two hours faster than any of the five men who managed this feat before her.

1928

Women's track-and-field events are offered at the Olympics for the first time, but they are almost banned from future Olympics due to grossly exaggerated reports of exhausted runners in the 800-meter race. "The final of the women's 800-meter run . . . plainly demonstrated that even this distance makes too great a call on feminine strength," wrote Wythe Williams of *The New York Times*. "At the finish six out of the nine runners were completely exhausted and fell headlong on the ground." It would be another thirty-two years before women would again run any Olympic race longer than two hundred meters.

America's Best Girl, Gertrude Ederle
English Channel
Photographer unknown, AP/Wide World Photos, 1926

1928

"Under prolonged and intense physical strain a girl goes to pieces nervously. She is 'through' mentally before she is completely depleted physically. With boys, doctors experienced in this problem of athletics maintain the reverse is true. A boy may be physically so weak that he has not strength to 'smash a cream puff,' but he still has the 'will' to play. The fact that a girl's nervous resistance cannot hold out under intensive physical strain is nature's warning. A little more strain and she will be in danger both physically and nervously." —Ethel Perrin, in "A Crisis in Girls' Athletics," *Sportsmanship*

1931

"Babe Ruth and Lou Gehrig are both Sultans in the Sovereignty of Swat. But when the two Yankee sluggers, playing in an exhibition game this week with the Chattanooga nine, faced Jackie Mitchell, organized baseball's only girl pitcher, of course they struck out. Her curves were too much for them!" —Report from the *Cincinnati Times-Star,* quoted in *The Literary Digest*

1932

Mildred "Babe" Didrikson qualifies for five of the six women's track-and-field events at the Los Angeles Olympic Games, but a rule passed after the 1928 Games allows women to enter no more than three events. Babe wins gold medals in the javelin and 80-meter hurdles and a silver in the high jump, where she ties for the highest jump but is penalized for her headfirst style. Her triple-medal performance launches a twenty-five-year career in which she awes fans in a wide range of sports.

Liberty, *November 18, 1933*

Miss "Jack" Mitchell with Lou Gehrig, far left, and Babe Ruth
Chattanooga, Tennessee
Photographer unknown, AP/Wide World Photos, 1931

1932

Amelia Earhart becomes the first woman to fly solo nonstop across the Atlantic Ocean. Five years later she would vanish mysteriously over the Pacific during her attempted around-the-world flight. She wrote in her 1937 book, *Last Flight,* "Now and then women should do for themselves what men have already done—and occasionally what men have not done—thereby establishing themselves as persons, and perhaps encouraging other women toward greater independence of thought and action."

1936

"Should girls play basketball—is it harmful or beneficial? The 'pros' say: 'splendid game for the development of health and character'—'basketball calls forth the best, physically, emotionally and mentally, in a girl.' . . . The 'antis' maintain: 'basketball, the sacrifice of the maidens'—'the slaughter of the innocents'—'one of the most atrocious crimes committed in the name of education.' And there are well-informed, intelligent people on both sides!" —Marjorie Bateman, in *Official Basketball Guide for Women and Girls*

1936

Ads for sanitary napkins, introduced in 1921, and tampons, introduced in 1936, target the "active" woman by emphasizing the increased freedom to play sports that these products make possible. "School girls, active in athletics and usually required to participate in daily programs regardless, have found that Kotex . . . guards against emergencies," explains a 1922 ad for Kotex sanitary napkins that shows young women ice-skating. "Every Day of the Month Is a Day of Freedom" proclaims a 1936 ad for Tampax tampons that shows women playing tennis and golf, bicycling, horseback riding, and dancing.

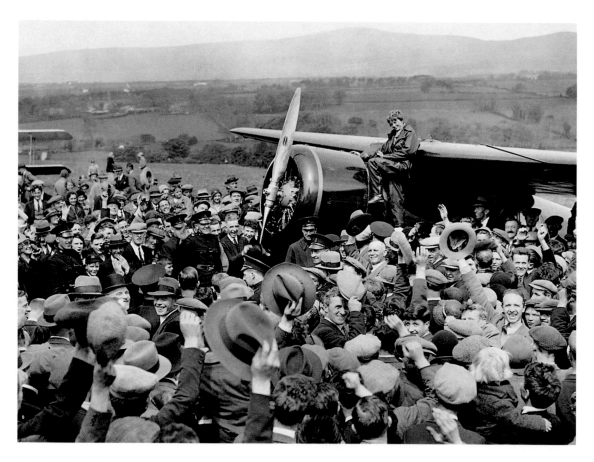

Earhart Solo Flight
Londonderry, Northern Ireland
Photographer unknown, AP/Wide World Photos, 1932

1943

P. K. Wrigley, of chewing gum fame, launches the All-American Girls Professional Baseball League to ensure that high-quality baseball continues on the home front during World War II. Over the course of the league's twelve seasons, more than six hundred women would play professional baseball and close to six million fans would pay to see their games.

1944

Swimmer Esther Williams stars in *Bathing Beauty,* her first "aqua-musical" for MGM. Williams, the 1939 U.S. national 100-meter freestyle champion, had been chosen for the 1940 U.S. Olympic swimming team, but the games were canceled due to the outbreak of World War II. Soon afterward, she joined Billy Rose's San Francisco Aquacade, where she was spotted by movie scouts. Williams would make over thirty movies and be among the top-ten leading box-office attractions in 1949 and 1950. "My movies made it clear it's all right to be strong and feminine at the same time," she would tell the Associated Press in 2000.

1948

Gretchen Fraser, the daughter of Norwegian immigrants, wins the first Olympic medals in skiing for the United States. Fraser, who had been named to the 1940 Olympic team before those games were canceled, wins gold in the slalom and silver in the alpine combined. Dubbed "the flying housewife" by the Associated Press, Fraser had retired from skiing after winning U.S. championships in 1941 and 1942, but returned to competition at her husband's urging. She would be featured on a Wheaties cereal box in 1951.

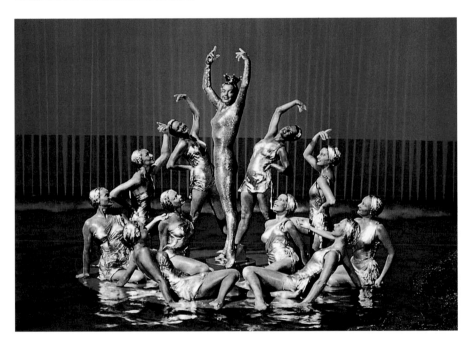

Million-Dollar Mermaid, Esther Williams
Movie theater lobby card, 1952

Strawberry
Rockford, Illinois
Photographer unknown, late 1940s
Rockford Peaches pitcher Lois Florreich is treated for a strawberry —the result of sliding in a skirt— by chaperone Dottie Green.

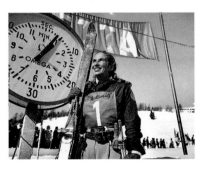

Smiling Champion, Gretchen Fraser
St. Moritz, Switzerland
Photographer unknown,
AP/Wide World Photos, 1948

1948

Alice Coachman is the first African-American woman ever to win an Olympic gold medal when she sets an Olympic record of five feet, six and one-eighth inches in the high jump. Hurdler Tidye Pickett had become the first African-American woman to compete when she participated in the Berlin Olympics in 1936, the same year Jesse Owens won four gold medals.

1949

Gertrude "Gorgeous Gussie" Moran brings women's tennis new visibility when she appears at Wimbledon in a tennis dress with lace-trimmed panties. "Swarms of tennis enthusiasts lined the path to the courts in the hopes of a glimpse of her famous under-apparel," reported *World Tennis* magazine. "Several fans even stretched out on the ground." Like contemporary tennis sex symbol Anna Kournikova, Gussie's game didn't quite reach the same heights as her fame. Although she never ranked higher than fourth, she was offered a rare pro contract and played exhibitions across the country before settling in as a club pro in Palm Springs, California.

1950

Althea Gibson becomes the first African-American athlete invited to compete at the Wimbledon and U.S. Nationals tennis tournaments, thanks in part to an editorial in *American Lawn Tennis* magazine written by four-time U.S. Nationals champion Alice Marble. "For every individual who still cares whether Gussy [*sic*] has lace on her drawers, there are three who want to know if Althea Gibson will be permitted to play in the Nationals this year," wrote Marble. "If Althea Gibson represents a challenge to the present crop of women players, it's only fair that they should meet that challenge on the courts, where tennis is played." Gibson would win both tournaments in 1957 and 1958. She would remain the only African-American woman to take either title until Serena Williams won the U.S. Open (successor to the Nationals) in 1999 and Venus Williams won Wimbledon in 2000.

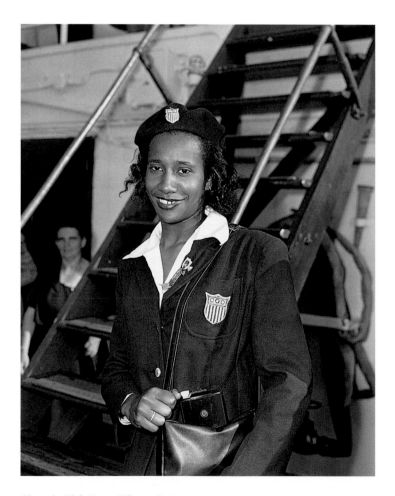

Olympic High Jump Winner Returns
New York, New York
Photographer unknown, AP/Wide World Photos, 1948

Gorgeous Gussie
New York, New York
Photographer unknown,
AP/Wide World Photos, 1948

1952

Katharine Hepburn stars in *Pat and Mike,* a film written to showcase her athletic prowess. As all-around athlete Pat Pemberton, Hepburn competes against—and usually beats—real-life stars including tennis players Alice Marble and Gussie Moran and golfer Betty Hicks. But when one potential cast member sees the original script, she almost walks away. The story calls for Hepburn to beat Babe Didrikson in a golf tournament, but Babe is too much of a competitor for that. She demands that the script be rewritten to let her win by one stroke on the eighteenth green.

1952

"Girls' baseball takes place at Dexter Park in the Woodhaven section of Queens, where the ABC station, WJZ-TV, has its cameras in readiness at 8:30 on Saturday nights. . . . The Arthur Murray dancers are the home team, and they are such a comely nine that it is difficult to believe that they cannot get dates on Saturday but must play baseball." —Jack Gould, "Radio and Television," *The New York Times*

1952

Eleanor Charlson Engle, a softball shortstop with no baseball experience, signs a contract with the Class AA Harrisburg Senators of the Interstate League. While Senators general manager Howard Gordon swears he signed Engle because of her skill, many brand the signing a publicity stunt meant to buoy lagging attendance. After Senators manager Buck Etchison declares, "This is a no-woman's land and believe me, I mean it. She'll play when hell freezes over," minor-league president George M. Trautman officially bans women from the minor leagues. No other woman would play in the minors until pitcher Ila Borders joined the St. Paul Saints in 1997.

Althea Gibson Wins Semifinal Match
Wimbledon, England
Photographer unknown, AP/Wide World Photos, 1958

Ruled Out
Harrisburg, Pennsylvania
Photographer unknown,
AP/Wide World Photos, 1952
From the Associated Press—"June 24, 1952: Mrs. Eleanor Engle, with hand to chin and mouth wide open, reads an Associated Press story that said she was ruled out of organized baseball by George Trautman."

1958

The Wham-O Manufacturing Company introduces the Hula Hoop, and more than 100 million are sold. From the Associated Press—"August 20, 1958: The many different ways an ingenious child can twirl a hoop were demonstrated today when more than one thousand children competed for prizes on 'Art Linkletter's House Party' on the CBS Television City parking lot. Girl Scouts, Brownies, Blue Birds, Campfire Girls and other groups competed. They removed shirts and replaced them, danced on one leg and tap danced, all while indulging in the current hoop craze."

1960

Wilma Rudolph wins three gold medals in track and field at the Rome Olympics and thrills audiences with her grace and skill in the first Olympics to be broadcast worldwide. "Wilma's accomplishments opened up the real door for women in track because of her grace and beauty. People saw her as beauty in motion," said Nell Jackson, coach of the 1956 U.S. women's Olympic track team, in a 1984 interview.

1964

At the Olympics in Tokyo, seventeen-year-old swimmer Donna de Varona wins the gold medal in the first-ever women's 400-meter individual medley and leads her teammates to a world record and another gold in the 400-meter freestyle relay. De Varona would dominate women's swimming in the early 1960s, winning thirty-seven individual national championships and setting eighteen national and world records. She then joined ABC as the first full-time female sportscaster in the United States. She helped found the Women's Sports Foundation and served as its first president, lobbied for the implementation of Title IX, and chaired the organizing committee for the 1999 Women's World Cup. "The effort I had to put forth in my swimming career gave me the stamina to become an activist," de Varona said in a 1999 chat on the USA Swimming website. "The world is political and you have to fight."

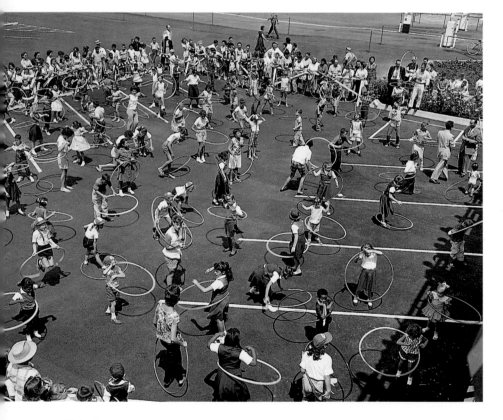

Hula Hoops
Los Angeles, California
Photographer unknown, AP/Wide World Photos, 1958

1967

Syracuse University student Kathrine Switzer manages to register for the men-only Boston Marathon under the name "K. Switzer," but officials see her running and try to force her off the course. "Women can't run in the marathon because the rules forbid it," says Will Cloney, the race director who chases after her. "Unless we have rules, society will be in chaos. . . . If that girl were my daughter, I would spank her." When photographs showing attempts to forcibly eject Switzer are published, they cause an uproar that leads officials of the Boston race to refrain from interfering with women runners starting in 1968. The Boston Marathon finally invites women to enter officially in 1972, one year after the New York City Marathon did the same.

1967

On December 6, Kathy Kusner testifies before the Maryland Racing Commission in her quest for a jockey's license. The commission turns her down on the grounds that Kusner, a veteran jumper and a member of the U.S. Olympic equestrian team, "simply didn't ride well enough." Kusner and her lawyer appeal the ruling and win, setting a precedent that opens opportunities for women as jockeys throughout the United States.

1972

"They were an amazingly good-looking group of people, especially when one thought of the stereotype of the woman athlete. Nobody had a beard. Nobody looked or sounded like Ernest Borgnine. . . . Nobody waddled, not a lumberjack in the group." —Edwin Shrake on the tennis players on the Virginia Slims tour, in "A Long Way, Bébé," *Sports Illustrated*

**No Jockey License for Kathy
(Kathy Kusner, right, and her lawyer, Audrey Melbourne)**
Laurel, Maryland
Photographer unknown, AP/Wide World Photos, 1967

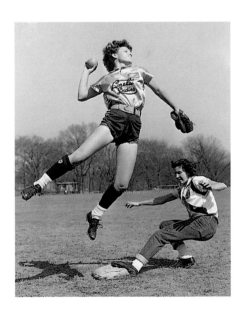

Spring Training for the Ladies
Atlanta, Georgia
Photographer unknown, AP/Wide World Photos, 1955

1972

"No person in the United States shall, on the basis of sex, be excluded from participation in, be denied the benefits of, or be subjected to discrimination under any education program or activity receiving federal financial assistance." So says Title IX of the Education Amendments to the 1964 Civil Rights Act, signed into law on June 23 by President Richard Nixon. By mandating equal opportunity in federally funded programs, Title IX gave legislative muscle to those who were campaigning for more girls' teams, better facilities for girls to play and practice in, and higher pay for coaches of girls' sports in high schools and colleges. Numbers would tell the story of the revolution brought about by Title IX. In 1971, 294,000 high school girls took part in interscholastic sports. By 2000, that figure would balloon to 2,675,874.

1973

"If substantially larger numbers of females take part in competitive athletics . . . sports previously thought too 'difficult' or 'physical' for girls may be opened to them. The demand for coaches and trainers, as well as for equipment specifically designed for females, will increase. In time, women's sports will attract greater public interest. The press will cover women's athletics more frequently and seriously. Women's professional sports will become more popular, more lucrative and thus more attractive in career terms." —Bil Gilbert and Nancy Williamson, "Programmed to Be Losers," *Sports Illustrated*

1973

On September 20, Billie Jean King beats Bobby Riggs in the $100,000 winner-take-all "Battle of the Sexes," broadcast live on ABC. Riggs, the 1939 Wimbledon men's singles champion, had dared King to disprove his assertion that any male player could beat any female player. Her straight-set victory (6-4, 6-3, 6-3) helps open people's eyes to women's athletic potential. Writes Neil Amdur of *The New York Times*, "There can be no doubt that Mrs. King's triumph, viewed by so many, has strengthened her [position] as the Joan of Arc of athletics."

World Champ
Akron, Ohio
Photographer unknown, AP/Wide World Photos, 1976
Joan P. Ferdinand, fourteen, is the second girl to win the All-American Soap Box Derby, following Karren Stead, eleven, in 1975.

Sock It to Him, Billie Jean
Houston, Texas
Photographer unknown,
AP/Wide World Photos, 1973

1977

During the 1970s, female sports reporters fight their own battles for equality as they try to win equal access to male athletes after games, even if it means interviewing them in their locker rooms. Here, Lawrie Mifflin, the first female sports reporter for the New York *Daily News,* interviews New York Rangers rookie defenseman Mike McEwen. Mifflin, who would go on to cover ice hockey, professional soccer, and the Olympic Games for *The New York Times,* was also a pioneer athlete. As a student at Yale, she had helped to form the women's field hockey club and served as captain when it became the school's first women's varsity team in 1972.

1977

The August issue of *womenSports* magazine asks a diverse group of women to explore their tomboy pasts. Comedian Gilda Radner and author Ntozake Shange are among them:

"being a tomboy, for me, had more to do with extending my personal space as a female than wanting to be a boy. how cd i accept not being able to play touch football. . . . i wanted girls' basketball to be as free as the 'real' thing. i wanted to use hardballs, not softballs. no one encouraged us to run fast, but we cd watch willie mays & know better. we could watch willie mays & know, somebody is movin simply cuz he can. i guess, 'tomboy' is having guts/something unheard of for a colored girl from a conventional town surrounded by white folks." —Ntozake Shange, *womenSports*

"At school, I played halfback on the reserve, junior-varsity field hockey team. I also played guard on the basketball team. I wasn't any good until the game, and then I could outdo everyone. The spirit of the competition always made me able to run faster, swim stronger, and bang shins harder than anyone else. During an actual baseball game, I could even catch a fly ball with my eyes shut." —Gilda Radner, *womenSports*

Lawrie Mifflin at NY Rangers Game
New York, New York
Cary Herz, 1977

First Female Batboy
New York, New York
Cary Herz, 1976

1978

"When everyone says you can't do something, and you do it, it's pretty empowering," says chemist Arlene Blum, leader of the American Women's Himalayan Expedition that reaches the 26,540-foot summit of Annapurna I. The expedition motto, "A Woman's Place is on Top," proves so popular that T-shirts printed with it substantially help fund the climb. An experienced snow and altitude climber, Blum organized this all-women's expedition after experiencing disappointment from male-led excursions where popular belief held that women jeopardized the "camaraderie of the heights" and were typically assigned to cooking duty rather than summit teams.

1978

Golfer Nancy Lopez wins nine tournaments and earns the LPGA Rookie of the Year title. She also earns $189,813, more than any male or female rookie golfer, ever. A New Mexico native who learned the game by following her father around the golf course from the age of seven, Lopez takes the golf world by storm the way Tiger Woods would two decades later. Writes Grace Lichtenstein in a 1978 issue of *The New York Times Magazine,* "[Lopez] finally brought women's golf the charismatic headliner it has desperately needed to catapult it into the front ranks of sports."

1980

Female athletes at Temple University file *Haffer et al. v. Temple University,* a landmark Title IX class action lawsuit that charges the school with discrimination in allocating funds to its men's and women's athletic programs. Marcia D. Greenberger of the National Women's Law Center, who works on the case, would later recount, "When young women were playing in actual matches with other teams and it came time for a men's team to practice on the field, they were kicked off the field and their game just ended. Witnessing that truly got to me. It was so enraging and so humiliating and so angering, it made me determined to end the injustice." In September 1988, the court would order Temple to add a women's swimming team, upgrade women's crew to varsity status, and submit to a court-monitored five-year plan to improve financial support and facilities for women's sports.

Above Camp II on Annapurna
The Himalayas, Nepal
Arlene Blum, 1978

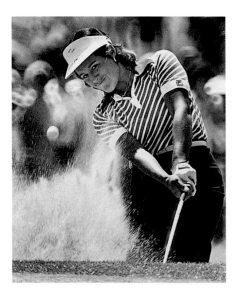

Lopez Blasts Out
Palm Springs, California
Photographer unknown, AP/Wide World Photos, 1978

1984

Six weeks after having arthroscopic surgery on her right knee, sixteen-year-old Mary Lou Retton scores a perfect ten on the vault to come from behind and take the gymnastics all-around gold medal at the Los Angeles Olympics. The first American woman to win a gymnastics gold, the four-foot, nine-inch Retton also comes away with silver medals in the team and vault competitions, and bronze medals in the uneven bars and floor exercises. Her performance earns her a place on a Wheaties box, as well as Sportsman of the Year honors (with Edwin Moses) from *Sports Illustrated*.

1986

American figure skater Debi Thomas joins countryman Brian Boitano in winning gold at the World Figure Skating Championships in Geneva, Switzerland. Thomas, winner of the ladies' singles title, would go on to become the first African-American athlete to win a medal at any Winter Olympics when she took the bronze at Calgary in 1988. While training for the Games, she would continue as a premed student at Stanford University, with the goal of specializing in orthopedic surgery.

1990

"It is reasonable to think that a cover featuring only females would be repugnant to those people who are most likely to buy the magazine, and there were only a very limited number of recognizable female athletes to draw from." —John Papanek, managing editor of *Sports Illustrated for Kids*, on why female athletes are underrepresented on the magazine's covers, as quoted in *Play and Culture*

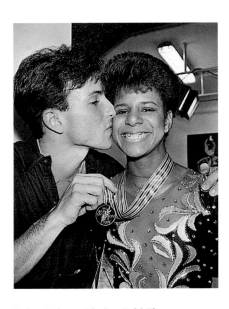

Brian Boitano Kissing Debi Thomas
Geneva, Switzerland
Michel Lipchitz, AP/Wide World Photos, 1986

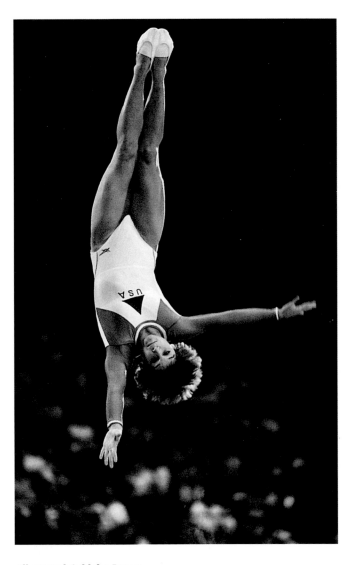

All-around Gold for Retton
Los Angeles, California
Photographer unknown, AP/Wide World Photos, 1984

1992

Michael D. Davis writes in *Black American Women in Olympic Track and Field: A Complete Illustrated Reference* about Florence Griffith Joyner, "With her shoulder-length hair, meticulous make-up, one-legged running tights, lace-trimmed bikini briefs and long multicolored fingernails, [Flo Jo] has run into the record books a rainbow blur of blazing color. 'Looking good is almost as important as running well,' she said, '[though in fact] I run more like a guy than a girl.'" Griffith Joyner had won three gold medals in the 1988 Seoul Olympics in the 100- and 200-meter sprints and the 4x100 relay, and a silver in the 4x400 relay.

1992

After two women's teams (gymnastics and volleyball) and two men's teams (water polo and golf) are downgraded to club status at Brown University, gymnastics team captain Amy Cohen leads thirteen other athletes in filing a class action lawsuit alleging gender discrimination in violation of Title IX. Following two years of hearings and injunctions, a Providence, Rhode Island, court would find in favor of the athletes. An appeals court upheld this decision, and in 1997, the U.S. Supreme Court would let the decision stand. In the end, *Cohen et al. v. Brown University* would go a long way toward defining the standards for compliance with Title IX.

1992

A League of Their Own, a Hollywood film about the All-American Girls Professional Baseball League, earns more than $100 million from July through September, making it one of the top-grossing films of the summer. In a unique marketing move, director Penny Marshall appears on the QVC cable shopping network promoting commemorative baseball shirts, caps, and other items, most of which sell out quickly. Soon, TV commercials for everything from headache medicine to life insurance would show women joyfully playing sports.

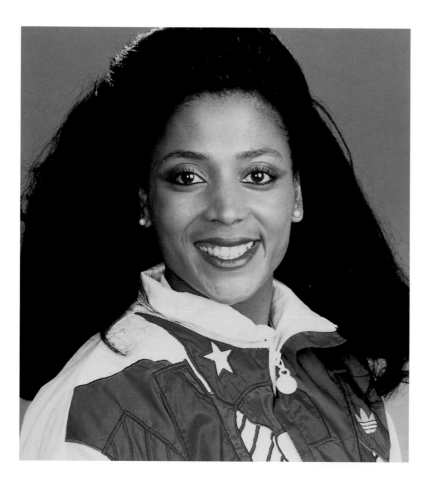

Flo Jo
Photographer unknown, AP/Wide World Photos, 1988

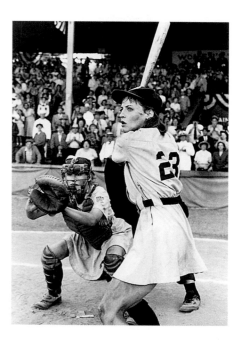

From *A League of Their Own*
Photographer unknown, 1992

1993

Lynn Hill stuns the rock-climbing world by "freeing the Nose"—becoming the first person to climb Yosemite's unyielding 3,000-foot rock wall, the Nose, using free climbing technique that allows her to use only her footwork, skill, and physical strength to pull herself up. Said Hill, "A big part of that climb was to make a statement that a woman can do something that is going to blow people's minds about what's possible."

1995

"[Female golfers are] handicapped by having boobs. It's not easy for them to keep their left arm straight, and that's one of the tenets of the game." —CBS golf commentator Ben Wright, as quoted by Valerie Helmbreck in the *News Journal* of Wilmington, Delaware

1996

After *Newsweek* labels it "Year of the Women" and *The New York Times Magazine* proclaims, "The story of this year's Olympics will be the women," female athletes from the United States excel in both individual and team sports at the Atlanta Games. In all, American women take home nineteen of the country's forty-four gold medals, including four of the five in team sports (soccer, softball, basketball, and team gymnastics). "The playing field still isn't level," writes U.S. basketball coach Tara VanDerveer in her book, *Shooting from the Outside*, "but it's getting closer all the time."

Wahine, *1998*
Charles Rehm, 1990s

1996/97

Following the success of the U.S. women's basketball team at the Olympics, competing investors launch two new professional hoops leagues for women in the United States. The American Basketball League (ABL), led by Teresa Edwards and seven of her teammates from the Olympic team, tips off first, in October. Eight months later, the National Basketball Association launches the Women's National Basketball Association (WNBA), using all of its marketing might. Although the ABL has a longer season (in 1997, forty-four games to the WNBA's twenty-eight) and many say the quality of its play is better, it does not attract the press coverage or have the TV presence of the WNBA. In 1998, the ABL would fold in the middle of its third season while the WNBA, led by its perennial champions, the Houston Comets, would see its franchises continue to expand and attendance continue to rise.

1997

Dee Kantner and Violet Palmer become the first female referees on the National Basketball Association's fifty-eight-member officiating staff. Both women join the league for exhibition games after working in the WNBA during its summer season. "We're ready for them," Dennis Rodman of the Chicago Bulls tells the Associated Press. "But are they ready for us? They've got to be ready to run with us on the court, get touched and even get a pat on the [behind] every now and then. If they can handle that, then everything will be all right."

1997

Heather Sue Mercer, a former placekicker with the Duke University football team, files a Title IX lawsuit against Duke claiming she had been cut because of her gender. Although Mercer's coach, Fred Goldsmith, claims he had cut her because she wasn't as skilled as his other kickers, Mercer testifies that he had suggested she would be a distraction to the other players and should "try something like beauty pageants" instead of football. In October 2000, a federal jury would find for Mercer and would award her two million dollars in punitive damages, saying they settled on the large amount because school officials had been aware of the discrimination and did nothing about it.

Referee, *March 1998*
Barry Mano, *1997*

1999

The third Women's World Cup—the first to be played in the United States—takes the country, and the media, by storm. More than 78,000 fans attend the opening doubleheader in Giants Stadium, East Rutherford, New Jersey, and 90,185 pack Pasadena's Rose Bowl for the final between China and the United States, which the United States wins in a shootout. The Rose Bowl crowd is larger than that at the 1999 Super Bowl, any game of the 1999 World Series, and any other women's sports event, ever. In December, *Sports Illustrated* names the U.S. team Sportswomen of the Year.

2000

After years of debate, the International Olympic Committee (IOC) suspends compulsory gender testing for female athletes at the Sydney Olympics on an experimental basis. Introduced at the 1968 Games, testing had consistently been considered inaccurate and degrading. Before the Sydney Games, a commission of athletes had voted unanimously to demand that testing be scrapped, and the IOC complied. Says Peter Tallberg, chairman of the IOC's athletes commission, "Testing of this nature is not a part of a proper, modern attitude to gender and equality in sport."

2000

With close to five thousand women competing in 130 events, the Sydney Olympics are the culmination of a century in which women's sports evolved from an afterthought to the main event, and the very perception of female beauty changed to embrace muscles and strength. "At the end of the day, win or lose, big or small, these athletes are gorgeous," writes Allison Glock in the *Women's Sports & Fitness* magazine Olympic preview. "They break records and stereotypes. They radiate the honed magnificence of a body refined to pure use. They take flight. And in doing so, they teach the rest of us to fly."

Nikki McCray with WNBA President Val Ackerman
New York, New York
Richard Drew, AP/Wide World Photos, 1997

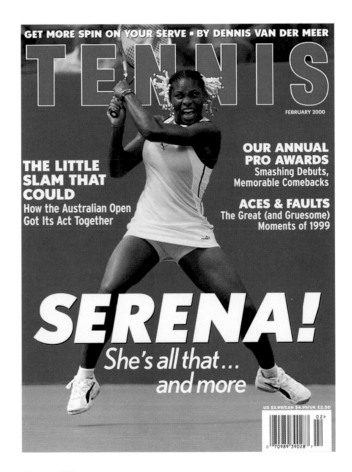

Tennis, *February 2000*
June Harrison, 2000
Serena Williams had beaten her big sister, Venus, on the way to winning the 1999 U.S. Open. But Venus beats Serena in the semifinals at Wimbledon in 2000 and goes on to win that championship, which she follows with the 2000 U.S. Open title and the tennis gold medal at the Sydney Olympics.

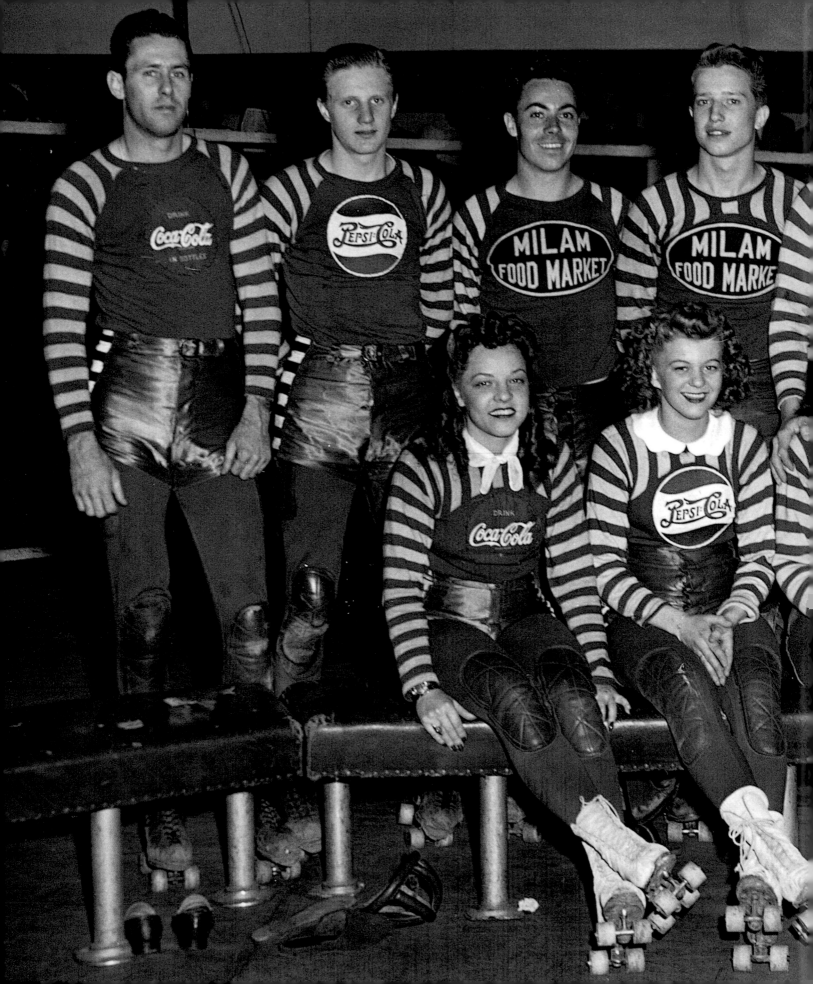

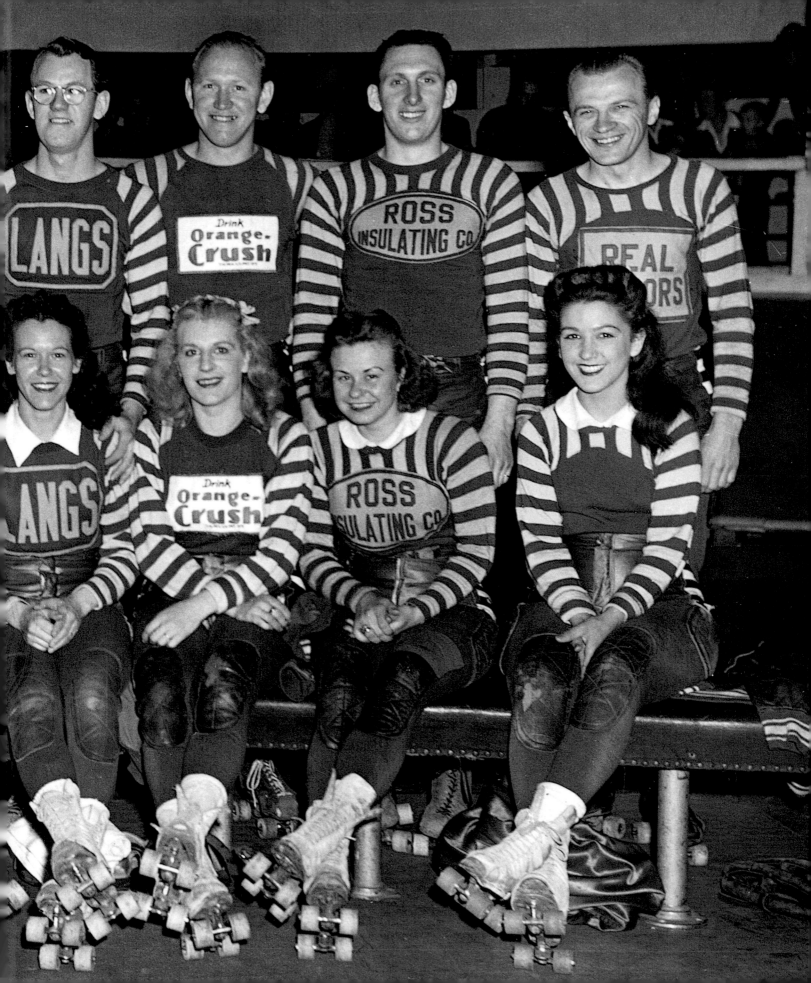

In-kind Sponsors of Game Face:
The Associated Press/Wide World Photos
Raffi Imaging, New York, New York
Title 9 Sports

Sports Illustrated
Los Angeles Times
The New York Times
The Philadelphia Inquirer
The Commercial Appeal (Memphis, Tennessee)
Star-Tribune (Minneapolis, Minnesota)
Fort Worth Star-Telegram
Detroit Free Press
The Press Democrat (Santa Rosa, California)
Allsport
Gerald Seltzer of the World Skating League
Phoenix Communications

Acknowledgments

To all the photographers who sent work to Game Face and all the people who shared their stories with me, thank you for making this idea a reality.

Geoffrey Biddle co-curated the Game Face exhibition and edited this book. His offer of assistance could not have come at a better time, nor could the sincerity of his pledge to help have been more true. His involvement has fundamentally shaped this project. To him I offer thanks and love for sharing this vision with me and for generously giving his time, ideas, humor, and expertise.

Grateful thanks to Marilyn Shapiro, whose insight and persistence brought to Game Face many of the wonderful photographs and words you see in these pages. Marilyn generously shared her contacts in the photo world and expertly tracked down the athletes pictured in these pages, conducting original interviews so their voices could be included.

I owe deep gratitude to Sue Macy, who developed, researched, and wrote the Snapshots section of Game Face. Sue's knowledge and perspective on women's sports is inspiring. I am grateful to Sue for her work on this project and for showing me the ropes in our earlier photo and text collaboration, *Play Like a Girl*.

Special thanks to Penny Marshall for supporting this project and contributing her Foreword, and thanks to Lori Marshall for her involvement as well.

Ellen Dorn of the Smithsonian Institution appreciated this material early and continuously, and helped bring it to the public. Mary Beth Byrne and Elisabeth Cannell of Ralph Appelbaum Associates designed the exhibition.

The Associated Press and Wide World Photos gave Game Face access to their archives and donated the use of many photos that are included in the project. In particular, sincere thanks to Joel Miller, for recognizing the value of this project when it was still being formed; Vin Alabiso, for granting his approval; and Sean Thompson, for the many services and solutions he provided.

Thanks to Raffi and Jean Hartman of Raffi Imaging for their in-kind support in providing Game Face with book and exhibition prints, not only for all the AP/Wide World photos but also for many of the other images in the book and exhibition.

Game Face owes thanks to Colin Crawford of the *Los Angeles Times*; Phyllis Collazo, Barbara Mancuso, Margaret O'Conner, Mike Smith, Jim Mones, and Nancy Lee of *The New York Times*; Clem Murray of *The Philadelphia Inquirer*; Bob Swofford of *The Press Democrat* (Santa Rosa, California); Dennis Copeland of *The Commercial Appeal* (Memphis,

Tennessee), Max Frank of the *Fort Worth Star-Telegram*, Peter Koeleman of the *Star-Tribune* (Minneapolis, Minnesota), Nancy Andrews of the *Detroit Free Press,* Peter Orlowsky of Allsport, Alex Burrows of *The Virginia Pilot,* and Joe Elbert of *The Washington Post.*

Jenifer Levin and Nancy Nerenberg each generously allowed me to include excerpts from their short stories. Terril Neely's design solutions have been valuable throughout. Thanks to Ruth Silverman for her unfailing support and for sharing with me her knowledge of pictures, books, and exhibitions.

The photographs and ideas about photography for this book came from many and varied sources. Particularly valuable assistance was given by Andi Schreiber, Marianne Thomas, Meri Simon, Sheron Rupp, Susan Schwartzenberg, Elizabeth Krist of *National Geographic;* MaryAnne Golon, Margaret Moulton, Mark Edward Harris, Shelby Thorner, Charles Harbutt and Joan Liftin, Karen Mullarkey, Kim Wong, Julia Scully, Tom Seawell, Kelly LaDuke, Laura Chun, Gerald Seltzer of the World Skating League; Helen Fanus, Jay Ruby, David Binder, Gigi Frias, Susan Spaight, Jennifer Warren, Judy Mason and Anne Biddle. The professionals at several agencies were also very helpful, especially Jeffrey Smith and Robert Pledge at Contact Press Images, Midge Keator at Woodfin Camp & Associates, Karen Carpenter at *Sports Illustrated,* Mary Engel at the Ruth Orkin Photo Archive, Libby McCoy at the Bill Owens Photo Archive, and Janet Borden at the Janet Borden Gallery.

Knowledge of how to develop a project like Game Face came from Lisa Cremin, Mary Virginia Swanson, Charles Melcher, Patti Richards, Lynn Gordon, Fran Ravel, Carole Kismaric and Marvin Heiferman, Alanna Stang, Deena Andre, Jill Vexler, Cindy Miller, Jennifer Elias, Bess Bendet, Zachary Morfogen, Susan Rothstein, and Meeghan Prunty.

The guidance of my agent Sarah Lazin helped bring Game Face to Random House where Susanna Porter and Kathy Rosenbloom were particularly helpful. Larry Wolfson's design helped present the material clearly. Game Face has also benefited from the legal advice of David Korzenik and Michael Lefkowitz. Copyediting was provided by Jane Herman and transcription assistance by Melinda Bruno. Kim Wong interviewed Pam Gill-Fisher, and Nicole Keys collaborated on the interview of Andra Douglas. Many of the black-and-white book prints were made by Ryan Speth, who also provided technical assistance with our computers.

Help with understanding the world of women's sports was provided by Janet Justus, who introduced me to many of this project's supporters within the National Collegiate Athletic Association and the Committee on Women's Athletics, including Bridget Belgiovine, Robin Green, Lori Hendricks, Dr. Jane Meyer, Athena Yiamouyiannis, Cheryl Levick, and Patty Viverito of the Missouri Valley Conference. Help was also forthcoming from Evelyn C. White; Wayne Wilson of the Amateur Athletic Foundation; Michael Yeager; Dr. Mary Jo Kane of the Tucker Center for Research on Girls & Women in Sports; Missy Park of Title 9 Sports;

Dr. Alpha Alexander; Beth Rasin; Dr. Carole Oglesby of Temple University; Verna Simpkins of Girl Scouts of the U.S.A; Ellen Markowitz; Jeff Orleans of the Council of Ivy Group Presidents; Linda Haynes of Girls Inc.; Margaret Duncan at the University of Wisconsin; Sheila E. Schroeder; Anne Kletz of SportsBridge; Jennifer Alley of the National Association of Collegiate Women Athletic Administrators; Donna Lopiano, Marjorie Snyder, Tuti Scott and Colleen McDonough of the Women's Sports Foundation; Darrell Hampton of the Oscar Bailey-Acorn Track Team; Ernestine Miller of Women and Sports and Events; Whitney Ransom, Carolyn Colletti, and Meg Moulton of the National Coalition of Girls' Schools; Bernice Sandler of the National Association for Women in Education; Julie Kennedy; Marcia Greenberger of the National Women's Law Center; Jennifer L. Caldwell; Joshua Schwartz; Tim Simmons; Katie Arnold; Jane Betts; Don Beard; Connie Wilson; Mary Spelman; and Mary Elizabeth Grimes-Nutt.

I received additional timely help from Eve Biddle, Geena Davis, Sue Rodin, Laura Harnish, Steve Nislick, Gary Dorin, Riki Thierfelder, Percy Pyne, Steve Fisch, Gail Gendler, Chris Ma, Peggy Orenstein and Steven Okazaki, Stacy Stuart, Eve Grubin, Matt Schneider, Kelly McDonald, Geoff Belinfante, Ruth Berkowitz, Mark Rubin, Patti Matson and Ed Gottesman, Phyllis and Jim Easton, Senator Manfred Ohrenstein, Peter Joseph, Don Becker, Rachel Cooper, Ana Yagozinski, Pam Burdman, Janet Daly, Tom Sternal, Laura Talmus, Brenda Stine, and Laura Watts of Pillsbury, Madison and Sutro LLP.

This project came to fruition over a ten-year period. Many, many people have helped me along the way, and I'm sure I have forgotten some. Within the Game Face office, Penelope Mahot has been thorough, steady, and positive, even in times of crisis, and Jennie Santos has been a cheerful and diligent presence. From my own home, I cannot thank enough my parents, Jerry and Paula Gottesman, and my sisters, Abbie, Archie, and Sally, for their patience and love.

Photographer Credits

Ansel Adams, courtesy The Library of Congress, 59

William Albert Allard, National Geographic Image Collection, 33

Tina Barney, courtesy Janet Borden Gallery, 32

Geoffrey Biddle, 17, 31, 120, 180

Nathan Bilow, 36

Kenneth Bizzigotti, 164

Arlene Blum, 212

David Brauchi, courtesy AP/Wide World Photos, 101

Raymond L. Brecheisen, courtesy *Morning Sun,* Pittsburg, Kansas, 117

David Brewster, courtesy *Star-Tribune,* Minneapolis, Minnesota, 97

Karen Bucher, 12

Robert Bukaty, courtesy AP/Wide World Photos, 74

David Burnett, Contact Press Images, 34

Pete Burnight, 112

Cristiana Ceppas, 187

Etta Clark, from *Growing Old Is Not for Sissies* 2,

Catherine Cobb, 162

Mark Cohen, 22, 52

Francis L. Cooper, courtesy Francis Cooper Collection, Pennsylvania State Archives, 46

Ralph Crane, TimePix, 69

Paul D'Amato, 29, 80

Penny De Los Santos, 64

Richard Drew, courtesy AP/Wide World Photos, 216

Tony Duffy, courtesy Allsport/Tony Duffy, 107

Melissa Farlow, *Courier Journal and Louisville Times,* Louisville, Kentucky, 186

Larry Fink, 193

Susie Fitzhugh, 72, 118

Nancy Floyd, 189

Eve Fowler, 35

Ruth Fremson, courtesy AP/Wide World Photos, 142

Mary Frey, 60, 185

Lee Friedlander, courtesy Janet Borden Gallery, 156

Karen Fuchs, 1

Bob Galbraith, courtesy AP/Wide World Photos, 93

Mark Gallup, 115

Julian Gonzalez, courtesy the *Detroit Free Press,* Detroit, Michigan, 65

Arlene Gottfried, 70, 159

Brad Graverson, *Daily Breeze,* Torrance, California, 21

Judy Griesedieck, 170

Charles Harbutt, 20

June Harrison, courtesy *Tennis Magazine,* 217

Cheryl Hatch, 148

Cary Herz, 211 (both)

Abigail Heyman, 30, 76

John Huet, 49

Walter Iooss Jr., courtesy Walter Iooss Jr./*Sports Illustrated,* 166

Julie Meinich Jacobsen, 63

Jeff Jacobson, 40, 89, 174

Kenneth Jarecke, Contact Press Images, 154

Lynn Johnson, 16, 150, 168

Frances Benjamin Johnston, courtesy The Library of Congress, 184

Karen Kasmauski, 56

Heinz Kluetmeier, courtesy Heinz Kluetmeier/*Sports Illustrated,* 91, 102

Justine Kurland, 172

Lisa Kyle, 178

Dorothea Lange, copyright the Dorothea Lange Collection, The Oakland Museum of California, City of Oakland, gift of Paul S. Taylor, 182

Eileen Langsley, 50, 75

Brian Lanker, 175

Chang W. Lee, courtesy Chang Lee/NYT Pictures, 96, 132, 167

Annie Leibovitz, Contact Press Images, 73

Mark Lennihan, courtesy AP/Wide World Photos, 152

Michel Lipchitz, courtesy AP/Wide World Photos, 213

Jerry Lodriguss, courtesy *The Philadelphia Inquirer,* 140

Norman Y. Lono, 126, 160

Barry Mano, 216

Robert Mapplethorpe, copyright © The Estate of Robert Mapplethorpe, used with permission, 195

Stephen Marc, 79

Mary Ellen Mark, 2, 87, 138

Joyce Marshall, courtesy *Star-Telegram,* Fort Worth, Texas, 43

Andrea Modica, courtesy The Groton School, 27

Peter Moriarty, 108, 194

Barbara Norfleet, 38

Ruth Orkin, courtesy Ruth Orkin Photo Archive, 125

Christine Osinski, 24, 26

Bill Owens, courtesy The Bill Owens Archive, 176

Greg Peters, courtesy *Hutchinson News,* Hutchinson, Kansas, 123

David Peterson, courtesy *Des Moines Register,* 137

Bill Phelps, 48

Sylvia Plachy, 190

Michael Probst, courtesy AP/Wide World Photos, 130

Susan Ragan, courtesy AP/Wide World Photos, 192

Anacleto Rapping, courtesy *Los Angeles Times,* 86, 146

Charles Rheims, courtesy *Wahine* Magazine, 215

Gaspano Ricca, courtesy Sue Macy, 203

Patricia D. Richards, 85, 98

Rick Rickman, 62

Walter Rosenblum, 84, 196

Sheron Rupp, 28, 66, 81

Jeffrey Allan Salter, 82

Larry Salzman, courtesy AP/Wide World Photos, 158

Amy Sancetta, courtesy AP/Wide World Photos, 128

April Saul, 92

Al Schaben, courtesy *Los Angeles Times,* 95

Richard D. Schmidt, *Sacramento Bee,* Sacramento, California, 54

Andi Faryl Schreiber, 18

Barbel Scianghetti, 58

Art Shay, TimePix, 110

Victoria Sheridan, 171

Barton Silverman, courtesy Barton Silverman/NYT Pictures, 141

Meri Simon, 177

Steven G. Smith, courtesy *Commercial Appeal,* Memphis, Tennessee, 163

(Swatch Team), courtesy AP/Wide World Photos, 131

George Tiedemann, courtesy George Tiedemann/*Sports Illustrated,* 105

John Freeman Todd, 104

Nancianne Vizzini, 8

G. H. Welch, courtesy The Library of Congress, 224

Annie Wells, courtesy *Press Democrat,* Santa Rosa, California, 44

Angela West, 181

Gerald Williams, courtesy *The Philadelphia Inquirer,* 121

Geoff Winningham, 71, 122

Dan Winters, 39

Lui Kit Wong, 147

Carl Yarbrough, courtesy Carl Yarbrough/*Sports Illustrated,* 111

Artist unknown, courtesy Sue Macy, 199

Photographer unknown, 205, 214

Photographer unknown, © Bettmann/Corbis, 14, 42, 78

Photographer unknown, courtesy Annie Oakley Foundation, 198

Photographer unknown, courtesy AP/Wide World Photos, 4, 10, 61, 114, 133, 136, 144, 153, 188, 202, 203, 204, 205, 206 (both), 207 (both), 208, 209 (both), 210 (both), 212, 213, 214

Photographer unknown, courtesy Jane Gottesman, 200, 201 (both)

Photographer unknown, courtesy National Baseball Library, Cooperstown, New York, 205

Photographer unknown, courtesy The Library of Congress, 100

Photographer unknown, courtesy The Museum of Modern Art, New York. Gelatin-silver print, 8"x10" (20.3x25.4cm). Gift of Jacques Henri Lartigue. Copy print © 2000 The Museum of Modern Art, New York, 124

Photographer unknown, courtesy University of Nebraska-Lincoln Library Archives & Special Collections, 106

Photographer unknown, from *Roller Derby to Roller Jam: The Authorized Story of an Unauthorized Sport,* 218

Text Credits

All quotes are from original interviews unless otherwise noted.

Page 4, excerpted from "A Young American Fulfills Her Modest Goal: Bronze," by Bill Pennington, copyright © 2000 by *The New York Times.*

Page 13, excerpted from *Next Game,* by Nancy R. Nerenberg, copyright © 1994 by Nancy R. Nerenberg. Used by permission of the author.

Page 39, excerpted from "Haw!" by Sonja Steptoe, copyright © 1991 by *Sports Illustrated.*

Page 45, excerpted from "Raymond's Run," from *Gorilla, My Love,* by Toni Cade Bambara, copyright © 1971 by Toni Cade Bambara. Used by permission of Random House, Inc.

Page 55, excerpted from *Her Marathon,* by Jenifer Levin, copyright © 1994 by Jenifer Levin. Used by permission of the author.

Pages 111, 167, from *Good Morning America* interviews, ABC-TV, 1999.

Page 112, excerpted from "The Woman Who Rides Mountains," by Joni Martin, copyright © 1999 *Wahine.*

Page 127, excerpted from *On the Rez,* by Ian Frazier, copyright © 2000 by Ian Frazier.

Page 140, from "Taking Flight," by Kelli Anderson, copyright © 2000 by *Sports Illustrated for Women.*

Page 151, from *In These Girls Hope Is a Muscle,* by Madeleine Blais, copyright © 1995 Madeleine Blais.

Page 169, from "Disabled Athlete Ends Tufts U. Symposium," by Russell Capone, copyright © University Wire.

Page 194, quoted by Bruce Chatwin in *Lady Lisa Lyon,* by Robert Mapplethorpe, copyright © 1983 by Viking Penguin.